Leonardo to Van Gogh: Master Drawings from Budapest

D0746717

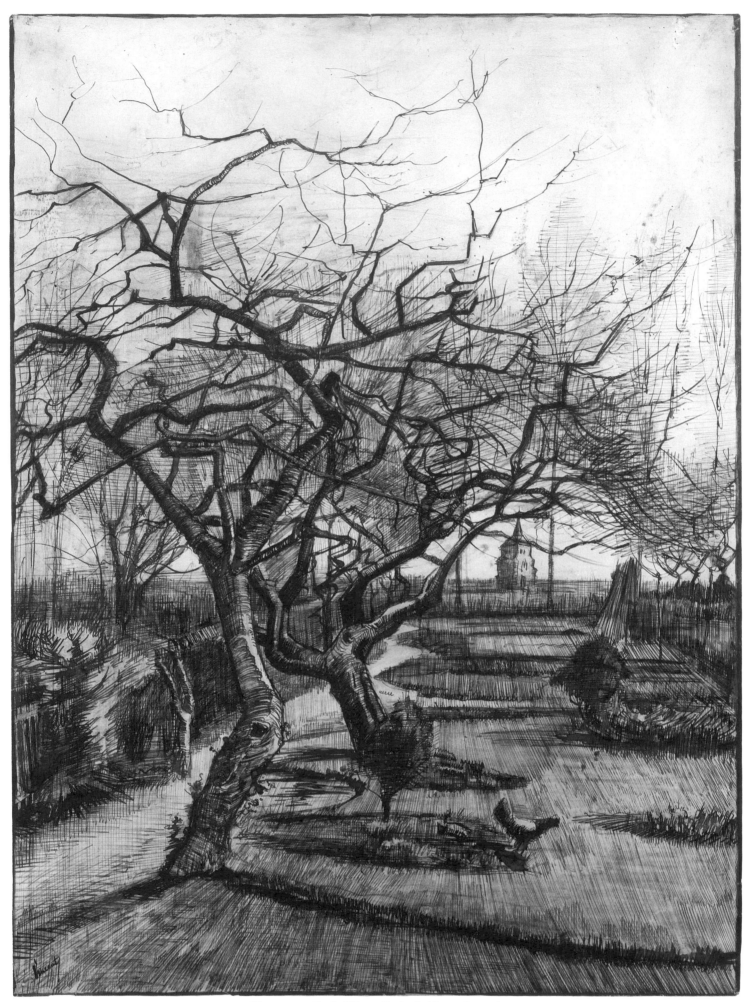

Vincent van Gogh, *Winter Garden in Nuenen* (cat. 90).

Leonardo to Van Gogh
Master Drawings from Budapest

Museum of Fine Arts, Budapest

National Gallery of Art, Washington

The Art Institute of Chicago

Los Angeles County Museum of Art

The tour of this exhibition was made possible in part by a grant from Occidental Petroleum Corporation. Support for this catalogue and the exhibition it accompanies was also received from the National Endowment for the Arts, a Federal agency. This exhibition is supported by an indemnity from the Federal Council on the Arts and the Humanities.

The exhibition locations and dates are: National Gallery of Art, Washington, D.C., May 12–July 14, 1985; The Art Institute of Chicago, July 27–September 22, 1985; Los Angeles County Museum of Art, October 10–December 8, 1985.

This catalogue was produced by the Publications Department of The Art Institute of Chicago and the Editors Office, National Gallery of Art, Washington, D.C.
Editor and Coordinator of Publications, The Art Institute of Chicago: Susan F. Rossen.
Translated from the Hungarian by Janos Scholz.
Edited by Mary Yakush, National Gallery of Art.

Coordinated in Budapest by Teréz Gerszi, Curator of Prints and Drawings, Museum of Fine Arts, Budapest.
Color photographs by Alfréd Schiller.
Transparencies courtesy Corvina Kiadó; black and white photographs courtesy Museum of Fine Arts, Budapest.

Designed by Lynn Martin, Chicago, Illinois.
Typeset in Bembo by Michael and Winifred Bixler, Skaneateles, New York.
Printed by Eastern Press, New Haven, Connecticut. Bound by Riverside Bindery, Rochester, New York.

Cover ill.: Leonardo da Vinci, *Study of a Warrior's Head* (cat. 5).

Library of Congress Catalogue Card Number: 84–22370

Library of Congress Cataloging in Publication Data
Main entry under title:

Leonardo to Van-Gogh—master drawings from Budapest.

 "This catalogue was produced by the Publications
Department of The Art Institute of Chicago and
the Editors Office, National Gallery of Art,
Washington"—T.p. verso.
 From the collection of the Szépmüvészeti Museum,
Budapest.
 Bibliography: p. 218
 Includes index.
 1. Drawing—Exhibitions. 2. Szépmüvészeti Museum
(Hungary)—Exhibitions. I. Yakush, Mary. II. National
Gallery of Art (U.S.) III. Art Institute of Chicago.
IV. Los Angeles County Museum of Art. V. National
Gallery of Art (U.S.). Editors Office. VI. Szépmü-
vészeti Múzeum (Hungary)
NC15.W37N375 1985 741.94'074'013 84–22370
ISBN 0–86559–064–8

Contents

Foreword

The exhibition *Leonardo to Van Gogh: Master Drawings from Budapest* represents a significant collaborative effort between Eastern European and American museums. The extraordinary generosity of the Museum of Fine Arts, Budapest, brings to the United States for the first time a renowned group of master drawings. Few museums have riches comparable to those of the Esterházy collection, which forms the nucleus of the Budapest museum. The strength of the Budapest collection is its representation of the great masters of the graphic arts of the fifteenth through the seventeenth centuries, whose drawings seldom, if ever, are available in American collections, all of which were formed more recently. From Leonardo's monumental studies for the *Battle of Anghiari* through Altdorfer's view of Sarmingstein and Rembrandt's powerful late *Female Nude*, no more quintessential masterpieces of the art of drawing could be imagined. The breadth and depth of the Budapest collection distinguishes it as one of the greatest drawing cabinets, not only in Europe but in the world.

The realization of the current exhibition is in itself noteworthy and historic. Never before have so many treasures from the Budapest museum been loaned, even within Europe. We are grateful for the spirit of understanding and cooperation that brings these works to America.

The seed for this collaboration was planted several years ago when J. Carter Brown invited Dr. Klára Garas, director of the Budapest Museum of Fine Arts at that time, to visit Washington and to tour the United States and study the major American museums and their collections. During this visit many friendships were established, among them a special rapport with the late Dr. Harold Joachim, the esteemed curator of prints and drawings at The Art Institute of Chicago, whose grandfather, the virtuoso violinist and favorite of Brahms, Joseph Joachim, came from Budapest.

Subsequently, J. Carter Brown invited James N. Wood to accompany him on a visit to Budapest, and in the spring of 1982 they laid the foundations there for the current exhibition, working out its general character with the Hungarian officials. It was agreed that Andrew

Robison, curator of prints and drawings at the National Gallery, Dr. Joachim, and Suzanne Folds McCullagh, assistant curator of prints and drawings at The Art Institute of Chicago, should travel to Budapest to confer with the curators of the Museum of Fine Arts on the exact selection of drawings. Unfortunately, due to illness, Dr. Joachim was unable to participate in that mission, and it is especially regretted that he did not live to see the drawings that meant so much to him come to America.

Teréz Gerszi, curator of prints and drawings in Budapest, and her able staff assembled a group of nearly 200 sheets from which a selection could be made. The hospitality and openness of the staff to the choice within that list—and to the additions made to it—were remarkable. They indulgently allowed our curators to assemble a survey of their holdings that is at once broad in scope and penetrating in its presentation of those areas seldom seen in American collections. Thus, the representation of the early Italian, German, and Netherlandish schools outweighs that of the French, in which American museums are so rich.

We are pleased that this important exhibition can be enjoyed by audiences in Washington, Chicago, and Los Angeles, largely through the generous encouragement and sponsorship of Dr. Armand Hammer and Occidental Petroleum. All three of the participating museums are especially appreciative of his role in making this exhibition a reality.

We are very grateful as well to Dr. Ferenc Merényi, who became director of the Museum of Fine Arts in early 1984, for his continuing support of this enterprise. Many others in Budapest should be acknowledged for their contributions to this project, chief among them former director Klára Garas, with whose enthusiastic support the original plans for the exhibition were laid; Teréz Gerszi and Andrea Czére who both deserve special thanks for sustaining the project and guiding it to a successful conclusion, and the energetic staff of the print room who prepared the scholarly entries published here in a relatively short period of time. Corvina Press provided the outstanding color transparencies for the plates included in the catalogue.

On this side of the Atlantic, details of the exhibition have been handled by Dodge Thompson, head, exhibition programs, and Diane De Grazia, curator of Italian drawings at the National Gallery of Art; by Katharine Lee, assistant director, and Suzanne Folds McCullagh at The Art Institute of Chicago; and by Myrna Smoot, assistant director in charge of museum programs of the Los Angeles County Museum of Art. The efforts of the many other museum staff members who have worked so extensively and cooperatively on the project are gratefully acknowledged.

The catalogue was enhanced by the sympathetic and careful translation provided by Janos Scholz, the eminent Hungarian-born musician, art collector, and historian now living in New York. The translation was further refined by Réka Viczian of New York, and edited by Mary Yakush of the National Gallery of Art editors office. The production of the catalogue was overseen by Susan F. Rossen, editor and coordinator of publications in Chicago; the elegant design was the work of Lynn Martin of Chicago. We hope that this volume will provide an enduring record of the magnificent generosity of the Budapest Museum of Fine Arts and help document the outstanding riches entrusted to their care.

J. Carter Brown
Director
National Gallery of Art

James N. Wood
Director
The Art Institute of Chicago

Earl A. Powell III
Director
Los Angeles County Museum of Art

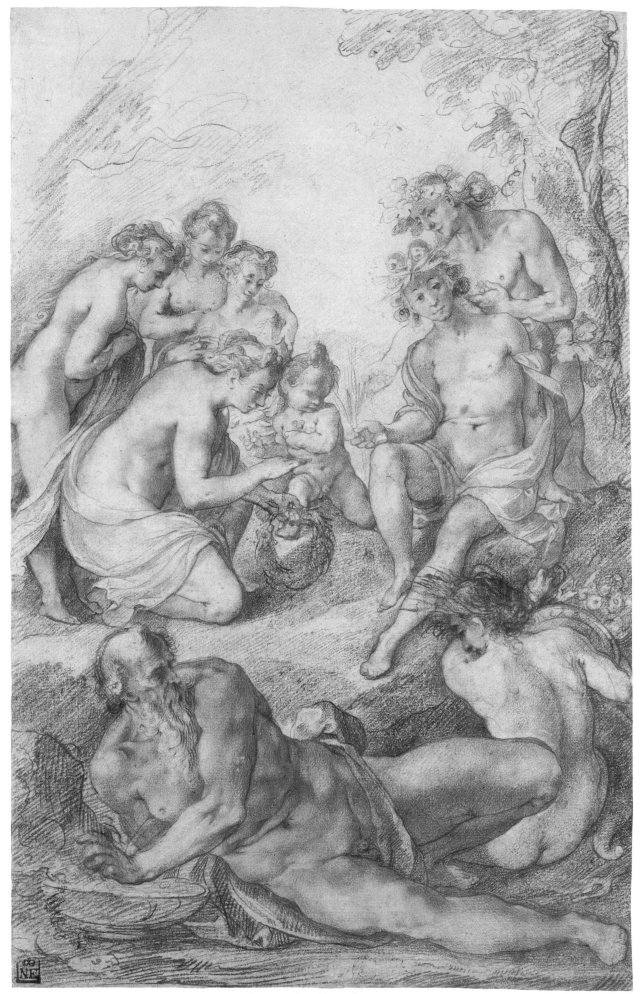

Joseph Heintz the Elder, *Allegory* (cat. 53).

Preface

Acknowledgments

This is the first exhibition that the Budapest Museum of Fine Arts has sent to the United States. Heretofore only a few individual works of art have been requested for exhibitions abroad. For initiating the idea for the exhibition and for valuable help in its realization we would like to express our thanks to the directors of the National Gallery of Art, Washington, The Art Institute of Chicago, and the Los Angeles County Museum of Art, as well as the Department of Museums of the Hungarian Ministry of Culture. We are also grateful to the head and staff of our print room for preparing the exhibition and writing the catalogue, in which the results of research by international and Hungarian scholars are presented.

The 103 drawings by 86 Italian, German, Netherlandish, and French masters encompass the art of drawing from the fifteenth to the twentieth centuries. The selection of drawings was made jointly by the American and Hungarian curators. While our main objective was to show the great breadth of the Budapest collection, emphasis was placed on German drawings, which are relatively rare in America. At the same time, due to the sizeable number of French drawings in America, the group of French drawings was kept small. In addition to important sheets by the great masters, we wanted to show the public some less known but interesting works of art that have been recently identified. A number of the drawings have already been exhibited in Europe, but some have never before been seen outside Hungary.

We regard this exhibition as an important manifestation of the cultural collaboration between the United States and Hungary, and we hope that it will be enjoyed by the American public.

Ferenc Merényi
Director
Museum of Fine Arts, Budapest

It was a great pleasure for us to work with our American colleagues in every phase of the preparation and presentation of this exhibition, because of their great competence and enthusiasm for the project. We are immensely grateful to Andrew Robison and Diane De Grazia of the National Gallery of Art, Washington, Suzanne Folds McCullagh of The Art Institute of Chicago, and Myrna Smoot of the Los Angeles County Museum of Art, who all collaborated in organizing the exhibition. Special thanks and appreciation must go to Professor Janos Scholz for his excellent translation into English of the Hungarian text, to Mary Yakush for her astute and thorough editorial work, and to Susan F. Rossen for seeing the catalogue through production.

Last but not least I thank my colleagues in Budapest very much for their valuable contributions to the catalogue. Special gratitude is expressed to Andrea Czére, who helped me to revise the original manuscript and check the translation. In the latter work Szilvia Bodnár was also particularly helpful. I thank István Pankasyzi of our conservation laboratory for his skillful work, as well as Maria Szenczi for the beautiful black and white photographs.

Teréz Gerszi
Curator of Prints and Drawings
Museum of Fine Arts, Budapest

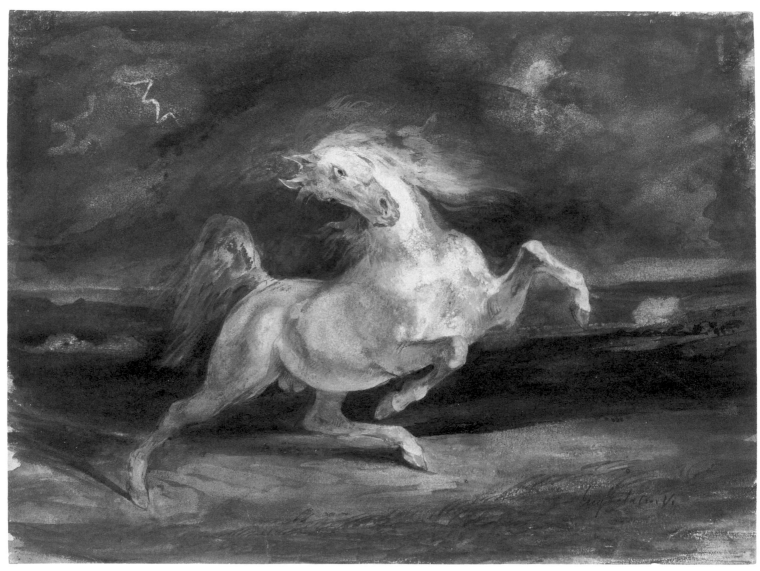

Eugène Delacroix, *Horse Frightened by Lightning* (cat. 94).

The Origins of the Drawing Collection in the Museum of Fine Arts

The Szépmüvészeti Múzeum (Museum of Fine Arts) is the largest public museum of European art in Hungary. Since opening its doors in 1906, it has become known as one of Europe's most important and wide-ranging collections, encompassing all areas of art history (except the decorative arts) from the classical period to the twentieth century.[1] Works of Hungarian origin are not exhibited, however, because since 1957 these have been housed in the Hungarian National Gallery. The holdings of the Museum of Fine Arts' print and drawing cabinet[2] are exceptionally numerous and of fine quality. The collection comprises more than 90,000 prints (both individual works and series of works) and about 8,000 drawings, ranging from medieval miniatures to contemporary works. The art of Italy, The Netherlands, and Germany is represented by a number of drawings of high quality, while equally fine but fewer French and English works are included. Most of the prints and drawings are from the sixteenth through the nineteenth centuries.

Works from the private collection of the Esterházy family are at the heart of the museum's two most important departments—the painting gallery and the graphic cabinet.[3] The Hungarian public collections, unlike those of other large European museums, were not formed from remnants of royal collections. The great Hungarian king Mathias Corvinus (1433–1490) was an early patron and collector of art,[4] but after his death collecting activity in Hungary was halted by historical events: after 1541 the country was torn into three parts, with the Turks occupying the southern part, the Hapsburgs dominating the western, and the eastern section, including Transylvania, remaining comparatively independent. In such a critical period, which included a 150–year–long Turkish rule and subsequent fighting for independence from the Hapsburgs, art collecting in Hungary did not flourish. The Hapsburgs had been particularly ruthless in their method of appropriating privately owned Hungarian collections: they confiscated the treasures of the aristocratic Báthory, Nádasdy, Zrinyi, and Rákóczi families on false charges of treason, for example.[5] The Hungarian public museums—also including the Museum of Fine Arts—were formed mainly from the collections of the aristocrats and art-loving church dignitaries of the eighteenth and nineteenth centuries.

The Esterházy family, which had always remained loyal to the Hapsburgs, possessed immense land holdings (mostly in western Hungary), and during the seventeenth century it became one of the most respected, powerful, and politically important families in the country. This noble family included outstanding diplomats, palatines, and soldiers, a few of whom had manifested during the seventeenth century a definite flair for assembling objects of beauty and an urge to build houses, castles, and fortresses. Miklós Esterházy (1582–1645) was the first collector in the family; he struggled to rise from the ranks of the small nobility up to the most exalted position of a palatine. His example was followed by his son Paul (1635–1713), builder of the large castle in Kismarton (Eisenstadt), and to an even greater degree by Miklós Esterházy, called The Magnificent (1714–1790), creator and master of the splendid castle of Esterháza (Fertöd). The latter's grandson Miklós Esterházy (1753–1833) formed a world-famous painting gallery and the drawing and print cabinet. He retained only a limited number of objects from the family holdings, but he succeeded within a few decades in assembling an entirely new collection of more than one thousand paintings, as well as over 3,500 drawings and 50,000 prints. His taste for classical art does not seem to have caused him to exclude works from other periods and schools, except that of the rococo. Esterházy acquired many objects during his extensive travels, and his agents kept him informed of works on the art market. In Paris in 1803 he met the Viennese engraver Joseph Fischer (1769–1822), who conscientiously and competently cared for the Esterházy collections for twenty years and helped make purchases as well.

The most important Esterházy acquisitions were made after the beginning of the nineteenth century. In 1803 the estate of Count Franz Anton Nowohratsky-Kollowrath from Prague was purchased. It included an important print collection and a smaller number of very fine master drawings from the Dutch school, among them a group of four Rembrandt sheets including the

Woman with Crying Child and Dog (cat. 77), the *Dutch Farmhouse* (cat. 76), and Ferdinand Bol's drawing of *The Angel Appearing to Manoah and His Wife* (cat. 80).[6] Even more important was the purchase of a portion of the famed Praun collection through the Nuremberg dealer J. F. Frauenholz in 1804. The merchant Paul von Praun (1548–1616), an erudite, well-traveled connoisseur, left his business affairs in the hands of his brother and concentrated on forming a magnificent collection of paintings, Italian drawings, prints, sculptures, and medals. He divided the collection between Nuremberg and Bologna. Praun bought Italian drawings in Italy; he was particularly interested in the mannerists and Bolognese masters of the early seventeenth century. Artist friends who assisted him in collecting material were Denys Calvaert, Guido Reni, and Giovanni da Bologna in Bologna, and Jost Amman and the Jamnitzer brothers in Nuremberg.

From 1600 on Praun lived in Bologna and later, when he felt his end approaching, he moved his collection to Nuremberg in 1616. He bequeathed it to his family with the explicit request that the works be kept together forever. The drawings, including the most important sixteenth-century German ones, remained in the family until 1801 when the heirs chose to sell them. The decision to offer them for sale had been made at the end of the eighteenth century, and toward that end Ch. T. Murr had prepared a detailed catalogue of the varied holdings in 1797.[7] The uncertain economic conditions created by the Napoleonic Wars made it difficult for the family to obtain favorable conditions for the sale of this important material, since the international art market had been glutted. The Praun family finally succeeded in selling the drawings in 1801 to the dealer J. F. Frauenholz. Esterházy, after the publication of the Frauenholz catalogue in 1804,[8] was then able to purchase one-third of the approximately eight or nine hundred items from the dealer. As a result of this fortunate purchase, the Museum of Fine Arts in Budapest possesses exceptional works by Albrecht Altdorfer (cat. 43), Albrecht Dürer (cat. 36), Hans Baldung Grien (cat. 38), Lucas Cranach the Elder (cat. 42), Jörg Breu the Elder (cat. 40), Hans Burgkmair (cat. 41), Augustin Hirschvogel (cats. 49–50),

Hans von Kulmbach, and Wolf Huber (cat. 47).

In 1810 the collection of A.C. Poggi (1744–1836), the Italian painter, engraver, and editor, became available in Paris and was bought by Esterházy for an annual payment of 3,000 francs.[9] The several hundred drawings were sent in two shipments to Kismarton in 1811. Most of those works were sixteenth-century Italian; and seventeenth-century Italian, Netherlandish, and French works were also included.

Poggi bought mainly in London and Paris at important auctions. Thus he succeeded in acquiring masterpieces that had belonged at times to the famous Crozat, Mariette, Richardson, Lempereur, Barnard, Bourduge, and Reynolds collections. The splendid series of sixteenth-century Italian works by Raphael (cat. 7), Correggio (cat.10), Pontormo (cat. 14), Parmigianino (cat. 12), Tintoretto, Veronese (cat. 17), and Lodovico Carracci (cat. 21) were acquired mainly from the Reynolds collection. However, where Poggi purchased the three world-famous drawings by Leonardo (cats. 3–5) is not known. Notable works from the seventeenth century include those by Giovanni Benedetto Castiglione (cat. 25), Domenichino, Guercino (cat. 24), Guido Reni (cat. 23), and Salvator Rosa. We must mention among the Netherlandish drawings the four sheets by Rembrandt, including the *Female Nude* (cat. 78), as well as the drawings by Jacob Jordaens (cat. 84), Adriaen van Ostade (cat. 85), Jan Both, Cornelis Dusart, and Paulus Potter; the French groups contained drawings by Claude Lorrain, Lagneau, and Poussin, among them *The Finding of Moses* (cat. 91) by the latter master.

Esterházy made purchases from art dealers, mainly in Vienna—A. Artaria, Franz X. Stöckl, J. Gurk, and J. Grünling—and in Mannheim from Dominique Artaria and in Nuremberg from the aforementioned J. F. Frauenholz. The purchases, spanning three decades, suggest an extraordinarily systematic plan of acquisition aimed at the creation of an all-encompassing cabinet of master drawings. Attempts were made to fill important gaps, such as the purchase of notable early sheets as the fifteenth-century *Saint Margaret* (cat. 32) and the two *Mettercia* sketches by Veit Stoss. Among the great

"coups" of Esterházy are Dürer's *Lancer on Horseback* (cat. 35) and Tobias Stimmer's *Justitia*, which form an important supplement to the early German drawings from the Praun collection. His wise purchases created the foundation for the collection of works by seventeenth- and eighteenth-century German and Austrian artists.

Esterházy, through a mixture of luck and shrewdness, was able to enrich the Italian material considerably by the purchase of a study by Raphael (cat. 6), some splendid sheets by Perino del Vaga, Tintoretto, Federico Zuccaro, Francesco Salviati, and Pellegrino Tibaldi; and, among seventeenth-century painters, works by Daniele Crespi (cat. 22), Pietro da Cortona, and Carlo Maratti (cat. 26). Significant works by the eighteenth-century Giuseppe Galli da Bibiena (cat. 28) and a cityscape by Francesco Guardi are also included. The sixteenth-century Netherlandish collection was augmented by works of Bernaert van Orley (cat. 64), Frans Floris the Elder (cat. 65), Jacob de Gheyn (cat. 69), and Paulus van Vianen (cat. 71). To the Rembrandt group from the Nowohratsky-Kollowrath and Poggi collections were added five more examples by the master, in addition to works by Bartholomäus Breenbergh, Hendrick Avercamp (cat. 73), Jan Lievens (cat. 83), and Adriaen van Ostade. The French holdings, though relatively few in number, were enriched by the purchase of works by Laurent dc la Hyrc, François Verdier, several sheets by Charles Le Brun, and a series by Eustache Le Sueur (cat. 92); fine examples by Jean-Honoré Fragonard and Hubert Robert; and drawings by Jean-Baptiste Oudry and Charles Natoire.

The purchasing of drawings halted after the death of Fischer (1822), while efforts were made to enlarge the print collection. Large-scale purchases terminated with the death of Miklós Esterházy in 1833.

The Esterházy print and drawing collections and the library remained for some time in the Vienna palace of the Hungarian National Guard, while the paintings were housed in Kismarton. In 1806 the prince moved the paintings to his castle in Pottendorf, Austria, and then to his property in Laxenburg. Only after his purchase of the former palace of Count Kaunitz in Mariahilf, Vienna, was

he able to assemble his collections under one roof. The Esterházy collection thus came to be considered part of the cultural life of Vienna.

Due to the growing nationalistic spirit in Hungary, the idea of creating a national public collection was of great concern in the beginning of the nineteenth century. This concern bore fruit in 1802 when Count Ferenc Széchenyi offered his large library and heraldic and numismatic collections to the nation. These aristocratic collections formed the nucleus of the Hungarian National Museum, which opened in a handsome classical building in Budapest in 1846.[10] The return of the Esterházy collections to Hungary, which had preoccupied the Hungarian public, did not occur until 1865, when the works were installed in the newly built Hungarian Academy of Sciences. One year later, Prince Paul Esterházy died. His heirs, who were having financial difficulties, offered to sell the entire collection to the Hungarian government in 1867. In 1870 the government bought 637 paintings for 1,100,000 florins and the graphic collection of 3,353 drawings and 51,301 prints, as well as 305 books, for 200,000 florins. The amount for which the Esterházy family offered their collection to the Hungarian government was well below the actual market value of the objects. The collection was named Országos Képtár (National Picture Gallery), and thus became the second Hungarian national public collection. Later it would form the core of the Museum of Fine Arts. The celebration of the millennium of Hungary offered an opportunity for the creation of a new art museum; the Laws of 1896 directed the erection of a building and by 1893 plans for the organization and administration of the museum had been prepared. The next year the government allotted the considerable sum of 400,000 florins to be used toward acquisitions for the new institution. The director of the National Picture Gallery, Karol von Pulszky, made a number of important purchases during 1894 and 1895, including some drawings such as the *Madonna* by Bartolomeo Montagna (cat. 2), Dürer's *Mary Magdalene*, and sheets by Cornelis Engebrechtsz (cat. 63), Jan Brueghel (cat. 72), Jacob van Ruisdael (cat. 81), Pieter Molijn (cat. 79), and Cornelis Dusart (cat. 87). In 1901,

before the museum was even completed, a new bequest, that of the painter Istvàn Delhaes (1843–1901), added some 2,863 drawings and 14,453 prints to the national collection.[11] Delhaes, as restorer to the Liechtenstein princes, lived for decades in Vienna where he had amassed an extensive and valuable collection, buying from private collectors and art dealers. Though his interests encompassed all schools and periods of art, his chief concern was with the nineteenth-century German and Austrian masters and thus the Delhaes bequest supplemented the Esterházy material, most of which was pre-nineteenth-century. As the Esterházy collecting activities terminated during the first third of the nineteenth century, and the National Gallery started to buy contemporary works only toward the end of the century, the Delhaes collection filled an important gap. The Delhaes collection also augmented the German, Italian, Netherlandish, and French material from the sixteenth to the eighteenth centuries. Many mannerist works, in particular those of the Rudolphine circle, entered the museum: Hans von Achen, Joseph Heintz the Elder, Matthias Gundelach (cat. 54), Bartholomäus Spranger, Pieter Stevens, and Adriaen de Vries are represented. The eighteenth-century Austrian and Venetian masters Paul Troger, Lorenzo Sacchetti, and Gaspare Diziani, who are represented by series, occupy an equally important place in the collection.

The new museum building opened its doors in 1906 and from that time the curators concentrated on acquiring works for every department of the museum. Important purchases—especially during the years around 1910—were made in Vienna from Artaria and Gustav Nebehay, in Leipzig from C. G. Boerner, in Frankfurt from F.A.C. Prestel, in Lucerne from Gilhofer and Ranschburg, and in Berlin from A. de Burlet. The collection of works by the Netherlandish masters was expanded to include examples by Nicholas Berchem, Jan Both (cat. 82), Bartholomäus Breenbergh, Nicholas Moyaert, Gillis Neyts (cat. 75), Cornelis Saftleven (cat. 86), Esaias van de Velde, Willem van de Velde the Younger, and Jan Wildens. Important additions were also made to the Italian collection: drawings by Giovanni

Benedetto Castiglione, Bernardo Bellotto (cat. 31), Giovanni Domenico Tiepolo, and Francesco Fontebasso. The section of German and French drawings was notably enriched by the addition of nineteenth-century works.

The economic crisis brought about by World War I made it almost impossible to purchase drawings in the following years, but important works continued to be acquired from private sources and through gifts to the museum. Though few twentieth-century Hungarian collectors specialized in master drawings, important sheets remained in the collections of aristocrats and financiers. Thus many gifts came to the cabinet from these sources, among them a sheet by Watteau (cat. 93; from Ferenc Kleinberger), a figure study by Giovanni Battista Tiepolo (cat. 29; from G. Nebehay), Giovanni Domenico Tiepolo's *Head of Saint Giacomo* (from Simon Meller), and works by Delacroix (from Count Sándor Apponyi), Victor Hugo (from Count László Teleky), Gustave Doré (from Rudolf Bedö), Picasso (from Ferenc Hatvany), and Maillol (from József Wolfner). Several hundred portrait miniatures were also received by the museum in 1927 from Béla Procopius.

The most important donation to the collection in recent times was made by Paul Majovszky (1875–1935), who gave his collection of exceptional drawings, mainly from the nineteenth century, to the museum in 1934.[12] Majovszky was the chief of the fine arts section in the ministry of education and had assembled his drawing collection with the intention of giving it to the museum. He began to collect in 1911, aided by the erudite Simon Meller, then curator of the museum's drawing cabinet. Before World War I the competition in this field was not keen because most collectors focused on paintings, and thus Majovszky was able to assemble, over the span of a few years, a superb collection of 259 master drawings. His desire was to illustrate as completely as possible the history of drawing from the late eighteenth through the nineteenth centuries, but he succeeded in this only insofar as the French school is concerned. Consisting of 136 sheets, his French collection contained the finest examples by the most important masters from Ingres to Maillol: Honoré Daumier, Camille Corot, Gustave Courbet,

Edouard Manet, Edgar Degas, Alfred Sisley, Paul Signac, Paul Cézanne, Henri de Toulouse-Lautrec, and Paul Gauguin. Majovszky acquired entire series by certain masters, like Eugène Delacroix, Jean-François Millet, and Auguste Rodin. Characteristic and significant items, like the *Horse Frightened* by Delacroix (cat. 94), the *Barricade* by Manet, the Cézanne *Provençal Landscape* (cat. 100), and the *Waltzing Dancers* by Renoir found their way to his collection. His standards were equally high when purchasing works by the late eighteenth- and nineteenth-century English painters such as Thomas Gainsborough, Thomas Rowlandson, Dante Gabriel Rossetti, Edward Burne-Jones, Frank Brangwyn, and James Abbot McNeill Whistler. Also exceptionally precious are the examples of German-Austrian art that Majovszky collected: works by Joseph Kriehuber, Rudolf von Alt, Caspar David Friedrich, Adolf von Menzel (cat. 62), Wilhelm Leibl, Hans von Marées, Max Liebermann, and Käthe Kollwitz. Majovszky also collected works by the finest nineteenth-century Dutch masters as well: Vincent van Gogh (cat. 90) and Johan Barthold Jongkind. The outbreak of World War I prevented him from adding to his collection, but it was nevertheless a great achievement and has provided the foundation for the modern drawing section of the museum.

The safety of the museum collections was threatened during World War II: in 1944 almost the entire contents of the museum were haphazardly crated and sent to Germany by train. During their transport the works were in constant danger and were exposed to extremes of temperature. Soon after the end of the war, efforts were made to locate the works and to restore the badly damaged museum building. Miraculously, the objects survived the ordeal with comparatively minor damage. The material was returned to Budapest between 1946 and 1947 with the help of the American authorities. Because the restoration and reinstallation of the artworks proved to be very costly, funds for new acquisitions were very limited. The opening in 1946 of the first temporary exhibition of paintings and the subsequent opening in 1947 of an exhibition of master drawings represents a remarkable triumph.

Since 1945, the museum has been able to add 750 drawings to the collection, most by purchase and a few through gifts.[13] The collection was enriched by the works of Palma Giovane, Frans Snyders, Cornelis Saftleven, Gaspare Diziani, Giovanni Battista Piranesi, Giovanni Battista and Giovanni Domenico Tiepolo, Johann Michael Rottmayr, Johan Bergl, Friedrich Heinrich Fuger, Benjamin West, and Jacob de Wit. The nineteenth-century holdings in particular were enhanced through the addition of drawings by Ingres, Daumier, Henri-Joseph Harpignies, Rodin, Maillol, Signac, William Leitsch, Joseph Kriehuber, Jakob Alt, Anton Romako, and Giacomo Favretto. The development of the twentieth-century collection was comparatively difficult due to the impossibility of making foreign acquisitions; only through the generosity of living artists and occasional purchases was the foundation of a rather modest contemporary collection laid. Artists represented are Marc Chagall, Sonia Delaunay, Gustave Klimt, Jacques Doucet, André Lhôte, Egon Schiele, Kurt Schwitters, Theo van Doesburg, Alexander Rodschenko, George Grosz, Amedeo Modigliani, László Moholy-Nagy, Henri Nouveau, Victor Vasarely, and Etienne Béothy.

In 1957 the Hungarian National Gallery[14] was established, and all the works by Hungarian artists remaining in the Museum of Fine Arts were transferred to the new institution. Since then, the efforts of the staff of the graphic cabinet have been directed toward collecting, care, scholarly research, and exhibition of works from outside Hungary.

Since 1906 the Museum of Fine Arts has presented about 150 graphic exhibitions in its own gallery, most drawn from its own holdings and with only a limited number of works borrowed from collections abroad. In recent decades several exhibitions arranged by the graphic cabinet were sent abroad: to the Fondazione Giorgio Cini, Venice (1965); to the Albertina, Vienna (1967); and to The Hermitage, Leningrad, and the Pushkin Museum, Moscow (1970). Drawings and paintings from Budapest were exhibited at the Museum of Fine Arts, Bordeaux (1972), and drawings exhibitions were presented at the

Národní Galerie, Prague (1976), and the Barockmuseum, Salzburg (1981). With increasing frequency, loans of important drawings from the Budapest collection are requested for international exhibitions abroad. Scholarly and popular publications also contribute to the increased awareness of the noted drawings at Budapest, and to the belief that the drawing collection of the Museum of Fine Arts should be enjoyed not only by the Hungarian public, but should become a universally shared treasure of humanity.

<div align="right">Teréz Gerszi</div>

1. Pogany, O. Gábor, and Bácher, Béla, eds., *A Szépmüvészeti Múzeum 1906–1956* (The Museum of Fine Arts 1906–1956) (Budapest, 1956); K. Garas, *Paintings in the Budapest Museum of Fine Arts* (London, 1974).

2. Vayer 1957. Gerszi, T., "Budapest. Kupferstichkabinett in Museum der Bildenen Künste," in *Das grosse Buch der Graphik* (Braunschweig, 1968), 142–147.

3. Meller, S., *Az Esterházy képtár története* (The History of the Esterházy Gallery of Paintings) (Budapest, 1915).

4. Balogh, J., *Die Anfänge der Renaissance in Ungarn, Matthias Corvinus und die Kunst* (Graz, 1975).

5. Entz, G., *A magyar mügyüjtés történetének vázlata 1850–ig* (The History of Art Collecting in Hungary until 1850) (with German extract) (Budapest, 1937).

6. *Receuil d'estampes d'aprés les dessins originaux qui se trouvent à Prague dans la collection de François Antoine Nowohratsky-Kollowrath, gravés par Joseph Schmidt.*

7. Murr, Ch. T. de, *Description du Cabinet de Monsieur Paul de Praun à Nuremberg* (Nuremberg, 1797).

8. While preparing her doctoral dissertation (Freie Universität, Berlin) on the Praun collection, K. Achilles discovered in Nuremberg a catalogue by J. F. Frauenholz, published in 1804 (*Catalogue d'une collection de dessins des peintres italiens, allemands et de Pays-Bas, qui se trouvent dans le célèbre cabinet de Mr. Paul de Praun qui est maintenant à vendre au magazin de Frauenholz et comp. à Nuremberg. 1804*), in which several drawings are mentioned in greater detail than in the Murr catalogue, thus identifying more accurately sheets now in the Budapest collection. K. Achilles graciously allowed me to publish her findings, for which I herewith express my sincere gratitude.

9. Lugt 617.

10. The Hungarian National Museum (Budapest, 1978).

11. Lugt 761; *Delhaes István emlékkiállitás* (István Delhaes Memorial Exhibition) (Budapest, 1910), 3–5.

12. Hoffmann, E., "Die Majovszky-Sammlung," *Europa* 1/3 (1943), 149–156.

13. *Uj szerzémenyek I. A grafikai osztály LXXXV. kiallitása* (New Acquisitions I. The 85th Exhibition of the Department of Prints and Drawings) (Budapest, 1951); *A Szépmüvészeti Múzeum 30 éve. 1945–1975 legszebb uj szerzeményei* (30 Years of the Museum of Fine Arts, 1945–1975, Its Best New Acquisitions) (Budapest, 1975).

14. *Collection of the Hungarian National Gallery* (Budapest, 1976).

Note to the Reader

Measurements are given in millimeters followed by inches in parentheses. Height precedes width. All measurements refer to sheet size.

Abbreviated reference citations are fully explained in the Bibliography.

The following abbreviations have been used for the authors' names:

sz.b. Szilvia Bodnár t.g. Teréz Gerszi
a.cz. Andrea Czére v.k. Veronika Kaposy
k.g. Klára Garas l.z. Loránd Zentai

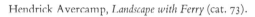

Hendrick Avercamp, *Landscape with Ferry* (cat. 73).

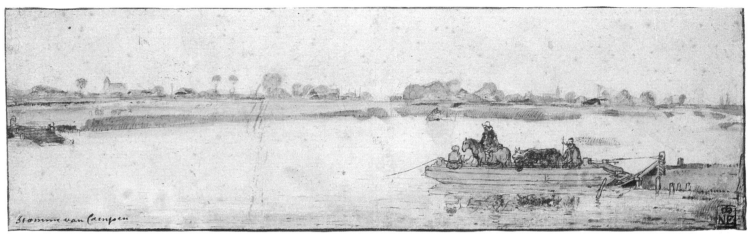

Anonymous Bolognese Master, early fifteenth century
Scene from a Knightly Tale

1
Anonymous Bolognese Master, early fifteenth century
Scene from a Knightly Tale
Pen and brush and brown ink with white heightening on dark
green, prepared paper; inscribed on the verso, *Glockenthon* N 36,
No. 3; 148 x 182 mm (5¹³⁄₁₆ x 7⅛).
Provenance: Praun; Esterházy (Lugt 1965); inv. 1778.
Literature: Schönbrunner-Meder, no. 751; Fenyö 1965, 27–28,
pl. 1, with previous literature; Venice 1965, no. 1.

Scene from a Knightly Tale, probably one of the museum's earliest and most beautiful but also controversial Italian drawings, entered the collection as the work of the Nuremberg illuminator Georg Glockenthon (active c. 1500). That attribution was refuted first by Josef Meder who saw in this sheet the hand of a northern Italian draftsman working in c. 1400. Later scholars had sought its author, not without reason, among the artists working in the court of Lombardy in the international Gothic style. Bernhard Degenhart showed that the artist was probably among those working in Bologna (Degenhart 1949, 30, fig. 4), a theory supported by the recently discovered fact that the sheet came from the Praun collection (see Introduction). (For this information I am indebted to Katrin Achilles.) According to Degenhart, the Budapest drawing and the frescoes of the Bolognini chapel in San Petronio, Bologna (c. 1410), are by the same hand. Close stylistic similarities make this suggestion very plausible. Though the authorship of the frescoes is also uncertain, more recent authors have been inclined to agree with Ricci who saw the hand of Giovanni da Modena in the chapel (*Dizionario Bolaffi*, vol. 6, 59–60). If it could be proved that Giovanni da Modena (active first half fifteenth century) spent time in Milan in c. 1399 and possibly encountered the Franco-Flemish artist Jacques Coene (active c. 1398–1411) there, the characteristics of the style and theme of our drawing, with its obvious influence of Lombard courtly art, could be satisfactorily explained.

Even today it is difficult to interpret this scene of five figures unexpectedly meeting in a barren, rocky landscape. The central figure, who may be a knight, is nobly attired and wears spurs. He faces three men. Two of them are bearded and their legwear seems to indicate that they are warriors.

They wear hoodlike garments over their clothes and do not appear to be armed. The middle figure at the left seems to stop the "knight" with his upraised hand. The man at the far left whose back is turned toward us prepares to draw his sword. This drawing has been called a hunting scene because of the inclusion of the hound, though the hunting horn, which according to sporting manuals of the period would be obligatory, is missing here. (See Gaston Phébus, *Livre de la Chasse* [Paris, Bibliothèque Nationale], ms. fr. 616, repr. in Couderc [n.d.], 34, figs. 36–39). Toesca first suggested that this was an episode from contemporary chivalrous literature (Toesca 1912, 452). The popularity of the Arthurian legend, which resulted from the strong French influence at that time in northern Italy, is confirmed by two richly illustrated Lombard manuscripts both in the Bibliothèque Nationale, Paris ("Giron le Courtois," fr. Nouv. Acqu. 5243, and "Lancelot du Lac," ms. fr. 343; see Milan 1958, nos. 69, 72). This type of literature, popular also in Bologna (Vienna 1962, 56), may have been the source for this drawing.

Because of the carefully executed grisaille technique of this drawing, scholars have believed that it was cut from a codex. Around 1400, however, such highly finished illuminations were executed only on vellum, while this scene was drawn with pen and brush on dark green, prepared paper. This technique, according to Cennini (*Il libro dell' arte,* cap. 15; see Degenhart 1968, vol. 1, XLI), had frequently been employed since the fourteenth century by Tuscan fresco painters in the last phases of preparation, when the problems of light and shading had already been worked out. The draftsman responsible for this sheet follows carefully the traditions of the trecento. If it is in fact by Giovanni da Modena, it should be considered one of his earliest works.

L.Z.

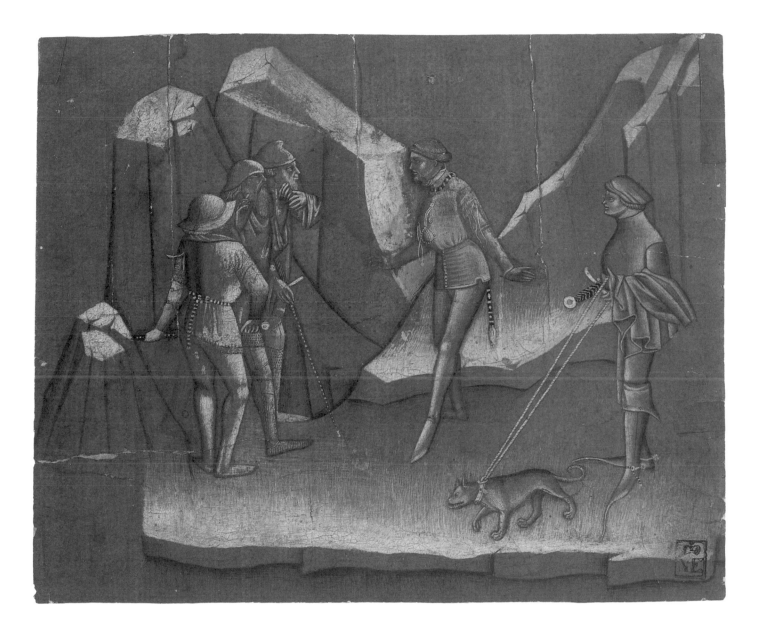

Bartolomeo Montagna
Madonna and the Christ Child

2
Bartolomeo Montagna
Orzinuovi (Brescia) c. 1450–1523 Vicenza
Madonna and the Christ Child
Pen and brown ink with blue washes; inscribed on the verso,
4 Aug 2 1890; 182 x 117 mm (7⅛ x 6¹⁵⁄₁₆).
Provenance: Museum purchase, 1895; inv. 1780.
Literature: Puppi 1962, 143, pl. 88; Fenyö 1965, 44–45, pl. 10,
with previous literature; Venice 1965, no. 6.

Purchased as the work of an unknown sixteenth-century Lombard-Venetian painter, the author of this drawing was verbally identified by Gustavo Frizzoni. As early as 1911 it was exhibited as the work of Montagna. Ivan Fenyö and Lionello Puppi are responsible for establishing the date of the sheet. Though it cannot be connected with any of Montagna's existing paintings, the character of the composition, the Madonna type, and some details point to his two large altarpieces in the Museo Civico, Vicenza (1487), and the parish church of Cartigliano (1495–1500) (Puppi 1962, figs. 37 and 87), and it should be dated accordingly. The Christ Child is closely related to Montagna's painting of the Madonna (c. 1490) formerly in the Bellesi collection, London (Puppi 1962, fig. 51). The Madonna figure and facial type seen in this sheet are very close to the *Lutomirsky Madonna* in Milan (Puppi 1966, 237, fig. 287), the compositional scheme of which is related to a print by Girolamo Mocetto (1458–1531) (Hind, no. 15). (Eckhart Knab [1966,

41] conclusively established this relationship to the Budapest drawing.)

This sheet is one of Montagna's rare compositional sketches, recognizable as a significant work of the Bellini school by its facile, crumbling contours and painterly nuances of shading. The monumental scale of the Madonna and the Christ Child and their predominance in the composition reflect the mature style of Giovanni Bellini (c. 1430–1516), above all the influence of Bellini's S. Giobbe altarpiece (Palluchini 1959, pl. 118), dating from the 1480s, in the Accademia, Venice. Though the technique of the drawing and its angular detail work hark back to quattrocento solutions, the geometric construction of the figures and their blocklike, massive quality show the influence of Piero della Francesca (active 1474–1497) and of earlier Tuscan prototypes as well. Together the characteristics of the Montagna drawing prefigure the style of the High Renaissance.

L.Z.

Leonardo da Vinci
Studies of Horses' Legs

3
Leonardo da Vinci
Vinci 1452–1519 Amboise
Studies of Horses' Legs
Black chalk; 214 x 145 mm (8⁷/₁₆ x 5¹¹/₁₆).
Provenance: Poggi (Lugt 617); Esterházy (Lugt 1965); inv. 1776.
Literature: Popham 1945, cat. no. 74; Vayer 1957, no. 21, with previous literature.

One of the three well-known Leonardo drawings in the museum, this study sheet was first published about eighty years ago by Paul Müller-Walde (1899, 103–105). Its authenticity has never been doubted, but it has been placed during almost all phases of Leonardo's activity and has been connected with various projects: early, even while working in the studio of Verrocchio (c. 1435–1488), or later, as a possible sheet of studies for the Sforza or the Trivulzio monuments or for the *Battle of Anghiari* (commissioned 1503). Today scholars agree that these are detail studies for an equestrian monument and should be connected with the detail sketches for the monument to Francesco Sforza, Duke of Milan, which are at Windsor. One of the horses from Sforza's famous stable probably served as the model.

Leonardo's overly ambitious plans for the Sforza monument, prepared toward the end of 1480, did not come to fruition: Lodovico Sforza, who had commissioned the statue, asked Lorenzo de'Medici in 1489 to find another artist to complete the work. Yet Leonardo continued, even after 1490, to work on the idea, returning again to the traditional pose of the stepping horse. He may have found inspiration in the monumental *Regisole* (in Pavia), of which he made a drawing (Windsor 12.345 r.). The execution of the horse and particularly that of the elevated left foreleg correspond with the final version of the equestrian monument seen in several compositional sketches at Windsor (12.317, 12.346 r., 12.350). The same pose found in this drawing is also seen in a sheet in the Codex Atlanticus, which was probably prepared for a clay modello (Biblioteca Ambrosiana, Milan; f. 216 v.) as well as in the newly discovered Madrid Codex drawing made for the metal casting of the monument (Brugnoli 1982, 108; Biblioteca Ambrosiana, Milan, II. f. 151v.). The Budapest drawing, then, was made during the last phase of the creation of the monument and should be dated accordingly.

The three-dimensionality of this powerful drawing seems both purposeful and logical. As the artist was left-handed, he would have first drawn in the upper right corner of the sheet. This first sketch, in which he laid down the carefully observed junction of the horse's leg and chest, was intended for the main view of the statue. Next, in the upper left portion he drew the three-quarter profile view of the limb, followed by the leg seen from the front and the inside view from the right. The hatching in this drawing, which runs from left to right, led Simon Meller (1918, 106) to conclude that a very similar drawing at Windsor (12.299) is a copy. Kenneth Clark (Clark-Pedretti 1968, vol. 1, 16) believed that Francesco Melzi was the author of the drawing, in which the elements were rearranged symmetrically somewhat in the manner of old pattern books. Though the artist of the Windsor sheet achieved, in this way, a more decorative impression, Leonardo's searching effects and his logical progression through various views of the horse's leg were lost. The Budapest drawing can be compared to companion sheets at Windsor dating from the same period, such as the nature studies (Windsor 12.310, 12.317, and probably 12.286, despite doubts raised by Clark in Clark-Pedretti 1968, vol. 1, 11–2, as well as one in Turin, Biblioteca Reale 15.580). Also at Windsor is an even more closely related proportional study of a raised left foreleg (12.294). The latter drawing seems to recast the naturalistic Budapest drawing in more classical proportions appropriate to the static demands of an equestrian statue.

The clay modello for the Sforza monument was ready during the autumn of 1493, and Leonardo prepared for the casting on 20 December. Unfortunately the casting never took place: on 17 November 1494 the assembled bronze was shipped to Ferrara where it was used to cast cannons. In 1499 French troops who occupied Milan are rumored to have used Leonardo's clay modello as a target. The drawings are all that remain of the project.

L.Z.

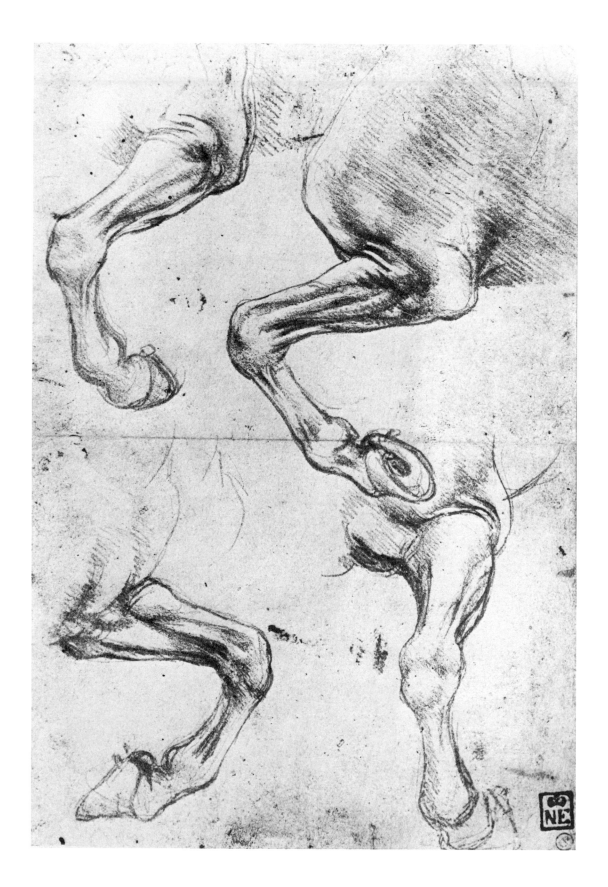

Leonardo da Vinci
Study of Two Warriors' Heads

4
Leonardo da Vinci
Vinci 1452–1519 Amboise
Study of Two Warriors' Heads
Black and red chalks; 191 x 188 mm (7½ x 7⅜).
Provenance: Esterházy (Lugt 1965); inv. 1775.
Literature: Popham 1945, no. 198; Vayer 1957, no. 20, with
previous literature; Vienna 1967, no. 4.

In 1503 the Signoria of Florence commissioned Leonardo to decorate a large wall in the council chamber of the Palazzo Vecchio with a fresco commemorating the martial glory of the Florentines: their victory, led by Niccolo Piccinino, on 29 June 1440 over the Milanese army at the Battle of Anghiari. Leonardo began the work in October 1503 but by May 1504 he had made little progress. The Signoria drew up another contract requiring him to complete and deliver the cartoon (now lost) by February 1505. It is most likely that the cartoon, at least for one portion of the work, was finished, since by March 1505 Leonardo was at work in the council chamber. (A recently discovered note in the Madrid Codex, dated 6 June 1505, does not necessarily mean that Leonardo began his work at this very moment; see Brizio-Brugnoli-Chastel 1981, 82.) But Leonardo's experimental painting technique failed, as is well known, and the fresco was never finished. Leonardo left Florence in 1506. For a few decades the abandoned fresco was allowed to deteriorate slowly; finally Giorgio Vasari (1511–1574) painted over it and obliterated all traces of Leonardo's work. The precise location of the original fresco cannot be established conclusively due to conflicting accounts given by contemporary sources, but recently scholars have proposed that it was painted on the east wall (see Isermeyer 1963, 83–130). However, earlier fresco fragments have been discovered on the west wall (Newton-Spencer 1982, 42–52). The Vasari frescoes will be detached eventually, but because of the ruined condition in which we expect to find Leonardo's underlying work, contemporary accounts, copies, and especially the drawings connected with the council chamber project will remain our most valuable sources of knowledge on the fresco.

From the historical description in the Codex Atlanticus, attributed to Macchiavelli (1469–1527), and the early compositional sketches, we can conclude with some certainty that Leonardo planned the various episodes of the battle either in a continuing cycle or in large panoramic compositions. An account by the late Renaissance painter, architect, and biographer Vasari suggested that the principal middle section would have shown the struggle for the banner. A copy by Peter Paul Rubens (1577–1640) executed in c. 1615 corroborates this. (See attempts at reconstruction in Neufeld 1949, Gould 1954, and Isermeyer 1963.)

The connection between this study and the main composition has long been established. The head at left, sketched in black chalk and shown in three-quarter profile to the right, is found in the second figure on the left side of Rubens' copy; he is the warrior wearing a red cap mentioned by Vasari. The head at right, shown in profile to the left, belongs to the figure in the very back of Rubens' copy.

The red chalk head (cat. 5) belongs to the very first figure on the right side of the picture. In addition, a sketch on the verso of this drawing represents a foot soldier wearing a helmet and carrying a spear. The figure is not found in Rubens' copy of the *Battle of Anghiari*, nor can it be connected convincingly with any figures in the compositional sketches. Moreover, because the soldier faces to the left, as does the whole composition, it is possible that he belonged to a Florentine reserve troop waiting to be called into battle. The comparatively careful execution of this figure suggests that Leonardo may have arrived at a more finished stage of this part of the composition than that seen in the other known sketches in Venice and London (Popham 1945, nos. 192–195).

L.Z.

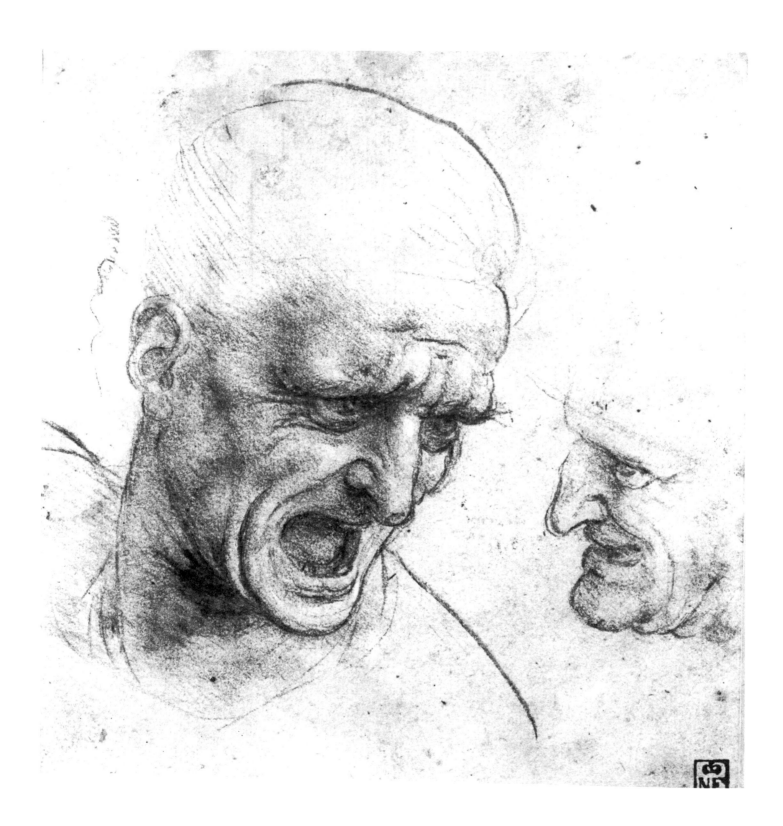

Leonardo da Vinci
Study of a Warrior's Head and *Soldier Holding a Spear*

5
Leonardo da Vinci
Vinci 1452–1519 Amboise
Study of a Warrior's Head
(verso: *Soldier Holding a Spear*)
Red chalk on pale, brown-toned paper; 226 x 186 mm
(8⅞ x 7⁵⁄₁₆).
Provenance: Poggi (Lugt 617); Esterházy (Lugt 1965); inv. 1774.
Literature: Popham 1945, no. 199; Vayer 1957, nos. 18–19,
with previous literature. See preceding entry.
Cover illustration.

Because of the forceful and direct facial expressions, both this and the preceding sheet seem to be detail studies after a live model. Their poses conform exactly with those of figures in Rubens' copy (c. 1615) of Leonardo's *Battle of Anghiari*; thus they must have been prepared at the same time as Leonardo's cartoon or even slightly earlier, between May 1504 and February 1505. The smaller sketch, in chalk (cat. 5), is probably a revision of an earlier head study (Popham 1945, no. 196; Accademia, Venice), in which Leonardo tried to capture the facial expression of a warrior type as he bared his teeth. However, the Budapest head faces in the opposite direction from the Accademia study. It is turned slightly to the side and forward, as required by the composition, and is stylized according to the ideal type of the "old Roman warrior." (For heads of warriors of the type of the Roman soldier-emperor Galba [reigned 68–68], used already by artists in Verrocchio's [c. 1435–1488] circle and in drawings by Leonardo, see Clark-Pedretti 1968, vol. 1, XLII; Meller 1963, vol. 2, 54; Clark 1969, 1.)

The expression of the warrior—human madness, "pazzia bestiallissima"—lifts the Budapest heads above the level of other battle images. Any further refinements to this drawing would probably have diminished its effect.

L.Z.

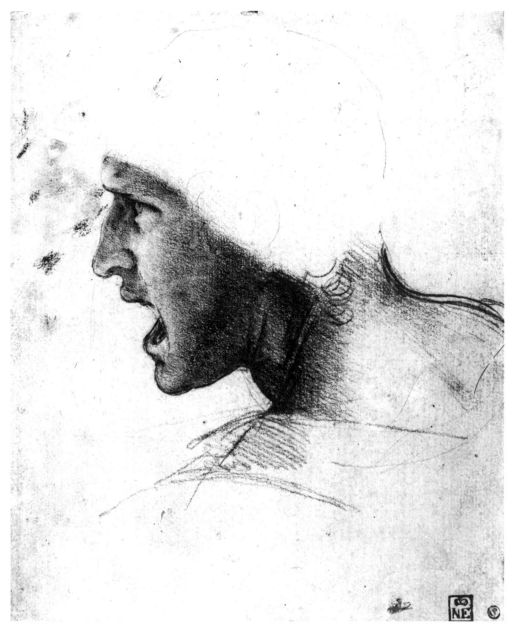

Recto

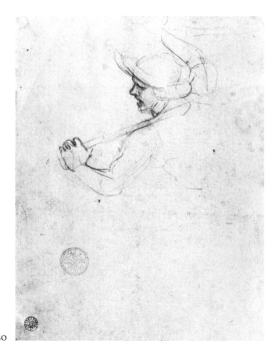

Verso

Raphael (Raffaello Santi)
Project for a Festive Decoration and *Sketches for the* Disputà

6
Raphael (Raffaello Santi)
Urbino 1483–1520 Rome
Project for a Festive Decoration
(verso: *Sketches for the* Disputà)
Pen and brown ink; 198 x 153 mm (7¹³⁄₁₆ x 6).
Provenance: Esterházy (Lugt 1965, 1966); inv. 1935.
Literature: Vayer 1957, nos. 23–24, with previous literature;
Joannides 1983, no. 215; Knab-Mitsch-Oberhuber 1983, 322,
no. 326.

The discussions about this double-sided drawing began long ago and always started with the sketches on the verso. There, as early as 1882, Karl von Pulszky had recognized the relationship between the slightly sketched half-figure of a male nude and the cherubs in the upper left corner with the *Disputà* fresco (Vatican, 1509). Pulszky also connected this sketch with a drawing at the Ashmolean, Oxford, for the Vatican frescoes (Parker 1956, no. 549). However, Oskar Fischel (vol. 6, no. 301) established the definitive link between two of the cherubs and two figures in the fresco. The pose of the angel in the Budapest drawing seems to be closest to that of the angel on the far right in the *Disputà*.

Whereas the sketches on the verso can be dated with certainty to 1509 through their connection with the Vatican frescoes, the drawing on the recto is a subject of much controversy. Pulszky first published this drawing as a plan for a statue. Subsequent authors have all considered it a project for a temporary festive decoration. The main figure, a standing male nude, brandishes a lance. He wears a helmet and probably represents Mars. The Belvedere *Apollo* is obviously the source for his pose. Fischel suggested that both the recto and verso were executed at about the same time, and that the recto might have been a plan for a decoration to celebrate the victory of Pope Julius II (reigned 1503–1513) over the Venetians (14 May 1509) at Agnadel. Fischel interpreted the three-pronged harpoon lying among the trophies at the feet of Mars as a reference to the conquered Venetians, but in reality this object is a simple Roman military emblem.

Perhaps Raphael used this sketch at a later date, for its style conforms with that of the early teens, when Michelangelesque and classical influences were already apparent. Thus it may be connected with a period of Julius II's reign, around 1512, when the pope achieved several victories (Pastor 1899, 716, 727). The fact that the statue of Pasquino, which always reflected public opinion in Rome, was dressed in 1512 as Mars is yet another indication of the general spirit of the times (see Rodocanachi 1912, 144). Fischel surmised that the putto on the left is igniting the captured trophies to excite the crowd. But he may be extinguishing the torch, signifying the magnanimity of the victor and his peaceful intentions (see Shearman 1972, 20, 148, n.) and also explaining Mars' lack of military attributes. (A similar allegorical representation was created in the enemy camp: Antonio Lombardi's marble relief with an unclothed Mars, ordered for the glorification of the victory of Ravenna; see Lewis 1978, 233–245.)

However, the figure of the putto who extinguishes his torch may suggest another interpretation, which is that this may be a sketch for a funerary monument to the pope rather than one representing victory (Middeldorf 1945, no. 65). The two grotesque motifs on either side of the pedestal, a dragon-snake and a human skull (?), were often connected with monuments to the dead. If this drawing is connected with Julius II, it may refer not only to his victory but also to his mortality.

L.Z.

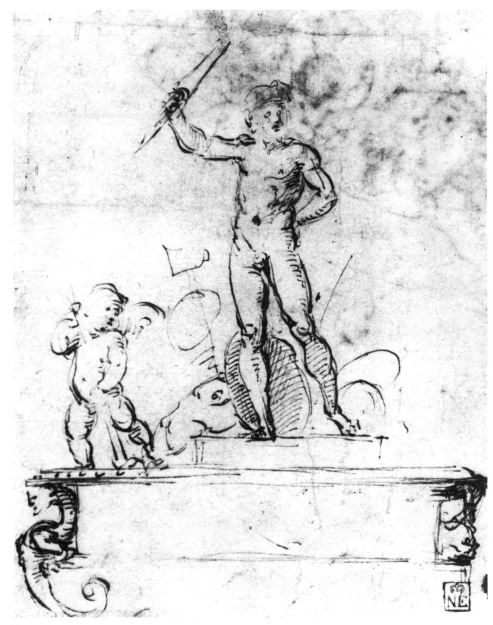

Recto

Verso

Raphael (Raffaello Santi)
Study for the Figure of Venus

7
Raphael (Raffaello Santi)
Urbino 1483–1520 Rome
Study for the Figure of Venus
Metalpoint on paper with light brown prepared ground;
189 x 75 mm (7⁷⁄₁₆ x 2¹⁵⁄₁₆).
Provenance: Reynolds (Lugt 2364); Poggi (Lugt 617); Esterházy
(Lugt 1965), inv. 1934.
Literature: Vayer 1957, no. 25, with previous literature;
Joannides 1983, no. 285; Knab-Mitsch-Oberhuber 1983, no. 545.

Around 1900, various writers connected this drawing with the composition of *Alexander the Great and Roxanna* by Raphael, claiming the figure to be a study for Roxanna. Later scholars suggested that it was by Giovanni Antonio Bazzi, called Sodoma (1477–1549), believing it to be preparatory for his fresco in the Farnesina. In the most recent literature, however, the drawing has been reattributed to Raphael.

The study must have been drawn from a live model, as can be seen from the realistic treatment of details, the softness of the flesh, and the lively surface of the skin. But the image, clearly destined for a special purpose and designed to a specific shape, relates to a well-known classic type popular during the Renaissance, the *Venus pudica* (Budapest 1970, no. 26). The most likely of the many versions of this figure that could have served as the model is the example in the collection of Cardinal della Valle, which was frequently copied by artists from the fifteenth century on. In April 1513, during the festive investiture of Pope Leo X (reigned 1513–1521), the della Valle statue, along with several other sculptures, was featured on the triumphal arch erected in front of the cardinal's palace, where it was depicted by many artists (Bober 1957, 47–50).

The original purpose of this drawing has been disputed, even to the present day. Edith Hoffmann believed it to be a study for the figure of Psyche in the Farnesina fresco cycle (Hoffmann 1929–1930). Her theory, however, is questionable, because the composition she cited is actually the print by the Master of the Die (B. 40) (Hoffmann 1929–1930, fig. 12), in which the figure's pose is akin to that in the drawing; this print was engraved after a drawing by Michel Coxcie

(1499–1592) that was a pastiche of Raphael's compositions. Konrad Oberhuber (Knab-Mitsch-Oberhuber 1983, no. 545) has posited that this figure was planned for a fresco in one of the lunettes of the Loggia di Psiche that was never executed.

A second theory seems a bit more convincing. Marcantonio Raimondi (1480–1527/1534) based his engraving of *The Judgment of Paris* (B. 245) in part on drawings by Raphael. The sources of Raphael's composition were two sarcophagus reliefs that did not provide adequate models for the three goddesses; thus, the master probably prepared separate studies for them. This study then could be for the Venus figure, as the stance and the proportions of the body and the similarity of the head—despite some alterations made to the gestures—would strongly suggest (a theory first proposed by Ollendorf 1926). Vasari and subsequent authors all have considered this print an early work by Raimondi, engraved in c. 1510, while some modern scholars are inclined to date it somewhat later in the decade (see Lawrence 1981, no. 43).

This subject apparently also occupied Raphael earlier, as can be seen from a grisaille composition in one of the window niches in the Stanza della Segnatura dating from the termination of the work there, around 1512/1513 (see Bianchi 1968, 660, pl. 23). This painting is only a weak studio production influenced by the master. The Budapest drawing probably dates from this period, for the sheet seems a bit awkward in comparison to the dazzling, mature studies the master prepared later (c. 1517) for the Loggia di Psiche. The closest parallel with this figure is the metalpoint drawing for the *Madonna della Sedia*, suggesting that these figures come from the same model (Joannides 1983, no. 285).

L.Z.

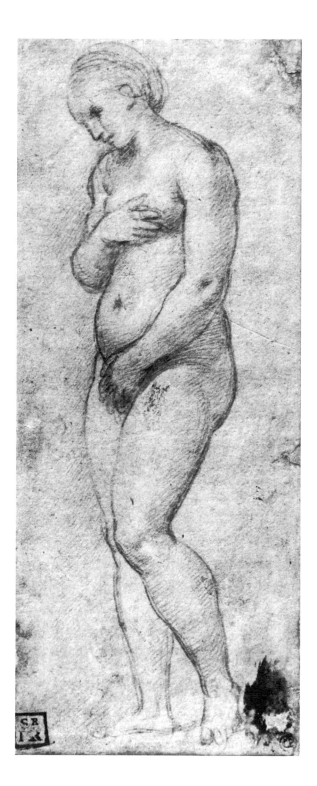

Girolamo Romanino
Riders

8
Girolamo Romanino
Brescia c. 1484/1487–1559/1566 Brescia
Riders
Pen and brown ink on light brown-toned blue paper;
inscribed at lower right, *Tiziano*; 280 x 270 mm (11 x 10⅝).
Provenance: Esterházy (Lugt 1965); inv. 1990.
Literature: Fröhlich-Bum 1928, 187, fig. 253; Tietze 1944,
no. A. 387; Vayer 1957, no. 37; Fenyö 1965, 51, pl. 14, with
previous literature; Venice 1965, no. 14.

This drawing entered the Esterházy collection as a work by Titian (c. 1477–1576); at first glance, its vigorous pen technique and strong composition evoke the style of the great Venetian master. But closer examination reveals certain weaknesses: the figures are puppetlike and the forms irrational. Scholars have sought its author among the lesser-known artists of the sixteenth century: L. Fröhlich-Bum suggested Paris Bordone (1500–1571), but was proved wrong by the Tietzes who suggested the hand of Romanino (see Fenyö 1965, 51), an attribution that is generally accepted today.

Romanino's skill as a draftsman is little known, and because only a few drawings have been securely attributed to his hand we must examine his painted oeuvre to establish a date for the Budapest drawing. Antonio Morassi suggested a date of c. 1530 based on a connection with the frescoes in Trento (Castello del Buon-Consiglio). Iván Fenyö saw an even closer kinship with the organ shutters of the Duomo in Asolo (1524–1527), while Lionello Puppi connected the

drawing with the frescoes in the Castello Colleoni, Malpaga. The work may even be dated slightly later, probably during the decoration of Santa Maria della Neve in Pisogne, between 1532–1534, and may be a drawing for the riders in the *Crucifixion* (for a dating of c. 1534, see also Griseri 1980, fig. 257). Almost all the figures in the Budapest drawing may be found, with some variations, in the Pisogne fresco covering the principal interior wall (Panazza 1965, 47, fig. 112). The friezelike composition of the fresco recalls the classicizing central Italian High Renaissance style exemplified in Lombardy and the Veneto by Pordenone (c. 1483/1484–1539). However, in its details it follows the popular naturalistic Lombard tradition, which must have appealed more to Romanino's provincial patrons. The blocklike construction of the group, its effect of relief, and the dramatic feeling of the figures' lively gestures are much closer in spirit to the Crucifixion painting in Pisogne than to the narrative composition in Malpaga.

L.Z.

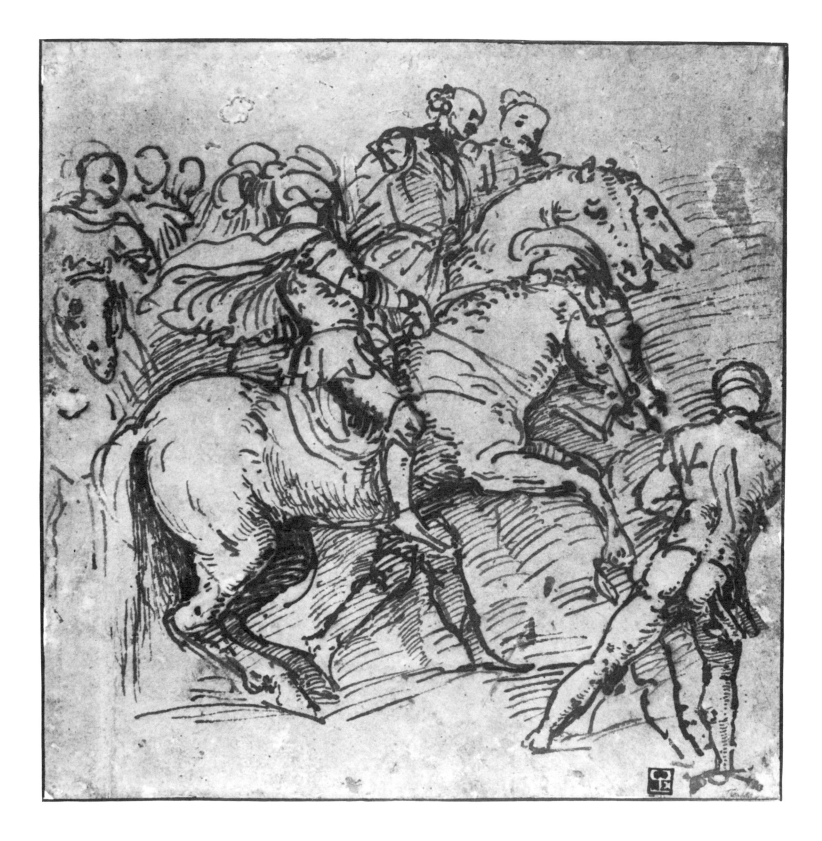

Correggio (Antonio Allegri)
Compositional Study with Two Female Figures

9
Correggio (Antonio Allegri)
? Correggio c. 1489/1494–1534 Correggio
Compositional Study with Two Female Figures
Red chalk; 104 x 118 mm (4¹⁄₁₆ x 4⅝).
Provenance: Arundel; Poggi (Lugt 617); Esterházy; inv. 1833.
Literature: Fenyö 1959, 422; Fenyö 1965, 56–57, pl. 18, with previous literature.

In his important volume (1957) on the drawings of Correggio, the late A. E. Popham published two prints (nos. 92, 93, p. 168) after lost drawings that were once in English collections. That Popham detected Correggio's hand in these mediocre reproductions is a testimony to his remarkable eye. Both drawings were discovered in the Budapest collection by Iván Fenyö who published them in 1959.

This sheet was engraved by Hendrik van der Borcht who was keeper of the Arundel collection between 1637 and 1646. Thus it is possible that the drawing was then in the earl's possession. Later it passed through the Poggi and Esterházy collections and, with the latter, into the museum.

The drawing, as Popham surmised, is in brilliant red chalk, Correggio's favorite medium, and fits well into the group of paintings and drawings assigned to the end of the second decade, such as the *Adoration of the Magi* (Metropolitan, New York; Popham 1957, pl. vi), the *Mystic Marriage of Saint Catherine* (Capodimonte, Naples; Gould 1976, pl. 92A), the *Noli me tangere* (Prado, Madrid; Gould 1976, pl. 98A), or the *Diana* in the Camera di San Paolo in Parma (Gould 1976, pl. 33).

The kneeling woman, according to Johannes Wilde, was inspired directly by Michelangelo's scene of Noah's sacrifice in the Sistine Chapel (Popham 1957, 16). Correggio could also have known the kneeling figure in Michelangelo's famous Doni *Holy Family* (Uffizi, Florence). However, though there are many indications of a Roman trip, there is little to indicate a Florentine experience.

We have only a few suppositions to offer on the theme and purpose of this drawing. Popham rightly connected this difficult iconographic puzzle with the Camera di San Paolo (1519), for which it was probably part of a decorative plan that was never carried to conclusion. The two known drawings for the project (British Museum, London; Popham 1957, pls. viib, viiib) are less highly finished. The subject matter could be an episode from the story of *Amor and Psyche* (Apuleius, *The Golden Ass*), as Popham concluded; but Stechow's argument that the drawing represents the moment when Venus commands Psyche to separate the mixed grain, rather than the scene when Psyche brings Venus water from the Styx (Stechow 1963, 280–282), seems the most convincing. If the Psyche story is thus interpreted allegorically, this drawing could represent a discarded phase of the lunette series symbolizing the four elements for the San Paolo frescoes, which have been ably studied by Erwin Panofsky (1961).

L.Z.

Correggio (Antonio Allegri)
The Virgin Mary Seated on Clouds

10
Correggio (Antonio Allegri)
? Correggio c. 1489/1494–1534 Correggio
The Virgin Mary Seated on Clouds
Red chalk; 262 x 183 mm (10¹⁵⁄₁₆ x 7³⁄₁₆).
Provenance: Houlditch (Lugt 2214); Hudson (Lugt 2432);
Reynolds (Lugt 2364); Poggi (Lugt 617); Esterházy; inv. 2101.
Literature: Fenyö 1959, 421–425; Fenyö 1965, 53–54, pl. 16,
with previous literature; Vienna 1967, no. 9.

A. E. Popham (1957) recognized that an engraving by Metz in a series of copies after drawings from the Sir Joshua Reynolds collection was after a Correggio drawing (see cat. 9). Iván Fenyö subsequently published the drawing along with the *Study for the Figure of Christ* (inv. 2000). The drawings were conserved at different locations until they both entered the Reynolds collection. From there they went to the Poggi and the Esterházy collections and then to the Budapest Museum of Fine Arts.

Both drawings can be reasonably placed among the group of preparatory sketches for the fresco in the half-cupola of San Giovanni Evangelista, Parma, painted between 1520 and 1522. Unfortunately the work is known only through the fresco painted by Aretusi toward the end of the sixteenth century (Gould 1976, pl. 39A) to replace the Correggio original that was almost completely destroyed c. 1586 during the reconstruction of the east apse of the church (Gould 1976, pl. 40A), as well as from the relatively numerous remaining preparatory drawings.

The starting point of our examination is a compositional sketch in Rotterdam (Popham 1957, pl. xxviii) that shows both main figures, the Virgin and Christ, on clouds escorted by putti. The figure of Christ was developed from a drawing in Poitiers (Popham 1957, pl. xxxib, cat. 23) and through drawings in Oxford and Paris (Popham 1957, pls. xxxiib, xxxb) coming close to the final state of the painted figure that appears in the counterpart of the Budapest sheet (inv. 2100, not exhibited). Correggio's composition was inspired by Raphael's Roman painting style of the beginning of the second decade, which can most clearly be seen in this figure. (On the question of Correggio's Roman trip, see Gould 1976, 40.) Correggio must have had access to Raphael's sketches for a Coronation of the Virgin as well as to figure studies for the *Disputà* frescoes, all of which were prepared at the same time. The pose of the Christ figure corresponds closely with the one seen in the engraving by the Master of

the Die after a lost composition by Raphael (B. 10); the influence of this very composition is also found in the setting of the figure of the Virgin (see Zentai 1978, 197, ill. 3).

The path that led Correggio to the Madonna figure could be the subject of a separate essay. In brief, the Madonna illustrates his assimilation of High Renaissance principles. In the Rotterdam drawing, the Madonna sits with drawn knees in the pose of the Madonna of Humility, with the soles of her left foot visible. Her body is powerfully and unnaturally twisted and the carriage of her head and her facial expression seem to denote ecstasy. In the Louvre drawing (Popham 1957, pl. xxxa), the figure is vertically elongated, the twisted posture relaxed due to the lowered feet and the turn of the body to the side. She seems more in repose, her placement more floating and less natural (the sole of her foot has disappeared), her contours more harmonious and decorative. However, the lower portion of the body and the limbs has restless contours that end below in a somewhat pointed, unstable unit and terminate in three putti.

The decisive change made by Correggio in the course of the development of the composition may be seen in the Budapest drawing. Here the artist turned the body somewhat forward to achieve a more relaxed, more harmonious inner contrapposto; in this solution lessons of Raphael's *Madonna of Foligno*, c. 1512 (Gemäldegalerie, Dresden) are recognizable, some of which were employed in earlier works by Correggio such as the *Madonna di S. Francesco*, c. 1514–1515 (Gemäldegalerie, Dresden). The Budapest Madonna's head is also more compact, orblike; the drawn-up knees are covered by ample folds; the foot of the putto hidden by the garment counterbalances the visible right foot of the Madonna. Through these devices the figure of the Virgin appears as a well defined, blocklike structure and conforms to the festive, monumental spirit of Roman High Renaissance ideals.

L.Z.

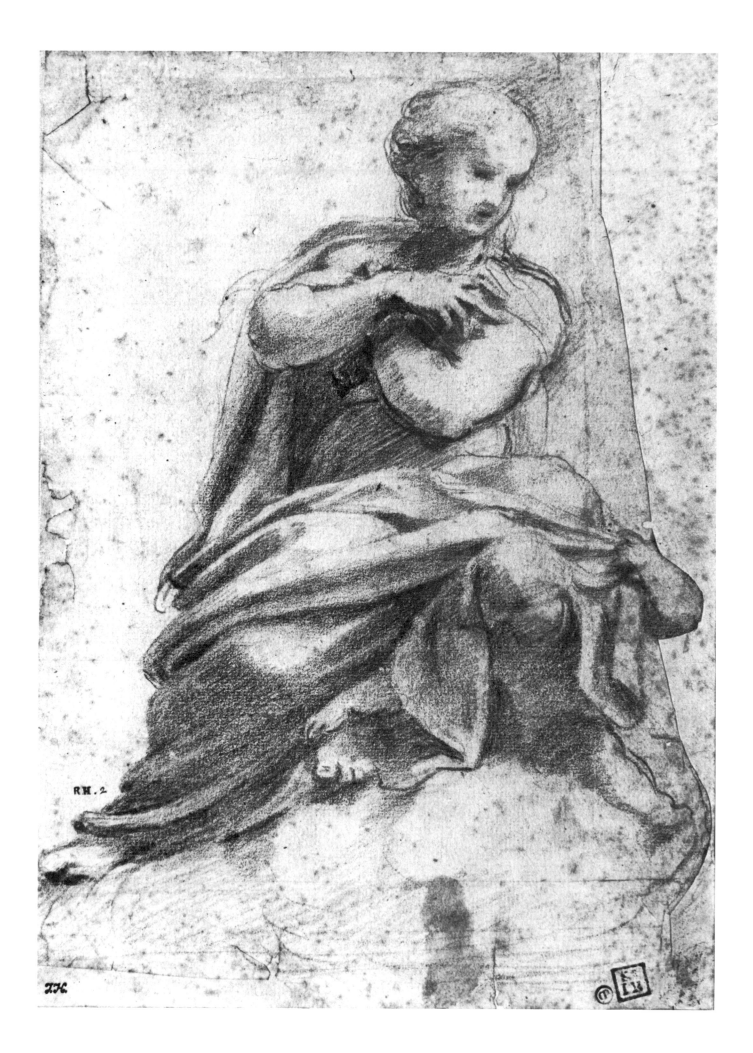

RM.2

JH

Parmigianino (Francesco Mazzola)
Venus Disarming Cupid

11
Parmigianino (Francesco Mazzola)
Parma 1503–1540 Casalmaggiore
Venus Disarming Cupid
Pen and brown ink and brown washes with white heightening
and traces of black chalk on paper tinted pink; 188 x 143 mm
(7⅜ x 5⅝).
Provenance: Baiardo(?); Praun; Esterházy (Lugt 1965, 1966);
inv. 1890.
Literature: Vienna 1967, no. 11; Popham 1971, cat. no. 30, pl. 276.

The Budapest Parmigianino group of more than twenty works is among the notable European collections of the master's drawings. The two works included here are examples of the master's style in his middle and late years.

Parmigianino made numerous studies of *Venus Disarming Cupid*; at least six are known. Among them the Budapest sheet and the one in the collection of Major Robb, London (Popham 1971, cat. no. 755, pl. 276), are the most developed.

The artist experimented several times with the relationship between the raised arm of the female figure and the child reaching for the bow. A sheet in the Ecole des Beaux-Arts (Popham 1971, cat. no. 520, pl. 278) contains various versions of the nude figure of Venus, which Parmigianino began to develop in earlier chalk drawings now in the Galleria Nazionale, Parma (Popham 1971, cat. no. 539, pl. 275), and in the collection of Count Seilern, London (Popham 1971, cat. no. 766, pl. 277). The frontally depicted figure in the latter drawing occupies virtually the entire picture, and its pose is almost the same as that seen in the Budapest drawing, though reversed. In the London drawing Cupid is placed on the side of the reposing arm, impeding any contrapposto effect hidden in the composition. Cupid's pose, standing on one leg and lifting the other knee, seems to be the accepted one, originating in the Paris version and also

evident in the Major Robb drawing. The Budapest *Venus Disarming Cupid* seems to be the most developed version and is indisputably the most graceful and unified composition of the many drawings of the subject.

Popham correctly dated the drawing to c. 1524–1530 and placed it within Parmigianino's Roman or Bolognese period. The strong contrapposto of Venus' figure appears also in an altarpiece of the *Vision of Saint Jerome* (1526–1527; National Gallery, London). One of the principal sources of inspiration may be found in the Laocoön group; some of Michelangelo's figures too are reflected here. The powerfully developed body of Venus (her right arm rested on a cushion in the first sketch) sharply contrasts with her narrow, triangular face full of compassion and charm.

Popham suggested that the Budapest drawing could have been preparatory for a chiaroscuro woodcut. This theory is strongly supported by its execution and technique (see the Diogenes by Ugo da Carpi [active c. 1500–1532], Popham 1971, cat. no. 7, pl. 117), and by the fact that at this time Parmigianino worked with the wood engraver Antonio da Trento (active first half sixteenth century). Parmigianino's drawing of Saint John the Baptist (Musée Bonnat, Bayonne) was engraved in a chiaroscuro woodcut and is similar in composition and technique to our drawing.

L.Z.

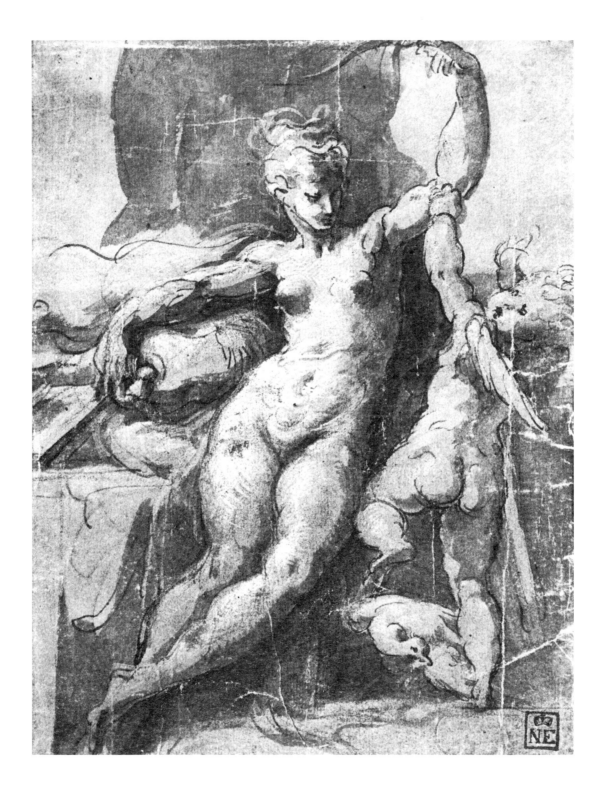

Parmigianino (Francesco Mazzola)
Composition Study

12
Parmigianino (Francesco Mazzola)
Parma 1503–1540 Casalmaggiore
Composition Study
Pen and brown ink with gray washes; inscribed at lower left,
Parmegianino; 192 x 127 mm (7⁹⁄₁₆ x 5).
Provenance: Poggi (Lugt 617); Esterházy (Lugt 1965); inv. 1893.
Literature: Popham 1971, cat. no. 31, pl. 380, with previous literature.

This late sketch for a specific cyclic project is unique in Parmigianino's oeuvre. Its framed middle field with the Assumption of the Virgin is of a type popular during the sixteenth century. Behind the Virgin, who floats heavenward, the traditional halo is visible; above her is God the Father in an oval field. The central frame is surrounded by eight small panels, all representing themes from the life of the Virgin. The sequence described in the legend is not strictly observed, but rather the scenes alternate from left to right. The third picture on the right seems to represent Christ appearing to Mary after the Resurrection; this is a part of the Passion iconography, rarely portrayed in Italian art of this period. Possibly Parmigianino adapted the composition from a Northern engraving (Breckenridge 1957, 9–32).

A. E. Popham doubted that this delicate drawing could be a sketch for a monumental work such as an altarpiece, as Parmigianino's drawings for such projects are of a totally different character. Popham proposed that the Budapest study may be a design for a reliquary or a preparatory study for a printed title page. He discarded the latter idea, though the characteristics of the sheet strongly suggest that it was a design for an etching. The composition may have been influenced by Marcantonio Raimondi's *Quos ego* engraving (B. 352), although the themes are not identical. The figure of the Virgin appears often in Parmigianino's late works, from the *Madonna of the Long Neck*, c. 1535 (Uffizi, Florence) to the frescoes in the east vault and apse of Santa Maria della Steccata, Parma, and in his last large altarpiece, *The Madonna with Saints Stephen and John the Baptist*, 1540, now in the Gemäldegalerie, Dresden; and even perhaps the unfinished *Immaculata* mentioned only by one source (see Fagiolo Dell'Arco 1970, 43, 280). All of the aforementioned works may have been inspired by the cult of the Virgin Mary espoused in Parma by the Franciscans and the Servites.

L.Z.

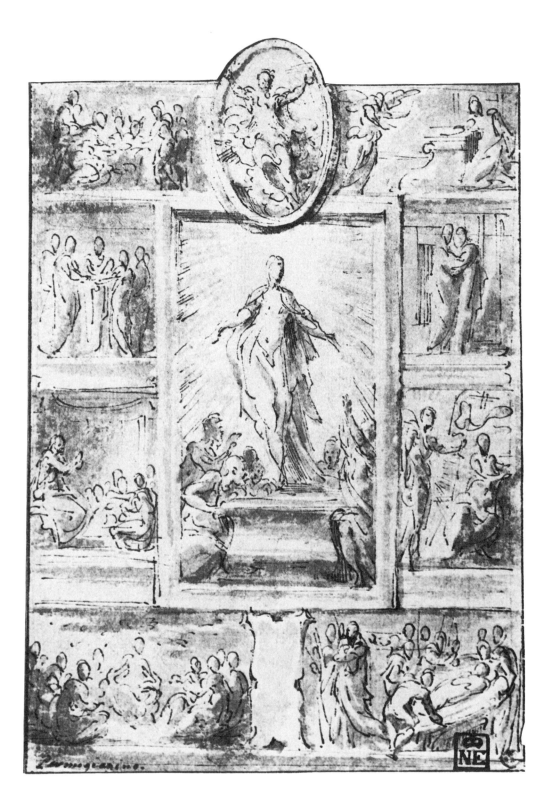

Pontormo (Jacopo Carrucci)
Seated Youth

13
Pontormo (Jacopo Carrucci)
Empoli 1494–1556/1557 Florence
Seated Youth
Black chalk and traces of black charcoal, trimmed at the right;
inscribed at upper left corner, B *80*; at lower left edge (effaced),
Cantarini (?); 242 x 314 mm (9½ x 12⅜).
Provenance: Esterházy (Lugt 1965); inv. 2181.
Literature: Fenyö 1961, 59–60, fig. 45; Cox-Rearick 1964, 109,
n. 11; Cox-Rearick 1970, 364, pl. 1.

This drawing, preparatory for the seated youth in Pontormo's fresco for the atrium of the SS. Annunziata (1514–1516, Florence), was first authenticated by Iván Fenyö. It is representative of Pontormo's early drawing style. The fresco is one of the most remarkable works of the Florentine High Renaissance. Even Heinrich Wölfflin who considered Pontormo a painter of secondary rank wrote about it with appreciation (Wölfflin 1904, 150). Fra Bartolomeo (1475–1517) and Andrea del Sarto (1486–1530) may have inspired the composition, whereas the monumental disposition of the male and female figures—their formulation and placement—suggests an intimate knowledge of Michelangelo (1475–1564) and Raphael's Vatican paintings. This also suggests that Pontormo had traveled to Rome; however, there are no records of such a trip (Beck 1981, 437).

Beneath the solid plastic construction of the head and the torso in this sheet, indicated with many pentimenti, the mastery in draftsmanship that Pontormo had acquired in the studio of Fra Bartolomeo is revealed. Some details of the body in particular, which is depicted naturalistically, strongly suggest the influence of Michelangelo, sharply contrasting with the masklike face of the seated youth, which presages Pontormo's late, mannerist style. The final form, hidden within the confused net of chalk lines, is ultimately secured by black charcoal lines.

The Budapest drawing was undoubtedly preceded by a vertical composition in the Uffizi (Cox-Rearick 1964, no. 12) that did not fit into the whole composition. The seated youth at Budapest exhibits the robust proportions of the *garzone* prototype, transformed to meet the compositional requirements of the fresco.

L.Z.

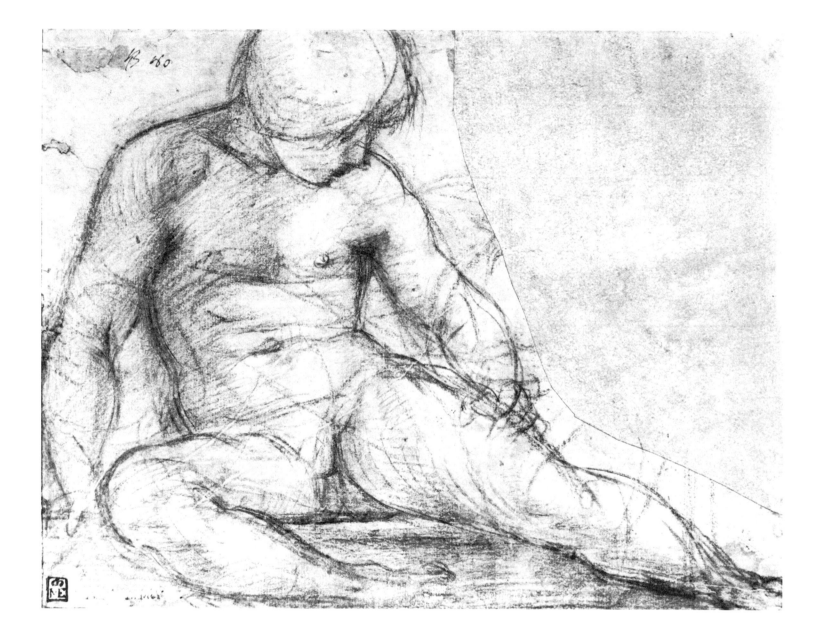

Pontormo (Jacopo Carrucci)
Four Singers

14
Pontormo (Jacopo Carrucci)
Empoli 1494–1556/1557 Florence
Four Singers
Red chalk with traces of black crayon; 237 x 288 mm
(9⁵/₁₆ x 11⁵/₁₆).
Provenance: Richardson, Sr. (Lugt 2183); Barnard (Lugt 1419);
Reynolds (Lugt 2364); Poggi (Lugt 617); Esterházy (Lugt 1965);
inv. 1927.
Literature: Vayer 1957, no. 45, with previous literature;
Cox-Rearick 1964, no. 172, fig. 164.

Three young men are shown surrounding a fourth, seated figure at center who holds a book from which they all read or possibly sing. Their attire is typical of that worn by student painters (tuniclike shirts, smocks, berets), and the furnishings are small chairs and footstools of the type found in studios. The composition is rare in Pontormo's large drawn oeuvre for the reason that it cannot be connected with any painting. It could be one of the few sketches made for its own sake, except that Pontormo was not given to genre compositions. This carefully arched composition filled with figures may be a preparatory study for a lunette, perhaps terminating an altarpiece and decorated with a group of singing angels.

Frederick M. Clapp dated the work to c. 1520, during the more developed phase of the painter's youth, for stylistic reasons (Clapp 1914, 80). The peculiarities most characteristic of this period are strongly evident: the bulk of the bodies is clearly defined, yet is transparent, luminous, and seemingly weightless; the contours surround the forms with ease, but their decorative effect is premeditated. A few black crayon strokes remain from the earlier searching phase. Even if this drawing is just the first stage in a longer creative process, it exploits so well the chromatic possibilities of the red chalk technique that it appears to be a finished work of art.

L.Z.

Perino del Vaga
Design for the Decoration of a Wall and The Feast of Herod

15
Perino del Vaga
Florence 1501–1547 Rome
Design for the Decoration of a Wall
(verso: *The Feast of Herod*)
Light black chalk, pen, and brown ink with brown and gray
washes; inscribed on the verso (as read by Gino Corti),
paganazo /[rosso]/ *di viterbo libre 15 | nero di fuma libre 2 |
leone batista alberti | le stampe d'alberto |* [Dürer] / ; 419 x 290 mm
(16½ x 11⅜).
Provenance: Esterházy (Lugt 1965); inv. 1838.
Literature: Gere 1960, 9–19, fig. 17, with previous literature.

This large, extremely decorative sheet from the Esterházy
collection was formerly thought to be by Pontormo. Walter
Vitzthum recognized Perino's hand and J. A. Gere (1960)
connected it to the partially destroyed fresco (four scenes are
gone; two are extant) and stucco decorations of the Massimi
Chapel in Trinità dei Monti, commissioned from the artist
in 1537–1538 and the first and most decisive work of his
second Roman period. As other sketches prove, the chapel
decorations were carefully prepared. The first phase of the
project is seen here: a compositional sketch in which Perino
adhered firmly to the existing wall space, even with its pierced
surfaces that interrupt the axial symmetry of the artist's plan.
Drawings in the British Museum and the Victoria and Albert
present Perino's final solution: two symmetrically placed
doors, one functional and the other *trompe l'oeil* (Pouncey-
Gere 1962, cat. no. 169*, pl. 139b, and Ward-Jackson 1979,
no. 362).

The Budapest drawing still differs from the finished
project in its iconography, if the description by Giorgio
Vasari is accurate. The *Feast of Herod* sketched on the verso
was never executed in fresco. On the recto we see only one
unidentifiable biblical scene, while three scenes from the

New Testament appear in the fresco. Elements of all three
miracles of Christ's Raising from the Dead are found in the
drawing, among them that of the Raising of Lazarus, which
can be seen in the fresco. However, the composition does
not completely correspond with any of the relevant biblical
texts. Since we can also detect several motifs of Christ's mir-
aculous healings in the drawing, it is not impossible that this
is an early variant of the miracle Healing of the Lame Man,
because the miracle of Lake Bethesda also appeared on the
completed decoration.

While the style of the central New Testament scene
seems rather modern (Gere suggested the influence of the
young Salviati [c. 1520–c. 1575]), the grotesque decoration
on the Budapest drawing is somewhat archaic, recalling the
Vatican Logge pilaster and window-frame decorations by
artists in the Raphael shop. Though Perino carried some ele-
ments (chained prisoners, caryatids) in the Budapest sheet
over into the two London sheets, his astonishing change to a
more contemporary Michelangelesque style in those sheets
should be noted. Perino later utilized the caryatids in his
basamenti painting for the Stanza della Segnatura, commis-
sioned by Pope Paul III (reigned 1534–1549).

L.Z.

Recto

Verso (detail)

Perino del Vaga
Saints Peter and Paul

16
Perino del Vaga
Florence 1501–1547 Rome
Saints Peter and Paul
Pen and brown ink on two sheets of paper pasted together;
inscribed at lower edge, *D. Campagnolla*; 262 x 293 mm
(10⁵⁄₁₆ x 11½).
Provenance: Esterházy (Lugt 1965); inv. 1985.
Literature: Budapest 1963b, no. 36, with previous literature.

The group of drawings by Perino del Vaga in the Budapest Museum of Fine Arts has been researched during the last twenty years. Before then the drawings were misattributed or their authors were unknown. The drawing of *Saints Peter and Paul* entered the Esterházy collection as the work of Domenico Campagnola (1500–1564). It was recognized as the work of Perino by Iván Fenyö in Budapest 1963b (an attribution with which Bernice Davidson agreed). Fenyö dated it to the early 1530s, though convincing analogies can be found among the master's datable drawings from the 1540s. (See the sketch for the figure of Prudentia; Bean 1982, no. 168.)

The central portion of the original drawing appears to have been removed, and a vertical seam at the center is obvious. The two saints are seated on a small bench or ledge, the front panel of which contains fragments of a relief with scenes from the martyrdom of the saints. In the center two slim putti, mannerist adaptations of Michelangelo's *ignudi*, carry heavy garlands over their shoulders. In the "lost" area of the composition, between the two standing figures, the discontinued lines suggest that there once may have been a medallionlike wall panel. As in the Sala Paolina, designed by Perino, 1545–1547 (Castel Sant'Angelo, Rome), the overdoor design contains similar pairs of putti, proportionately smaller, holding medallions depicting scenes from the life of Saint Paul.

The purpose for which this drawing was intended remains uncertain. Perino completed many works for Pope Paul III whose patron saint was Saint Paul. The Cappella Paolina in the Vatican also should be considered as a possible destination, since in 1540 Antonio da San Gallo the Younger (1483–1546) completed his work there. According to Vasari, Perino executed the stucco decorations of the ceiling, now destroyed, after drawings by Michelangelo, as well as "molte cose di pittura" (ed. Milanesi, 7, 216). This drawing could also have been for the frescoed lunettes, also destroyed. Whether or not the *Saints Peter and Paul* can be connected with the aforementioned works is uncertain, but some interesting hypotheses have been advanced since the discovery of drawings connected with the earlier decorations of the Sala Paolina (Rome 1982, vol. 2, nos. 68–71), and it is also possible that the Budapest drawing, which dates from the time of those projects, should be included among them.

L.Z.

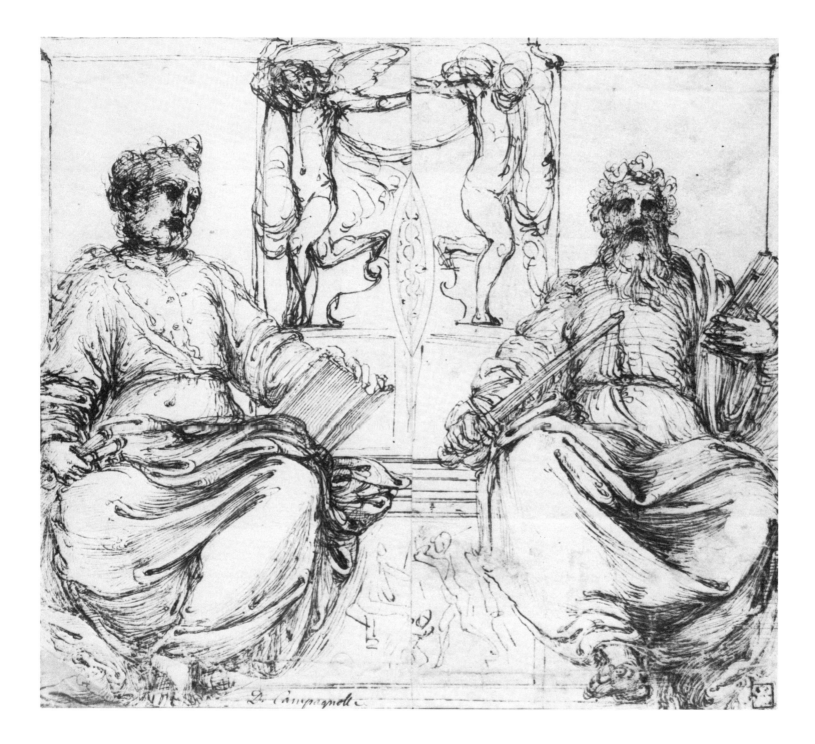

De Campagnoli

Veronese (Paolo Caliari)
Peter of Amiens before the Doge Vital Michele

17
Veronese (Paolo Caliari)
Verona 1528–1588 Venice
Peter of Amiens before the Doge Vital Michele
(verso: the same composition in reverse)
Pen and brown ink with gray washes; inscribed at middle right
(read and explained by Gino Corti), *Sechretario, Capitano*; verso:
todero [Theodore, in Venetian dialect], *Po.* [Pietro ?] *ala destra del
Pe., Prima in fatia* [faccia] *ma roveso* [rovescio]; 140 x 273 mm
(5½ x 10¾).
Provenance: Poggi (Lugt 617); Esterházy (Lugt 1965); inv. 2408.
Literature: Ridolfi 1648; Vayer 1957, no. 39; Fenyö 1965,
86–87, pls. 54–55, with previous literature; Venice 1965, no. 32;
Pignatti 1976, no. 222, pls. 534–536.

This double-sided drawing was known as a work by Paolo Veronese when it was in the Esterházy collection. Edith Hoffmann identified its subject through an engraving by Giovanni Antonio Lorenzini (1665–1740) and a description by Carlo Ridolfi (1648). The drawings are related to a painting which, along with another, was to have been used as a tapestry "cartoon." The tapestry designs were ordered by the Venetian senate as decorations for the Sala del Collegio in the Palazzo Ducale. We do not know if the tapestries were ever completed, but Ridolfi saw the two *bozzetti* in the house of Giuseppe Caliari. One of them has been lost, and the second, related to our drawing, is now in the Pinacoteca Nazionale in Lucca.

Veronese probably prepared the two designs around 1576–1577 when he received various commissions to replace works destroyed during the fire of 1574 in the ducal palace. The new decorations, which fit into the newly prepared woodwork of the ceiling, represented mostly allegorical themes intended to glorify the Venetian republic. A large painting of the great naval victory at Lepanto (1571) was placed above the throne of the doge. We know from Ridolfi that the event selected for the Budapest drawing was taken from the history of the first crusade: it is the moment when, at the request of Peter of Amiens, Doge Vital Michele (1096–1102) dispatched the Venetian fleet to participate in the liberation of the Holy Land.

The sketches on the recto and verso of the Budapest drawing suggest the final shape of the composition. The friezelike placement of the figures according to central Italian High Renaissance principles is successful. On the recto Veronese was concerned with the major figures surrounding the doge, the monk Peter, the commissioned leader of the Venetian troops, Enrico Castellano (the Capitano referred to in the inscription?), and his companion. The composition on the verso was drawn in reverse to accommodate the tapestry weavers who would work from the back, and the schematic drawing summarizes well the main concept of the picture: the group around the "Capitano" is defined; the columns in the background are reduced from four to two with the "todero" (Saint Theodore) at the left; on the sea the fleet is lined up. Of the two variants of the figure of Peter of Amiens, the one at the left was retained in the painting. It is possible that one of the inscriptions on the verso refers to the painter's choice of the figure. The composition on the recto, which was selected for the painting, reveals the colorful splendor of Paolo Veronese's art—unlike the painting, in which the hands of shop assistants are evident.

L.Z.

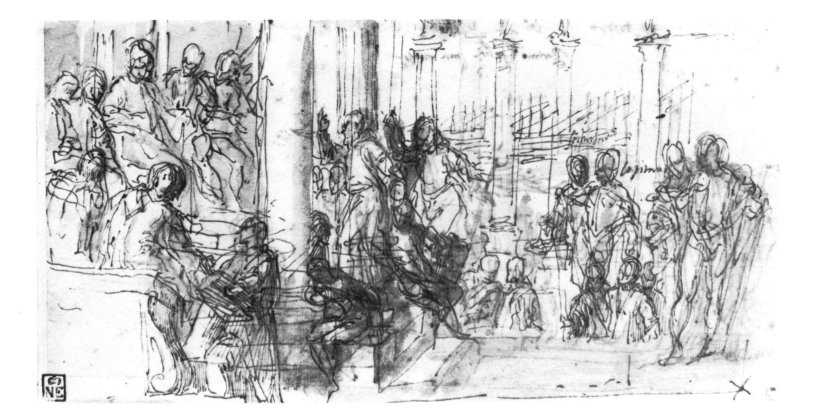

Taddeo Zuccaro
Fighting Men and *Tumbling Men*

18
Taddeo Zuccaro
S. Angelo in Vado 1529–1566 Rome
Fighting Men
(verso: *Tumbling Men*)
Black and white chalks on repaired blue paper damaged on
the borders; 337 x 220 mm (13 ¼ x 8 ⅝).
Provenance: Esterházy (Lugt 1965); inv. 1926.
Literature: Gere 1969, 67, no. 15, fig. 48, with previous literature.

Most of the Taddeo Zuccaro drawings at Budapest, like those by Perino del Vaga (1501–1547), were either unrecognized or misattributed until the appearance in 1969 of John Gere's monograph.

This drawing was attributed to Michelangelo (1475–1564) while it was in the Esterházy collection; it was later attributed to Pontormo (1494–1557). Konrad Oberhuber's attribution of the sheet to Zuccaro was accepted by Gere (1969) who dated it toward the 1550s and suggested a possible connection, unsubstantiated, with the frescoes in the Mattei Chapel of S. Maria della Consolazione, Rome. Gere proposed that the drawing was intended for a Christ Taken Prisoner, Saint Peter with Malchus, or even a Resurrection, but the violent, tumultuous action depicted on this sheet would suggest otherwise.

The sketches are splendid examples of Zuccaro's particular eclecticism, which bypassed the formal conventions of the earlier mannerist generation and drew from the works of artists such as Michelangelo and Correggio, resulting in a forceful, individual style. Michelangelo's plastic forms and dramatic rendering of motion, as well as Correggio's use of light and shade, merge into an elegant unity, especially on the verso where the network of interwoven forms makes an almost abstract composition. The powerful naturalism of the two figures on the recto, the dynamic motion of the kneeling figure with the three pentimenti around his head, and the light shining from below on the face of the recumbent man seem to look ahead to the later sixteenth century. A similar drawing by Taddeo, according to Gere, points to the art of the Carracci (Gere 1969, no. 224, pl. 118).

The precise location within Zuccaro's oeuvre of this double-sided drawing is difficult to establish. Perhaps this is a sheet with detail studies for a battle scene, as the horse's hoof in the background on the verso would seem to indicate. The falling warrior on the left can be detected in the fresco by Cavaliere d'Arpino (1568–1640), painted 1595–1599, in the Palazzo dei Conservatori (Rome 1973, fig. 9). The figure on the recto pinning down his adversary appears, with slight variations, in Zuccaro's fresco of 1564–1565 in the Sala Regia, Vatican (Gere 1969, fig. 159).

L.Z.

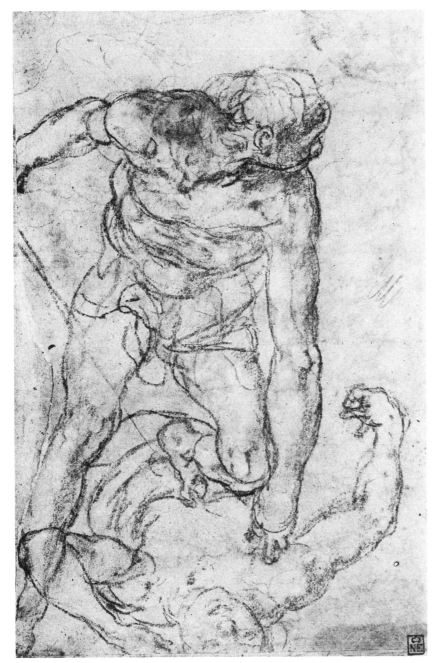

Recto

Verso

Ferraù Fenzoni
Male Nude

19
Ferraù Fenzoni
Faenza 1562–1645 Faenza
Male Nude
Red and black chalks and brush with reddish-brown ink;
inscribed at lower center, *Anibbal Caracci*; 400 x 275 mm
(15¾ x 10¹³⁄₁₆).
Provenance: Haym (Lugt 2908); Richardson, Sr. (Lugt 2184);
Hudson (Lugt 2432); Poggi (Lugt 617); Esterházy (Lugt 1965);
inv. 1851.
Literature: Vienna 1967, no. 22.

When this study entered the Esterházy collection it was attributed, not without reason, to Annibale Carracci. The true author of the work was discovered by Josef Meder through a print by Francesco Villamena (Le Blanc, no. 22), dated 1597 and bearing an inscription stating that it was engraved after an original by F. Fensonius (Schönbrunner-Meder, no. 501). The composition of the engraving depicts the *Raising of the Brazen Serpent* (Moses IV, 21:6–9) and is identical with the fresco painted in 1589 in the Scala Santa, Rome, commissioned by Pope Sixtus V (reigned 1581–1590) (Scavizzi 1960, 113, fig. 1). This fresco was part of the grand project for the decoration of the recently completed building on which more than a dozen artists had worked. The paintings, typical of the late mannerist style, were finished quickly. Several, including Fenzoni's painting, exhibited a strong influence from the Roman school of Federico Barocci (c. 1535–1612). According to the more recent literature, Fenzoni's heterogeneous style was mainly influenced by his elder colleague, the Baroccesque Andrea Lilio (1555–1610); it is also obvious that even in his early creative years the painter was very susceptible to several other influences.

The *Raising of the Brazen Serpent* is representative of an important phase in the painter's career and also of a high point in this decorative enterprise. Though Adolfo Venturi commented on the Michelangelesque plasticity of the figures (Venturi 1934, 1005), neither he nor subsequent writers commented that the prototype for the composition may be found in Michelangelo's Sistine Chapel, 1508–1512, on one of the pendentives of the vault. The discrepancies between the two compositions were caused on the one side by the different form of the fresco and on the other side, as in the figure of Moses (representing redemption), by an enforced acceptance of traditional iconography, following the requirements of Counter-Reformation ideology.

In addition to the Budapest sheet, we know of another preparatory study for this project in the Uffizi (Scavizzi 1966, 4, pl. 1). This sheet exhibits the hallmarks of the Roman style of drawing in c. 1590 based on the ornamental, linear structure of the Zuccaro followers and modified by the more painterly technique of the Barocci school. The broken, grotesque contours of the figure also reflect the influence of Northern mannerist painters working in Rome, recalling the tendencies of the early sixteenth-century anticlassical movement, of the so-called "primo manierismo." Though the strained contrapposto of the Budapest drawing is also typically mannerist, so is the effect of the undulating outlines, the dramatic facial expression, and the naturalistic rendering of the muscular torso and of the wormlike serpent, almost unparalleled in contemporary Roman painting. The only comparable elements can be detected in Giuseppe Cesari's (1568–1640) early, "revolutionary" drawings (Gere 1971, 21), but ultimately the prime source is found in Michelangelo. One more possibility remains to be explored, following the reasoning of Ruggeri (1967, 52): the birthplace of Fenzoni, Faenza, is not far from Bologna, and perhaps the young artist, before arriving in Rome in c. 1585, may have had some contact there with Annibale Carracci's innovative art.

L.Z.

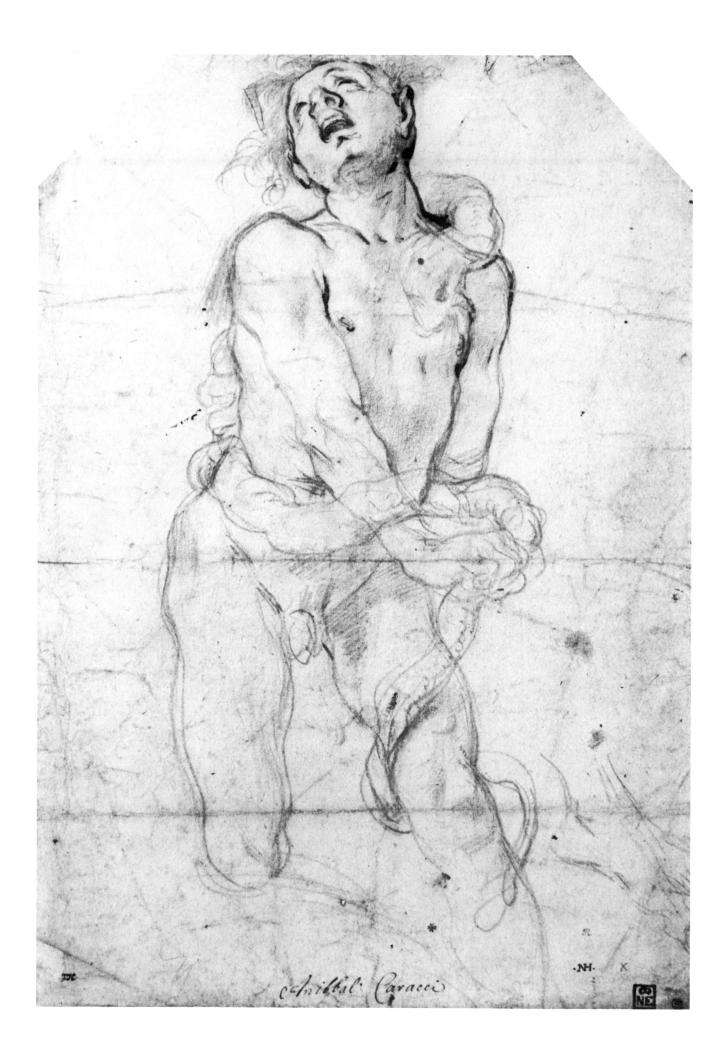

Annibale Carracci
Half-length Study for a Figure Pulling a Cart

20
Annibale Carracci
Bologna 1560–1609 Rome
Half-length Study for a Figure Pulling a Cart
Black and white chalks on blue paper with addition;
365 x 208 mm (14⅜ x 8³⁄₁₆).
Provenance: Poggi (Lugt 617); Esterházy (Lugt 1965); inv. 1810.
Literature: Hoffmann 1927, 145–146, fig. 32; Posner 1971,
vol. 2, no. 86; Johnston 1971, 82, pl. x.

This figure study, the finest among the Carracci drawings at Budapest, has been often published and exhibited. Hoffmann established its connection with the *Saint Roch Dispensing Alms* (Gemäldegalerie, Dresden), a large altarpiece commissioned by the lay order of San Rocco for the church of San Prospero in Reggio Emilia. According to a letter written by Annibale on 8 July 1595, the commission was given in c. 1587/1588 but the work was finished only in c. 1594/1595. The art of the Venetian painters Veronese and Tintoretto (1518–1594) must have inspired Annibale during its creation. The altarpiece represents a final phase in Annibale's Bolognese development. At this time he was preparing to move to Rome to begin work on the commission he had received to decorate the study in the Farnese palace (1595–1597).

The San Rocco altarpiece became very famous during the seventeenth century, and several prints were published after it—one attributed to Guido Reni (B. 53) and two other engravings by Bernardino Curti (d. 1679 ?) and Giuseppe Camerata (Nagler, vol. 2, 306). Posner and other recent authors have considered it one of the earliest significant baroque compositions in which nature, movement, and human behavior are observed. This is the first example of the works that made Annibale known as an innovative painter in the late sixteenth century, during the age of de-clining mannerism. Annibale's characterization of man was based on Renaissance examples as well as on the immediate observation of people in everyday situations and on the use of the live model.

Several static figures act as important connecting or terminating elements in the crowded altarpiece. Among them is the powerful half-length figure at the right edge of the painting who pulls an invalid in a cart, for which the Budapest drawing is preparatory. Despite the static pose, the drawing successfully expresses a single moment during the course of the figure's movement, through the rippling musculature and contours and the highlights accentuating the form of the body. If Annibale's drawing is compared to works by Tintoretto in an identical technique, Annibale's more intimate observation of nature and less self-contained calligraphy are immediately apparent. Within the contours, sometimes reinforced and sometimes faint, depending on the changing light, the delicately rubbed chalk lines do not express the play of light but accentuate the plasticity of the muscular structure. Through this manner and technique the "naturalness" of the subject is retained. This is a prime example of the spirit of the Carracci academy that created a new direction in drawing in the seventeenth century.

A.CZ.

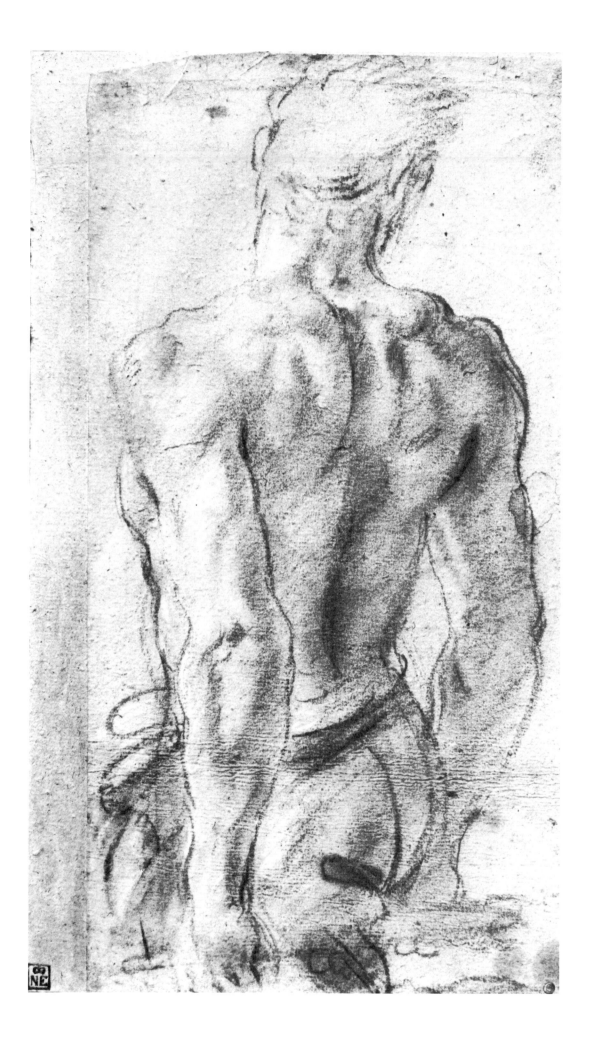

Lodovico Carracci
Half-length Male Nude Lifting a Stone

21
Lodovico Carracci
Bologna 1555–1619 Bologna
Half-length Male Nude Lifting a Stone
Black and white chalks on faded blue paper, with addition at the
head; 246 x 238 mm (9¹¹⁄₁₆ x 9 ⁵⁄₁₆).
Provenance: Reynolds (Lugt 2364); Poggi (Lugt 617); Esterházy
(Lugt 1965); inv. 1817.
Literature: Bodmer 1939, 120, 148; Johnston 1971, 81, pl. 1.

Lodovico Carracci, together with his cousins Annibale
(1560–1609) and Agostino (1557–1602), played an important
role in the renewal of Bolognese painting toward the end of
the sixteenth century. Their academy, established in 1582
(see Boschloo 1974, vol. 1, 39), concentrated primarily on
nature studies and on drawing from actual models, and
became the center of the new movement. Among the three
Carracci, Lodovico was the one whose forms tied him most
closely to the mannerists. At the same time, the simple struc-
ture of his compositions and their rhythm and exaggerated
lyric emotionalism seem to suggest baroque aspirations.
Lodovico's poetic attitude is evident even in drawings such
as this one of a workman trying to raise a heavy block of
stone with a beam.

Already identified by F. Antal in a note on the *passe
partout* of the drawing made some time ago, the study is for
one of Lodovico's frescoes, now almost completely de-
stroyed, in the cloisters of San Michele in Bosco (1604–
1605). Lodovico selected seven scenes from the life of the
founder of the earliest religious order, Saint Benedict. One
of them is the miracle when the saint drives away the devil,
who in an attempt to impede the building of the cloisters
immobilizes a large building block. Our figure study is for
the man seated on a stone at center in the left front side of the
painting. In the drawing this muscular body seems almost
independent of the fine, melancholy, turned head, which
suggests no muscular strain and which, as can be observed
from the pasted-on correction, must have caused some prob-
lems for the artist. (Lodovico apparently discarded the earlier
concept and pasted in a new version.) There is a definite
difference between the execution of the body and that of the
head: the former, drawn with forceful strokes, is sculpturally
constructed while the latter is rendered with more delicacy.
Neither the authenticity of the head nor its contemporary
date have been doubted, as the added paper is identical to
the original support. Further, the facial type suggests
Lodovico's hand. The head is disproportionately small for
the body and there are errors in the proportions of the arms,
and despite the bulging muscles the body does not express
real strain either. For Lodovico it seemed more important to
delineate the well-balanced motion of the arms, to model
the body surface richly, and to render a lyrical expression
than to depict a realistic body movement. Within the strict
discipline of the Carracci academy, the present drawing
seems to typify Lodovico's personal approach to nature.

A.CZ.

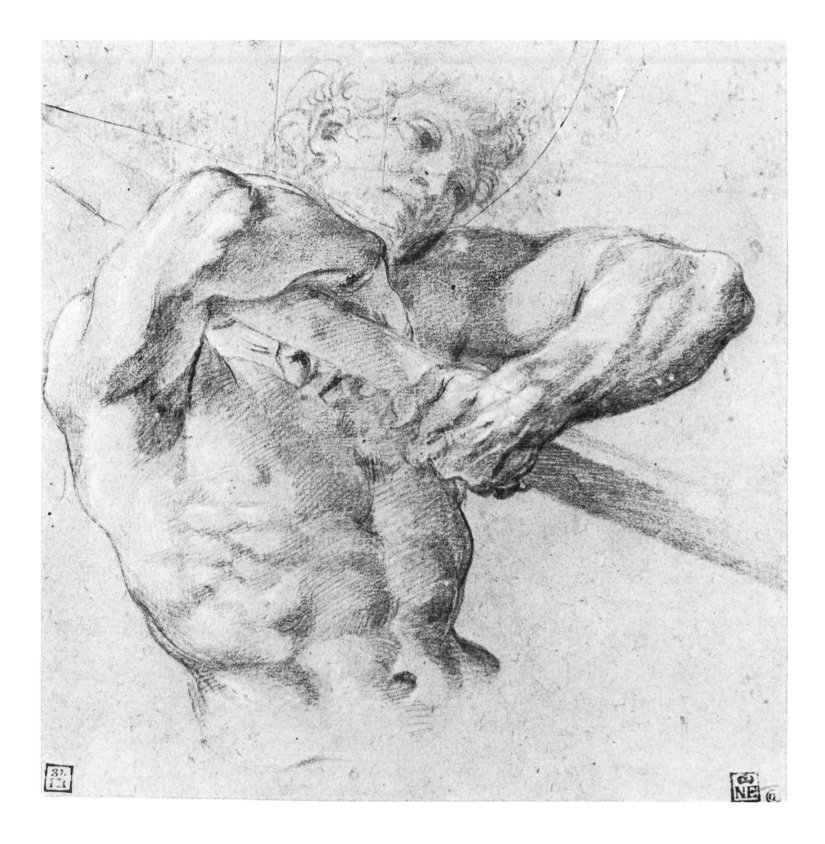

Daniele Crespi
Saint Cecilia

22
Daniele Crespi
Busto Arsizio 1590/1600–1630 Milan
Saint Cecilia
(verso: *Sketches for the Same Composition*)
Pen and dark brown ink over graphite; 276 x 378 mm
(10⅞ x 14⅞).
Provenance: Esterházy (Lugt 1965); inv. 2396.
Literature: Czére 1976, 87–96, 181–186.

Once catalogued in the Esterházy collection as a work by Francesco Albani (1578–1660), this drawing was later assigned to Federico Barocci (c. 1535–1612); then Giulio Cesare Procaccini (1570–1625) was mentioned as a possible author. However, the composition, forms, and the very painterly drawing style recall the mature pen drawings of Daniele Crespi. A sketch of the *Resurrection of Raimondo Diocrés* (Ambrosiana, Milan) shows strong affinities with our sheet. The Ambrosiana drawing was prepared in 1629 for the fresco cycle of the life of Saint Bruno in the Certosa in Garegnano near Milan (Milan [1974], no. 112).

The Saint Cecilia theme is not found among the known works by Daniele Crespi, but in the inventory of his effects prepared after his death, "una tela di Santa Cecilia" is mentioned. The saint became popular in the early seventeenth century following the rediscovery in 1599 of her body. From the late middle ages she is shown as the patron saint of musicians in compositions that originated in such paintings as the Coronation of the Virgin, where music-making angels also appear. The inspiration for the many representations around 1600 in Milan of Saint Cecilia playing the organ might have been a detail of Gaudenzio Ferrari's (1470–1546) ceiling in Saronno, the famous *Concert*, where an angel plays the organ with assistance from his helper.

The dynamic construction, forceful plasticity, and expressive, vehement style of this drawing are notable. The immediate visual effect of the figures' sensual realism and the excited mode of drawing distinguish Crespi from the other noted Milanese "primo seicento" painters, the Procaccini brothers and Cerano (1557–1633). The opposing figures, or rather their rhythmically complementing poses and motions, create animation enhanced by the energetic and occasionally patchy, widening pen strokes that bring the action to a climax. This image of Saint Cecilia, unlike traditional representations, is not idealized, nor is her religious ecstasy emphasized. The two principal actors are earthly beings: the pumping angel spreads its legs to muster the necessary strength for the task while Saint Cecilia loses herself in singing and playing. The passion of the music is expressed by her body, sensuously bent backward, and the swaying, veil-like garment. The mixed pencil and pen technique used for shading results in the extraordinarily plastic depiction of the saint's strong but supple form, seen through the transparent robe. The figure was first drawn on the verso in pencil and a comparison of the two versions demonstrates the changes Crespi made in the figure: the head and torso are turned in opposite directions and the body leans backward slightly more on the recto. In this way the liveliness of the movement is enhanced.

A.CZ.

Guido Reni
Crucifixion of Saint Peter

23
Guido Reni
Calvenzano 1575–1642 Bologna
Crucifixion of Saint Peter
Pen and brown ink and brown washes over preparatory red
chalk; 230 x 137 mm (9¹⁄₁₆ x 5⅜).
Provenance: Lely (Lugt 2092); Lankrink (Lugt 2090); Reynolds
(Lugt 2364); Poggi (Lugt 617); Esterházy (Lugt 1965); inv. 2366.
Literature: Pigler 1924, 46; Vienna 1981, no. 22.

The attribution of this sheet to Reni has never been doubted.
One of Reni's most outstanding compositional sketches, it
was recognized long ago as a preparatory sheet for the
Martyrdom of Saint Peter in the Vatican. Reni drew compo-
sitions for his paintings in the traditional manner, in pen or
chalk, and then prepared detail studies in chalk. The Buda-
pest drawing is the only authentic sketch known to us for
the painting. The detail studies in Dresden and in the Gabi-
netto Nazionale, Rome, formerly connected with this pic-
ture, have been proved to be later copies (Vienna 1981,
no. 22, nn. 1, 2).

This painting is characteristic of Reni's early,
Caravaggesque phase, and is his first masterpiece. At the
order of Cardinal Pietro Aldobrandini, the artist painted it
for the church of San Paolo alle tre Fontane in Rome.
According to documents, on 7 November 1604 he received
the sum of fifty *scudi* for the work. Because of the strong
light and shade effects, the altarpiece is often discussed in
connection with Caravaggio's *Martyrdom of Saint Peter* for
the Cerasi chapel in Santa Maria del Popolo (1601). How-
ever, the two artists' concepts differ significantly. Reni
worked in an idealized, classicizing style: he depicted the
dramatic event with restraint and did not suggest the gestures
naturalistically. Through this he achieved an especially
elevated spiritual mood.

The essence of the composition is already evident in
this drawing, where Renaissance prototypes established by
Leonardo or Raphael—closely knit groups that can be
easily arranged in a triangular space—are followed. The
characteristic connecting figures and actions of Reni's
mature style are already somewhat clear; with the figural
arrangement in this painting Reni reached an almost musi-
cal rhythm. A very dramatic moment containing the poten-
tial for heightened passion is shown in a well-balanced,
harmonious scene where neither the saint's suffering nor the
brutality of the event is accentuated. This very tendency
was further developed in the painting by the saint's humble
gesture, signifying noble resignation and submission. The
sheet is related stylistically to the Carraccis' compositional
drawings.

Reni first sketched the main figures in red chalk and
followed them with rapidly repeated pen strokes. Through
the defining lines surrounding the forms and the forceful
washes, applied later, the artist created an almost relieflike,
monumental plasticity among the four figures.

A.CZ.

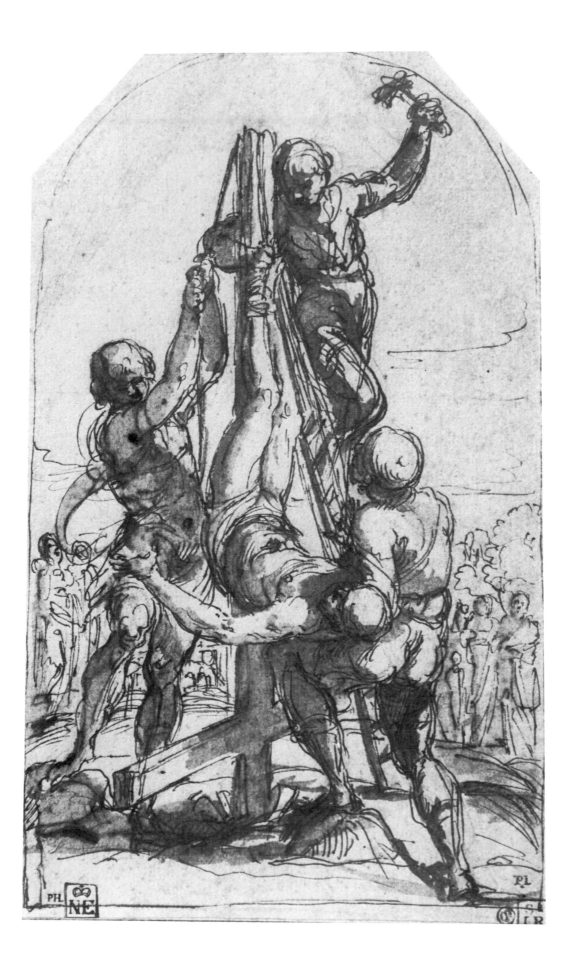

Guercino (Giovanni Francesco Barbieri)
Family Walking in a Landscape

24
Guercino (Giovanni Francesco Barbieri)
Cento 1591–1666 Bologna
Family Walking in a Landscape
Pen and brush and brown ink; 186 x 288 mm (7⁵⁄₁₆ x 11⁵⁄₁₆).
Provenance: Bourduge (Lugt 70); Poggi (Lugt 617); Esterházy
(Lugt 1965, 1966); inv. 2320.
Literature: Vayer 1957, no. 59.

Next to figure compositions, landscape drawing played an important role among the activities of Guercino, one of the most illustrious Italian draftsmen of the seventeenth century (Bologna 1968, 178). Though landscape was not then as highly regarded as figurative art, the Carracci academy in Bologna (see cat. 21) had already laid the groundwork for and aroused interest in a drawn landscape tradition. While Guercino showed interest in landscape painting mostly during his youth, he executed landscape drawings throughout his life. Unlike his figure studies, his landscapes were seldom done for a specific purpose. He used his keen observations of nature as a point of departure for fantasy images expressing a nostalgia for an ideal world. Guercino employed well-known elements from Annibale Carracci's landscape composition formula—the trees in the foreground and a winding river or a road in the central plane leading toward the background and terminating in hills topped with a group of buildings—to create an idyllic image. Though the motifs were not new, they soon acquired a special place in Italian art because of their masterly execution. Due to their witty compositions and virtuoso draftsmanship, Guercino's landscapes became highly esteemed in the eighteenth century and were often copied and imitated. (For example, in the Museum of Fine Arts, Budapest, there is a group of later landscape drawings in the manner of Guercino [Hoffmann 1929–1930, 179–186].)

Rembrandt's etchings greatly influenced the development of Guercino's personal landscape style: Guercino mentioned his admiration for the works of the Dutch master in one of his letters. Guercino's landscapes, though, are highly decorative works composed of delicately interwoven groups of motifs. The airiness and apparent economy lend an elegance to his drawings and at the same time arouse the imagination. His realization of space is also partly imaginary and his depth of perspective, achieved by the finer and paler receding line-work, is not always logical.

The Budapest landscape contains a strong emotional element noticeable in the rendering of the trees, which seem to tumble in all directions and create motion and drama with their wind-blown crowns. The concept and also the technique of the Budapest drawing approach closely a sheet of a *Man Sitting with a Child on a Hill* (British Museum, London; Bologna 1968, no. 197).

A.CZ.

Giovanni Benedetto Castiglione
Allegory of Human Wisdom, Idea, and Habit

25
Giovanni Benedetto Castiglione
Genoa c. 1610–1663/1665 Mantua
Allegory of Human Wisdom, Idea, and Habit
Brush and brown washes and reddish-brown, black, light blue,
and white oil paints on yellow-tinted paper; inscribed (later) at
lower right edge in pencil, *Castiglioni*; 455 x 332 mm
(17⅞ x 13⅛).
Provenance: Poggi (Lugt 617); Esterházy (Lugt 1965); inv. 2296.
Literature: Fenyö 1965, 122–123, 126, pl. 92.

After having become acquainted with genre painting in his native city and coming under the influence of Roman art, Castiglione arrived at a kind of classical allegorical subject matter. His style is marked by a conflation of often contradictory influences, from which he forged an individual style (Philadelphia 1971, 17). He drew from contemporary poetry and thought for his subjects. The futility of human action and the temporary nature of all human achievement troubled him, and a deep nostalgia for the "golden age" before civilization, for the carefree pastoral life, penetrates his art. The Budapest drawing is one of a group of works that has been regarded as an allegory honoring the duke of Mantua, the precise meaning of which has not been understood until now (Philadelphia 1971, 99, no. 73). In our opinion, the three principal figures can be identified from Cesare Ripa's iconology, a main source for the interpretation of baroque allegories. The young man seated in the foreground, holding a trumpet and surrounded by a quiver, armor, dead game, and a painter's palette is clearly the allegory of "sapienza humana," or human wisdom (Ripa 1630, *Parte Terza,* 39–40). Ripa explains that for wisdom, contemplation is far from enough, and that it requires also action and the acceptance of advice given by others. The wise man acquires and

defends his fame with arms, and does not allow himself to be inebriated by flattery. The female figure represents the "idea" while the child in her lap signifies "nature" (Ripa 1630, *Parte Seconda,* 429–432). This idea of the immaterial essence of divine reason, meaning also the origin and model of nature and of matter, is the principal concept of Platonic philosophy. The elderly man in the background leaning on a staff is the allegory of *consuetudine,* the personification of habit which, like the laws of the rulers, becomes firmer as it becomes older (Ripa 1630, *Parte Prima,* 137–138).

As the assembly of the three allegories was intended to honor the duke of Mantua, it probably expressed admiration for his virtues, his active and wise rule, his acceptance of habit, and his cultivated intelligence.

This Budapest drawing, which has long been considered an authentic work by Castiglione, is one of his most individual and brilliant oil sketches. For the technique, rare in Italian art, the artist must have looked to Van Dyck (1599–1641) and Rubens (1577–1640). The date of this work, as well as those of all the connected paintings and drawings, can be placed in the 1650s.

A.CZ.

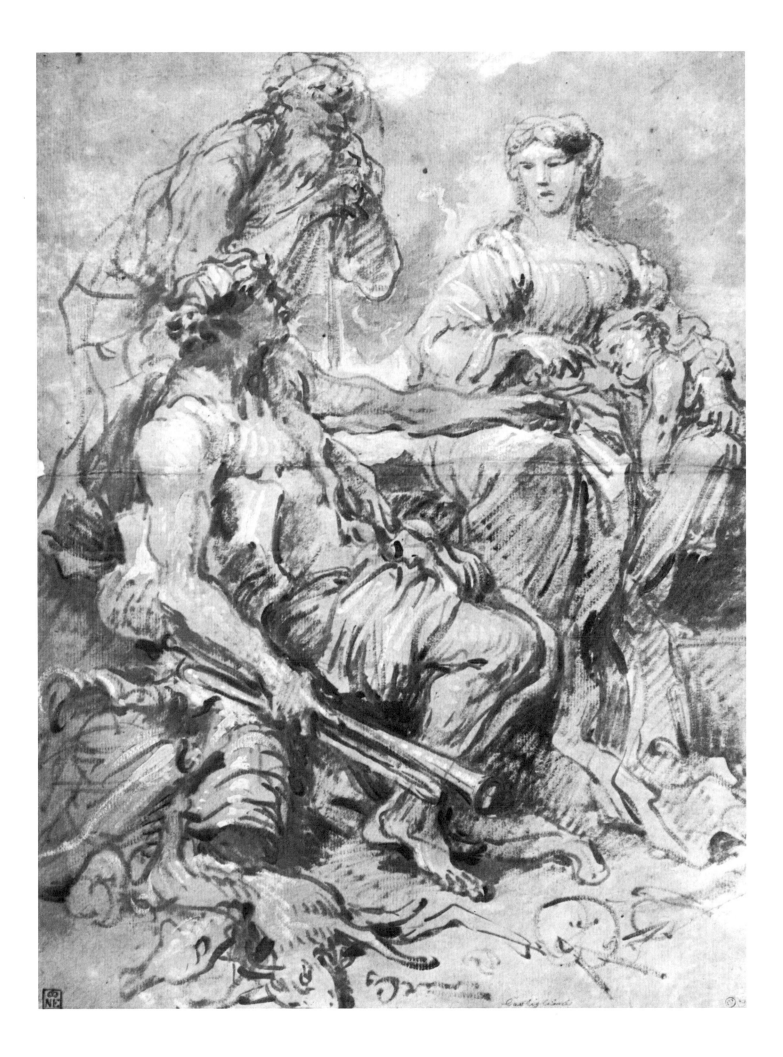

Carlo Maratti
Hera Calls upon Aeolus to Destroy the Trojan Fleet

26
Carlo Maratti
Camerano (Ancona) 1625–1713 Rome
Hera Calls upon Aeolus to Destroy the Trojan Fleet
Pen and brown ink and brown washes over preparatory red
chalk; inscribed (later) at lower edge in dark brown ink,
Marratti, and above the Poggi mark, in black ink, *10*;
232 x 289 mm (9⅛ x 11⅜).
Provenance: Poggi (Lugt 617); Esterházy (Lugt 1965); inv. 2528.
Literature: Pigler 1974, vol. 2, 284.

This drawing entered the museum with a group of works attributed to Maratti from the Esterházy collection. The subject, the moment when the goddess Hera intervenes in the Trojan War on the side of the Greeks (*Aeneid,* Book 1, 50–86), was popular with Roman and Bolognese artists of the seventeenth century. Maratti, the leading master of the late Roman baroque, studied the Bolognese and classic traditions: he was trained in the studio of Andrea Sacchi (1599–1661) and absorbed the ways of Annibale Carracci, Francesco Albani (1578–1660), and Guido Reni. He followed the examples of antiquity and Raphael in representing the human figure and its proportions. He employed a variety of techniques in his preparatory sketches, which were executed in either chalk or pen; very often he changed the final composition or the order of his figures and groups in the finished paintings.

Formerly classified among the questionably attributed works, the authenticity of the Budapest drawing can be affirmed by some works by Maratti treating an identical theme. On a sheet in the British Museum (inv. 1950.2.11.12,

verso; sketch for a *Noli me tangere,* recto) there is a variant of the same composition, where Hera is seen from the back; in the Budapest drawing she appears frontally. The Budapest version is compositionally more static, but the principal figures are more successfully emphasized. The other details are identical: at left the fleet, at right the rocks with the personification of the winds, and at center the seated figure of Aeolus holding his regal attributes. It is clear that the two sketches were for the same composition. That the Budapest drawing is the later version is made obvious by the varied techniques used, while in the British Museum drawing Maratti used pen only, and the rapid strokes with many pentimenti indicate a first thought. The Budapest drawing shows more mature shapes and definitive outlines and an effective depiction of light and shade, achieved through varied washes.

A painting representing a similar subject is also known (sale, Sotheby's, London, 26 June 1974). Though the postures and arrangements of the figures are different, a kinship is detectable.

A.CZ.

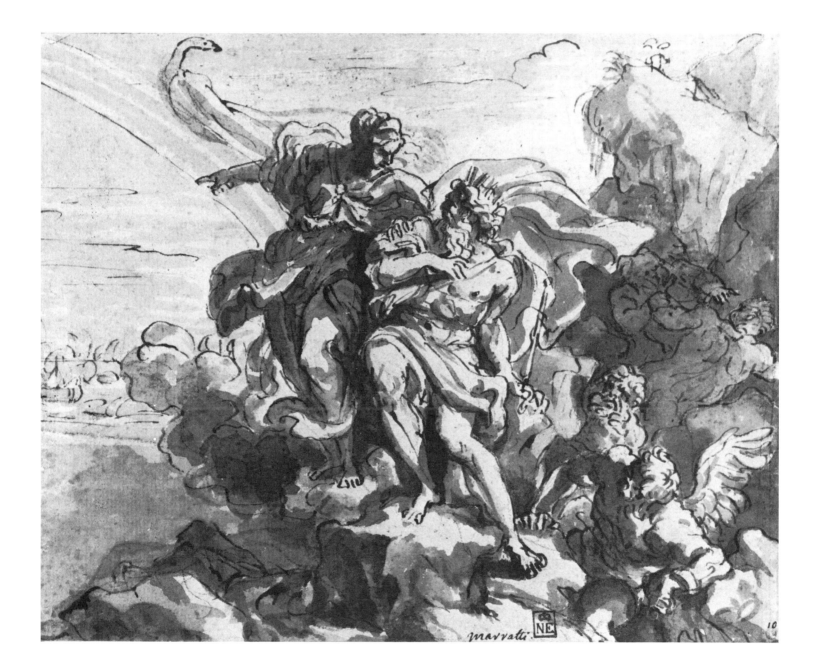

Giovanni Antonio Burrini
Study for the Portrait of Beatus Tommaso Abruzze, Celestine Monk and Bishop

27
Giovanni Antonio Burrini
Bologna 1656–1727 Bologna
Study for the Portrait of Beatus Tommaso Abruzze, Celestine Monk and Bishop
Black, red, and white chalks and gray and brown washes on repaired buff paper; 375 x 288 mm (14¾ x 11⁵⁄₁₆).
Provenance: Esterházy (Lugt 1965); inv. 1842.
Literature: Czére 1981, no. 3, 217–219.

Giovanni Antonio Burrini, an important late baroque Bolognese painter and a pupil of Domenico Maria Canuti (1620–1684) and Lorenzo Pasinelli (1629–1700), is remembered today mainly through his paintings; only a few drawings are attributed to his hand and within that group, documented or secure works are rare. Therefore, this study and the three other heads at Budapest (inv. 1840, 1841, 1843) preparatory for Burrini's frescoes in the church of San Giovanni dei Celestini, Bologna, are important for the study of his drawn oeuvre.

The frescoes, commissioned as ceiling decorations for the church of the order of the Celestini, founded during the thirteenth century, were Burrini's first large-scale works and his introduction to the public. The paintings were unveiled on 1 February 1688. The cupola decoration represents the apotheosis of Saint Peter Celestini, while in four spandrels life-size figures of the beatified fathers of the order are depicted. They are Roberto di Sala, Petrus da Roma, Tommaso Abruzze, and Joannes de Bassads, shown seated on clouds. Among the drawings in the Fachsenfeld collection in the Staatsgalerie, Stuttgart, are four more sketches that conform to the spandrel decorations (Stuttgart 1978, nos. 38 a–d).

For these figures the almost life-size head studies at Budapest were prepared. Their fine quality had aroused the interest of scholars long ago, but only recently, with the publication of the drawings in the Fachsenfeld collection and of the wall paintings in Bologna, could their authorship be established. Though the four studies are idealized portraits, their depiction of different facial types and their painterly execution, firmly anchored in Bolognese traditions, are impressive. The head of Tommaso Abruzze is outstanding because of its suggestive power. The gaze is convincingly fixed on the spectator. The prominent nose, the air of self-confidence, the energetic mouth with the fleshy underlip, and the small chin suggest that a live model was used. Burrini's skills as both a painter and draftsman work in close harmony. The coloring of the face, its plastic quality, and its luminosity are due to the masterly use of *trois-crayons*, the mixture of black, red, and white chalks, and in particular to the use of a wet brush with which the chalk lines were rubbed.

A.CZ.

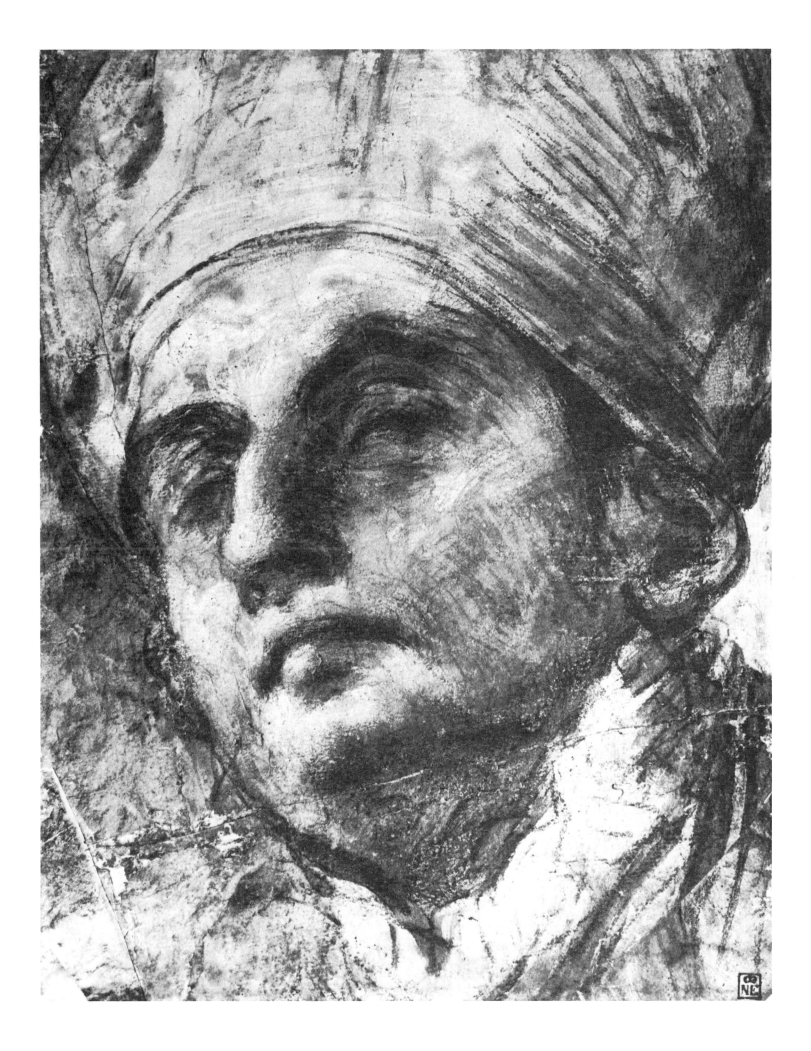

Giuseppe Galli da Bibiena
Stage Architecture with a Scene from the New Testament

28
Giuseppe Galli da Bibiena
Parma 1696–1756 Berlin
Stage Architecture with a Scene from the New Testament
Pen and brown ink and brown and gray washes; inscribed on a
banner in pen and brown ink, *Cum facis convivium, voca pauperes,
debiles/claudos et caecos : et beatus erit etc: Luca, Cap: XIV. 13. 14.*;
526 x 263 mm (20¾ x 10⁵⁄₁₆).
Provenance: Esterházy (Lugt 1965); inv. 2584.

Giuseppe Galli da Bibiena, one of the most illustrious members of the family of Bolognese architects and stage designers, worked from 1708 on for forty years for Charles VI, ruler of the Hapsburg empire from 1711 to 1740. Following in the tradition established by his father, Ferdinando (1657–1743), Giuseppe elevated court festivities to a spectacular level. Numerous projects for operas, plays, and religious celebrations have been preserved in various collections. A sumptuously illustrated book (published by Andrea Pfeffel in Augsburg 1740) dedicated to Charles VI attests also to his efficacy as a stage designer. Giuseppe worked mainly in Vienna, Dresden, and Berlin and in a number of other Austrian, German, and Italian cities.

The spacious, elegant, colonnaded building is carefully designed with thin pen lines and then washed with gray and brown. One of Giuseppe's simpler projects, it belongs to those *teatro sacro* designs in which he employed the traditional central perspective, but this is not necessarily an early work. It is likely that the scene of the performance, a rather narrow chapel, determined the chosen composition. The height of the unusually narrow sanctuary is twice its width. The proportions do not lend themselves to effective vertical division, but more to a horizontal one. Thus it was impossible to apply the popular *scena per angolo* perspective with its vanishing points placed at the sides to achieve complicated, foreshortened spaces. Instead the master created a single, deep space through the use of successively shortened columns and the repeated, shrinking coffering of the ceiling vault, which occupies more than two-thirds of the sheet.

Giuseppe's decoration could have been intended for a feast of Corpus Christi. The central element of the picture is the Sacrament, surrounded by angels and clouds. The circular form of the host fits well into the receding ceiling construction as well as into the diminishing space between the columns. The artist produced a remarkable play of perspective through the delicately chosen similar washes between the foreground and the distance, making the host seem to almost float above the table on the stage.

The banner explains the theme of the event represented here: "But when thou makest a feast, call the poor, the maimed, the blind. And thou shalt be blessed; for they can not recompense thee: for thou shalt be recompensed at the the resurrection of the just" (Luke 14: 13–14). The invitation to the feast is shown in the foreground where dignified men invite the unfortunate to the heavily laden banquet table. The principal scene in gray and the background with brown washes give the illusion of two separate stage sets.

A.CZ.

Giovanni Battista Tiepolo
Figure Study

29
Giovanni Battista Tiepolo
Venice 1696–1770 Madrid
Figure Study
(verso: *Head and Hand Study*)
Red and white chalks on blue paper; inscribed on the recto at
lower left in pen and brown ink, *739*; 392 x 228 mm
(15⅜ x 8¹⁵⁄₁₆).
Provenance: Gift of Gustav Nebehay, 1923; inv. 1923–1022.
Literature: Hoffmann 1927, 166–168, fig. 55; Fenyö 1965,
153–154, pls. 118–119; Knox 1980, M. 67, 216–217.

The standing figure of a man wearing a cloak and seen *di sotto in su* is a preparatory study for the ceiling fresco (c. 1750–1753) in the staircase of the archbishop's residence in Würzburg. That connection was established by Edith Hoffmann. The fresco, commissioned by Archbishop Karl Philip von Greiffenklau, shows Apollo appearing over the four continents (a symbol for the rising sun). Frank Büttner (1979, 159) very convincingly interpreted the composition as an allegory of the archbishop's virtues as a governor, comparing him to the life-giving sun. Thus the decorations of the Würzburg staircase are linked to a popular baroque tradition, which made use of the ancient sun cult in order to glorify a ruler.

The ceiling painting was finished by Giovanni Battista Tiepolo with the assistance of his sons, Domenico and Lorenzo. Among the representations of the four continents seen around the edges, that of Europe is the most outstanding; above this portion floats a portrait of the archbishop surrounded by the figures of Virtue and Fame. The continent of Europe is symbolized by a crowd of allegorical personages representing Christianity, military power, and the flowering of the arts and knowledge. The Budapest drawing is for the most conspicuous figure, standing at right, who may personify Sculpture (a relief and a bust are scattered near his feet). Scholars have suggested that this may be a portrait of Antonio Bossi, a Venetian sculptor, stucco worker, and collaborator with the Tiepolo family (Pignatti [1980], no. 46). Giambattista probably prepared the present sketch, as can be seen from the pose, the clutching of the cloak, the head turned toward us, and the folds of the fabric, after making studies from a live model. Other drawings are known for the same figure in the Museo Correr, Venice. These are contained in an eighty-seven-page album that includes the largest group of studies for the Würzburg project: the Budapest sheet also originally formed a part of that volume (see Knox 1980). The album later entered the Museo Correr through the painter Giuseppe Lorenzo Gatteri (1830–1884).

The Budapest figure is firmly modeled yet retains a painterly quality, and its lively contours and brilliant highlights are quite bold. It recalls a sheet in the Staatsgalerie, Stuttgart, of a cloaked man wearing a hat, seen from the back (Stuttgart 1970, no. 77). The Budapest and Stuttgart drawings are so close in execution and style that the painter may have sketched both on the same day. The sketches on the verso of the Budapest drawing, showing the head of a woman wearing a kerchief and above that a left hand probably holding a book, could have been detail studies for the figure of the Virgin in an Annunciation.

A.CZ.

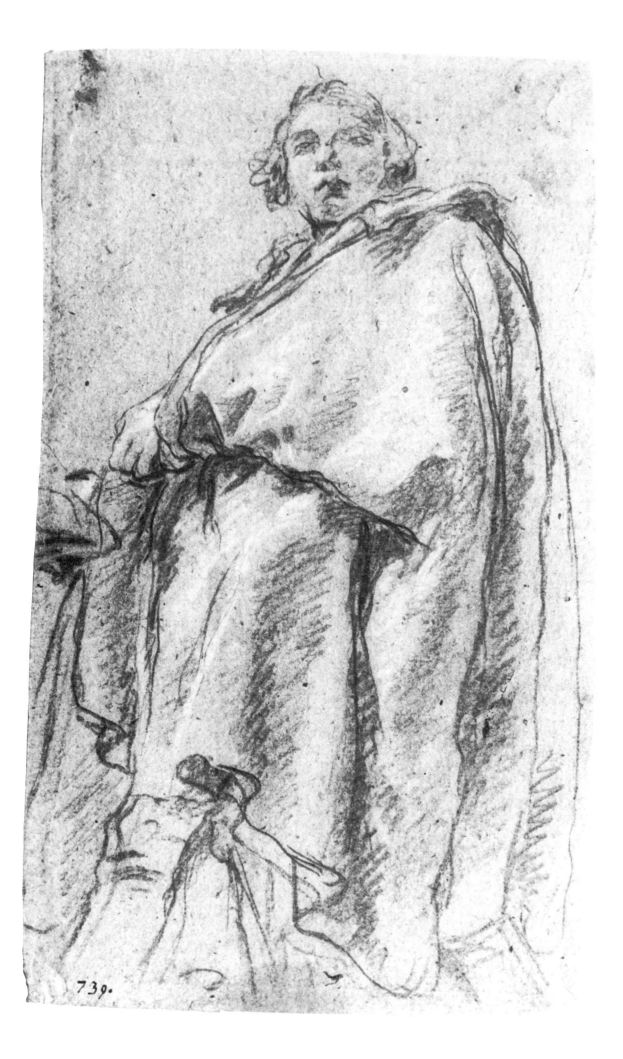

739.

Giovanni Domenico Tiepolo
Head of Saint James of Compostela

30
Giovanni Domenico Tiepolo
Venice 1727–1804 Venice
Head of Saint James of Compostela
Red and white chalks on blue paper; 322 x 253 mm
($12^{11}/_{16}$ x $9^{15}/_{16}$).
Provenance: Habich Collection (Lugt 862); Gift of Simon Meller,
1929; inv. 1929-2164.
Literature: Byam Shaw 1962, 65, 72; Fenyö 1965, 156, pl. 122;
Rizzi 1971, 290, no. 132; Knox 1980, м. 116 (as Giovanni
Battista), 223.

It is very difficult to distinguish the chalk drawings of
Giovanni Domenico Tiepolo, called Domenico, from those
of his father, Giovanni Battista (Giambattista), because their
styles are so closely connected. This is why the Budapest
sheet is sometimes attributed to one and sometimes to the
other. It is connected with Giovanni Battista's painting of the
Triumph of Saint James of Compostela over the Moors (1749–
1750) at Budapest (Pigler 1967, vol. 1, 687–688, and vol. 2,
pl. 138; Garas 1968, nos. 15–16) as either a preparatory study
or a copy. The separately sketched hand and the delineation
—flatter, more decorative than that seen in the father's draw-
ings—indicate that it is actually a copy after the painting. In
the Tiepolo family shop, copying of the master's drawings
constituted an important part of the younger Tiepolos'
education. Thus a large number of such copies by the sons
are known. The Tiepolo sons compiled albums of drawings
found in the shop, and they also produced prints of their
father's oeuvre and of their own works for use by students.

Domenico could have made this detail sketch also for a
print after his father's painting. Another possibility is that
Domenico planned a series of heads (the moor's head from
the same altarpiece [Rizzi 1971, no. 180, pl. LII] also
appeared as a print). Whether or not we can establish the
intended purpose of this drawing, it remains one of
Domenico's most successful re-creations of his father's works.
It documents his debt to his father's art, but at the same time
testifies to the differences in their artistic attitudes. Saint
James' facial structure in the painting as well as the drawing
is identical, but the expressions are different. Giovanni
Battista stressed sentimental rapture and religious devotion
while Domenico, with cooler and more rational objectivity,
aimed at bringing out the saint's youthful exuberance and
determination.

A.CZ.

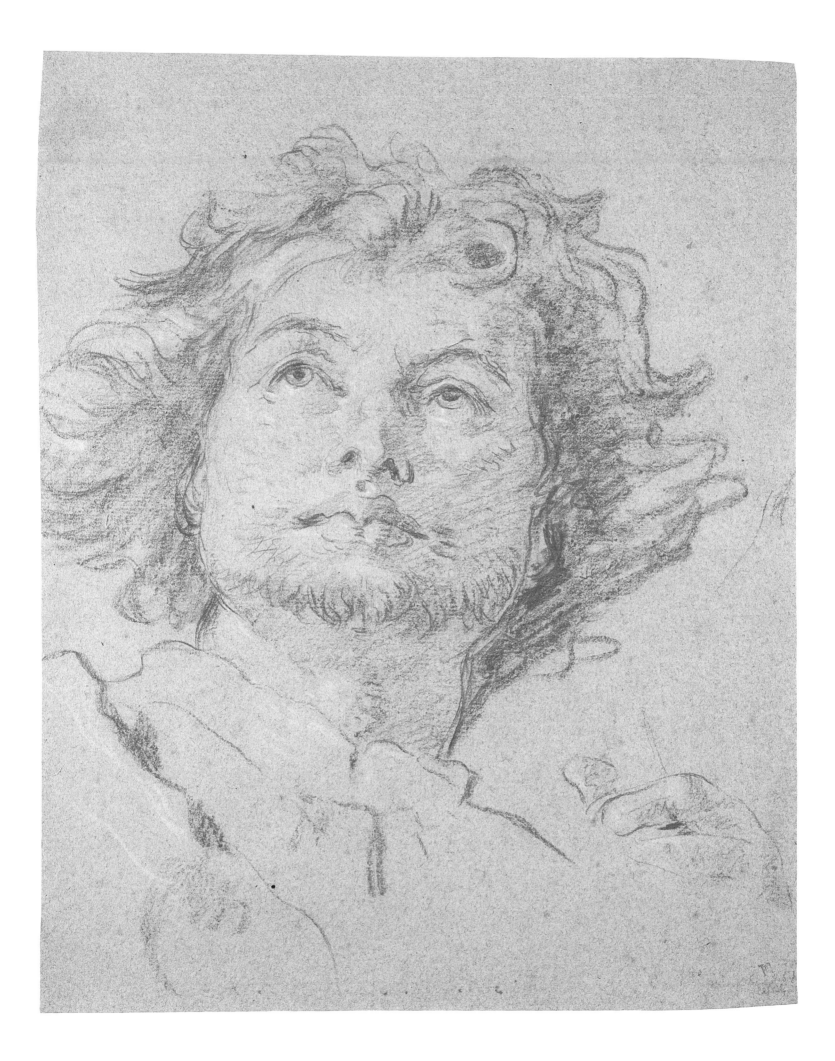

Bernardo Bellotto
View of Padua with the Porta Pontecorvo and the Santa Giustina Church

31
Bernardo Bellotto
Venice 1720–1780 Warsaw
*View of Padua with the Porta Pontecorvo and the Santa
Giustina Church*
Pen and brown ink with traces of graphite; 171 x 270 mm
(6¹¹⁄₁₆ x 10⅝).
Provenance: Bellotto family, Wilno, in the early nineteenth
century; Bojanus, Wilno; Darmstadt; after 1827, Eigenbrodt,
Darmstadt; from 1829, Hessisches Landesmuseum, Darmstadt;
R. Ph. Goldschmidt (Lugt 2926); sale, F.A.C. Prestel,
4–5 October 1917, Frankfurt am Main;
Museum purchase from C. Albert de Burlet, 1918; inv. 1918–481.
Literature: Hoffman 1929–1930, 188–189; Fenyö 1965, 164–165,
pl. 129; Kozakiewicz 1972, no. 35.

This Paduan view, datable to c. 1740–1742, is among the youthful, topographically precise Italian views that Bellotto prepared during his apprenticeship in the studio of his uncle and master, Antonio Canal, called Canaletto (1697–1768). After working in Venice, Rome, and northern Italian towns, he traveled to Dresden, Vienna, Munich, St. Petersburg, and Warsaw, drawing city views and landscapes marked by the precision and expert perspective of his master. Bellotto's colors, however, appear cooler and more subdued; the outlines are crisper and the handling of light and shade less lively than those of Canaletto.

The Budapest sheet is related to a series prepared by Canaletto during the early 1740s depicting various sights in Padua. Our example ties in well with a Canaletto drawing at Windsor (Parker 1948, no. 76, pl. 55) of the Santa Giustina church seen from the ramparts. Two other Bellotto drawings of this church are known: one in Darmstadt (Fritzsche 1936, 49, 52) and one in the British Museum (Von Hadeln 1930, 24). He enlarged the view on still another drawing (Darmstadt; Kozakiewicz 1972, nos. 36, 37, 38, 39) by adding the church of Saint Anthony in the background, and a rider and a prominent tree in the foreground. This version served

him later as a preparation for a print.

Among these works, the London sheet is closest to Canaletto's drawing at Windsor. The Budapest drawing follows the London version in all its details and differs only slightly in the line-work. The measurements of the two sheets are almost identical, though the height of the Budapest sheet is slightly less than that of the London sheet; it was trimmed, perhaps because it had been damaged. Stylistically, the two sheets are alike but at the same time differ from the Windsor prototype by Canaletto. Still, the drawing style is based on the works of Canaletto: Bellotto imitated here his master's stylized drawing manner, characterized by the calligraphic circles, arcs, and dots that form the contours and that were used in drawings intended as independent, decorative works of art.

Stefan Kozakiewicz believed these early drawings by Bellotto were preparatory for Canaletto's Windsor drawings. Rather, they may have been exercises or repetitions of a composition. It is certain that they represent the starting point for his later print.

A.CZ.

Rhenish Master, early fifteenth century
Saint Margaret

32
Rhenish Master, early fifteenth century
Saint Margaret
Brush and dark gray ink with black and red chalks; inscribed,
Martin Sien; 214 x 140 mm (8⁷⁄₁₆ x 5½).
Watermark: Bull's head (similar to Briquet 14,509).
Provenance: Esterházy (Lugt 1965); inv. 1.
Literature: Winzinger 1949, 6, 14, pl. 7; Drobna 1956, 14, 45, 46,
pl. 83; Krems 1967, 125, no. 44, pl. 17; Cologne 1978, vol. 3,
750–751.

The drawing is a characteristic work of the late international Gothic style—its special beauty is based on the harmony of lyric expression and delicacy of form. The curved pose of the body and the gesture of the hands pointing in opposite directions indicate restrained elegance. The intense formalization and stylized modeling of this figure produce a highly decorative effect. The silhouette is especially refined: the softly curved, simplified outline begins at the neck, follows the shoulders and the arms, and leads gently into the rippling folds of the cape. The same smooth, flowing line continues downward to Saint Margaret's symbol, the dragon, on which she stands. The strong contrast between the fine, barely modeled face and the almost sculptural cape, with its rich folds, recalls the "Fair Madonna" figures that were popular around 1400. The edges of the cloak fall on either side to the saint's feet and act as a decorative frame for the delicate figure.

The identification of the artist of this remarkable drawing is problematic. Around 1400 there was a synthesis of a number of schools whose local and national characteristics were subsumed within a universal style. The greater mobility of artists also contributed to the homogeneity of styles, making the identification of works from this period very difficult. Most scholars date the Budapest Saint Margaret c. 1400. But there is disagreement on the place of origin of this drawing (Cologne, Austria, Bohemia, and Augsburg have all been proposed) because it cannot be closely connected with any other work. Thus any attempt to place the drawing in a specific art-historical context remains unconvincing. The often-mentioned Vienna pattern book, considered either Austrian or Bohemian (Kunsthistorisches Museum, Vienna; Cologne 1978, vol. 3, 750–751) contains a head whose morphology recalls that of the head of the Budapest Saint Margaret. However, this cannot be considered proof that the drawing is either Austrian or Bohemian, as pattern books are assemblages of images observed and copied from a multitude of often widespread sources. The head of a Madonna and its mate, the head of an angel, in the Fogg Art Museum, Cambridge, have also been connected to the Vienna pattern book (Scheller 1963, figs. 90–92). This may indicate that the heads are based on a common source or that one was copied after the other.

The high quality of this drawing suggests that it was executed in a major artistic center. The influence of the French Gothic style is strong and immediately recognizable. The formalization suggests a closer kinship with western European art than with the art of Central Europe (with the Krumlow Madonna [Kunsthistorisches Museum, Vienna; Cologne 1978, vol. 3, v. 2686] and the Hasenburg Missal [Nationalbibliothek, Vienna; Stange 1958, vol. 9, fig. 254]). Thus its origin is to be sought in the areas whose art may have been touched by the French influence, that is, in the Rhenish regions.

T.G.

Swiss Master, c. 1450
Madonna and Child with Saint Paul

33
Swiss Master, c. 1450
Madonna and Child with Saint Paul
Pen and black ink with gray washes; 180 x 274 mm (7¹⁄₁₆ x 10¾).
Provenance: Esterházy (Lugt 1965); inv. 15.
Literature: Hugelshofer 1928, 14, 25, pl. 4; Fischel 1950, 113,
pl. 13; Stange 1951, vol. 4, 42, fig. 61.

The combination of the Madonna and Child with Saint Paul in one composition is unusual. The two blocklike adult figures, covered by opulently draped cloaks, appear distinctly separated from the background. The landscape in the distance is marked only with very delicate pen strokes; the artist's main concern seems to have been with the plastic and material rendering of the figures. An unusually forceful silhouette effect is achieved through the strong modeling of the simplified shapes. The draftsman modeled the heads with dots of varying intensity, while the broken and angular form of the Madonna's garment is constructed from a web of dense, parallel pen lines. A network of tiny, intertwined hooks was used for the figure of Saint Paul, creating fine tonal gradations and achieving a softer texture than that of the Madonna figure.

The regularity of the pen strokes implies that the master was an able engraver and keenly interested in experimenting with the expressive possibilities of various line-engraving techniques. The modeling of the figures is strengthened through the contrasting airy landscape in the background, showing a lake surrounded by hills and mountains.

For a long time the drawing was attributed to an unknown artist in the circle of Konrad Witz (1400/1410–1444/1446) (Lehrs 1908, 68, n. 3). During his wandering years, Witz perfected his art through the observation of works by Jan van Eyck (1380/1400–1441) and the Master of Flémalle (first half fifteenth century). Witz followed the new trend toward a three-dimensional conception of space, forceful plasticity, and expressive motion, even more eagerly than his Swabian and upper Rhenish colleagues. The master of this sheet, however, had some clearly archaic tendencies that lead us to believe that he belonged to an earlier generation than Witz'. He may be the "Master of 1445," who worked in Konstanz and followed a new direction toward realism as did Lucas Moser (after c. 1390–1434) and Hans Multscher (c. 1400–1467).

T.G.

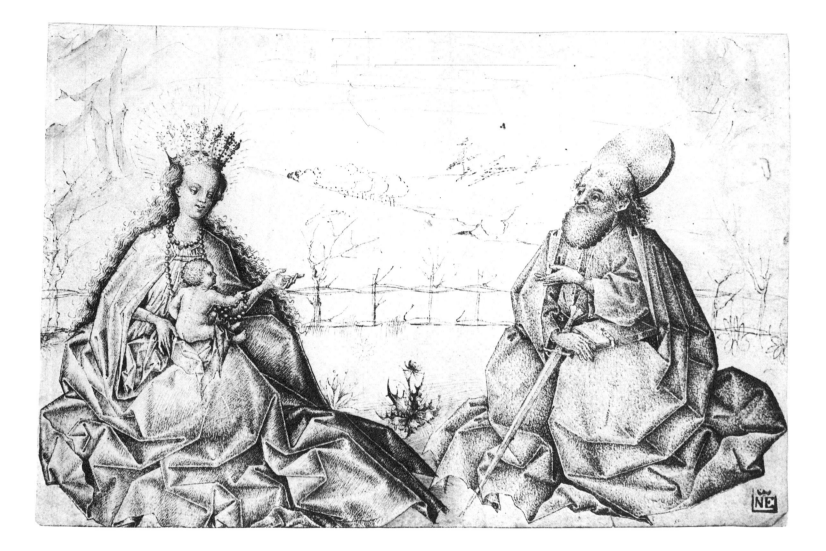

Nuremberg Master, c. 1480
Crucifixion

34
Nuremberg Master, c. 1480
Crucifixion
Pen and brown ink; inscribed on warrior's hat, *Absalom*
(in Hebrew); 368 x 282 mm (14½ x 11¹⁄₁₆).
Watermark: Cluster of grapes (Briquet 13036).
Provenance: Praun; Esterházy (Lugt 1965); inv. 4.
Literature: Schilling 1929, 8, 25, pl. 2; Nuremberg 1971, no. 103.

This Crucifixion is an outstanding work of Nuremberg draftsmanship before Dürer. It is closely connected to the workshop of Hans Pleydenwurff (d. 1472) who drew his inspiration mostly from the works of the Flemish artist Rogier van der Weyden (1399/1400–1464). From the fourth decade of the fifteenth century the Netherlandish influence transformed German and especially Nuremberg art. German art students traveling abroad encountered and experimented with the new Flemish trend toward three-dimensional space and plastic form.

This sheet can be linked to a tradition of Calvaries painted in Nuremberg and also in remote places, which in their general scheme hark back to Flemish prototypes. The figures of Christ, Saint John the Evangelist, Mary, and the Magdalene demonstrate a knowledge of Rogier's art in their physical types, powerful sculptural quality, attire, and grouping.

Two paintings from the Bamberg shop of Pleydenwurff, one in Dinkelsbühl (Church of Saint George) and the somewhat later Löwenstein *Crucifixion* in the Germanisches Nationalmuseum, Nuremberg (Stange 1958, vol. 9, figs. 189–190), are very close to the Budapest *Crucifixion*. The grouping, gestures, and facial expressions are very similar. Alfred Stange pointed out that characteristics of paintings from the Bamberg shops included pointed chins, a lack of silhouette effects around the figures, and a strong sense of drama (Stange 1958, vol. 9, 88). As all those hallmarks appear also in the Budapest drawing, its master must have had strong ties to the Pleydenwurff circle.

The Budapest drawing seems much more free and airy than the aforementioned painting in Dinkelsbühl, dated 1450–1460. This is due not only to the summary rendering of the background, but also to the fact that the figures are given more space. This, however, would indicate that its dating should be placed later, perhaps in the 1480s.

The drawing's quality is well above that of the aforementioned paintings and shows closer Flemish ties as well. The inner drawing is more differentiated: fine lines and line groupings account for the softer forms. The rendering of the different textures is more sensual and the depiction of air and light is more successful than those in other contemporary drawings from Nuremberg.

T.G.

84

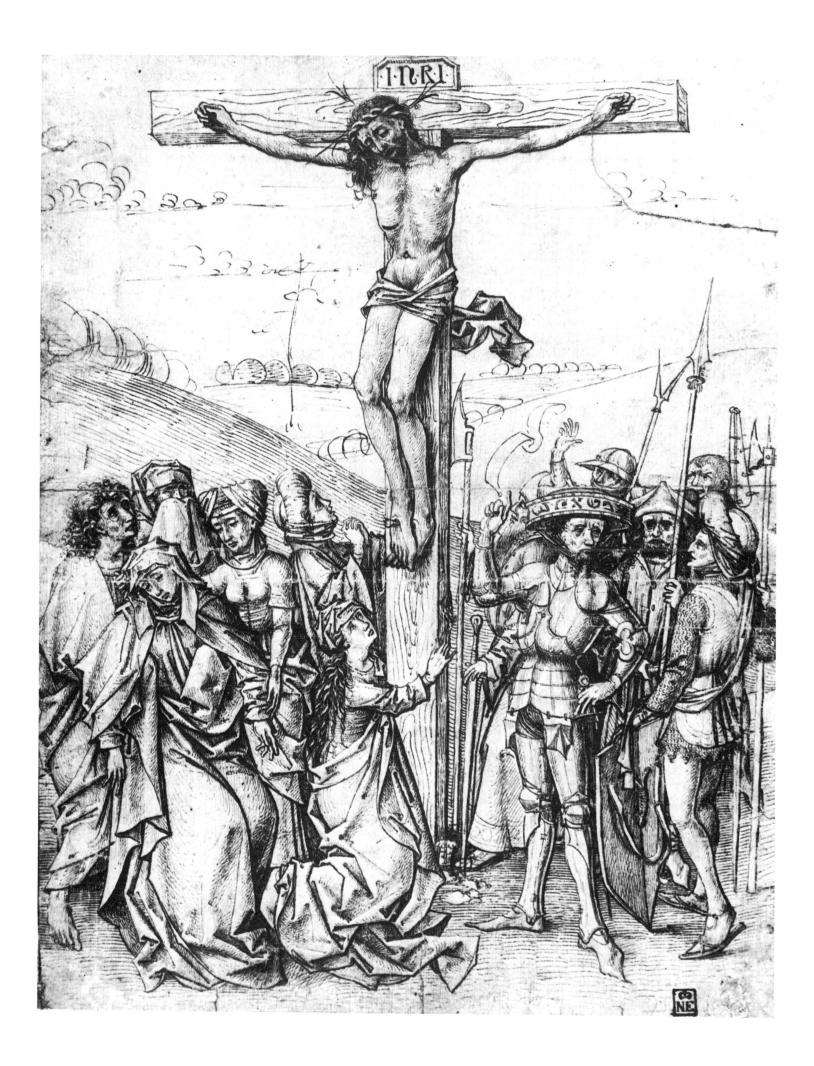

Albrecht Dürer
Lancer on Horseback

35
Albrecht Dürer
Nuremberg 1471–1528 Nuremberg
Lancer on Horseback
Pen and dark brown ink; inscribed with monogram below and
the date *1502* above; 272 x 215 mm (10¹¹⁄₁₆ x 8⁷⁄₁₆).
Provenance: Esterházy (Lugt 1965); inv. 75.
Literature: Winkler 1936, vol. 1, no. 255; Panofsky 1948,
no. 1669; Oettinger-Knappe 1963, 3, 15, 40, 93, nn. 100, 163;
Nuremberg 1971, no. 497; Strauss 1974, no. 1502/15.

The Budapest *Lancer* occupies a prominent place among
Dürer's horse and rider studies. Its elongated form recalls the
Galloping Rider of 1493 (British Museum) (Strauss 1974,
no. 1493/15), which is still based on the Gothic tradition, but
the puppetlike playfulness of the London horse is missing
here. The raised, slightly foreshortened head, expressive gait,
and lively figure of the rider prove that the artist had studied
nature. The horse and rider's realistic, bold formalization
gives evidence of the important change that took place in
Dürer's art from 1500 to 1505. To obtain a harmonic vis-
ualization, the artist used a compass not only to draw the
haunches of the animal but for the belly, chest, neck, and
back as well. He integrated the details with flexible outlines
into a perfect formal unit. The horse's musculature is indi-
cated with thin parallel lines going in many directions,
lending liveliness to the image.

The master started to show a strong interest in the
proportions of animals around 1500 when he met Jacopo
de Barbari (c. 1440–c. 1515) who was studying the problems
of ideal proportion. This interest received a new impulse in
1502 when, through his friend the noted humanist Willibald
Pirckheimer, Dürer met Galeazzo di San Severino, a cousin
of Leonardo's patron Lodovico Sforza (see cat. 3). Galeazzo
spent several months during the summer of 1502 in Nurem-
berg where he might have shown Dürer some of his pro-
portional or anatomical sketches by Leonardo. Though the
Budapest lancer was drawn during the same year, it still does
not reflect with certainty the knowledge of Leonardo's
studies; only in the later *Trotting Horse* from the Wallraf-
Richartz Museum, Cologne, can his influence be clearly seen
(Strauss 1974, no. 1503/28; Winzinger 1971, 17–18). But
there can be no doubt that the Budapest rider is in harmony
with Renaissance ambitions.

Until now the fact that the Budapest drawing is one of
the precursors of the famous 1513 print of *Knight, Death, and
the Devil* (B. 98) has been overlooked. Indisputably, the rider
on the 1498 watercolor (Albertina, Vienna; Strauss 1974,
no. 1495/48) comes closer to the engraving, but there the
animal remains static, whereas in the Budapest drawing and
in the print it is full of life and motion. In the Budapest
sheet we can seek the germ of Dürer's idea for the engraved
rider.

T.G.

86

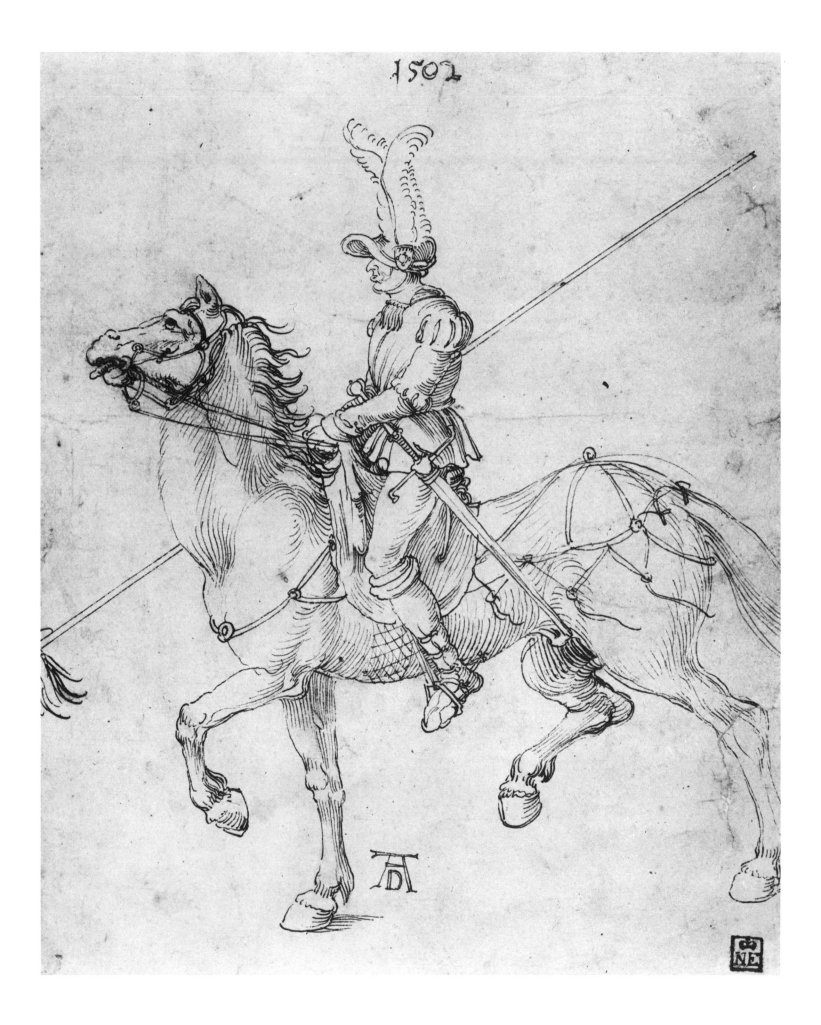

Albrecht Dürer
Various Sounds

36
Albrecht Dürer
Nuremberg 1471–1528 Nuremberg
Various Sounds
Pen and light brown ink; spurious monogram at upper middle
edge; 174 x 292 mm (6¹³⁄₁₆ x 11½).
Watermark: Cardinal's hat (similar to Briquet 3401).
Provenance: Praun; Esterházy (Lugt 1965); inv. 72.
Literature: Winkler 1938, vol. 3, no. 624; Panofsky 1948, no. 1471;
Strauss 1974, no. 1513/24.

The sketches on this drawing are related to one another only through the presence in each of a musical instrument. Many futile attempts have been made to find the meaning or intended purpose of this sheet. Only its style and subject matter, which indicate affinities with the marginal illustrations in Emperor Maximilian's (ruled 1493–1519) prayer book of 1515, can be pinpointed (Staatsbibliothek, Munich; Strauss 1974, no. 1515/45). On the verso of page fifty-six is a fool playing a wind instrument (recorder); that figure is similar to the figure at upper left in this drawing. On the recto of page fifty-two (Strauss 1974, no. 1515/40) are a bird with open wings, a satyr playing Pan's pipe, and a stout man. The latter figure has been thought to be a Saturn Devouring His Child, but he must represent another figure as he holds not a human body but rather a bagpipe resembling a jester.

Dürer prepared many drawings for the various decorative projects ordered by the emperor between 1512 and 1515 for the prints of the Triumphal Arch as well as for the aforementioned prayer book. An abundance of motifs, drawn from both fantasy and reality, merge into representative decorations in a worldly spirit. All those drawings, including this one, display a new side of Dürer's art through firm, clear, light-filled forms and a decorative, pleasing manner. The master often reworked traditional motifs or those of his own invention for later use in his works. Birds and satyrs appear on several drawings from this period. Certain faces reappear often; the sharp profile of the fool pushing a cart in this example is almost identical to that of the schoolmaster in a drawing from the Uffizi (Strauss 1974, no. 1515/65). The Budapest sheet can be placed among the works executed in c. 1515. It may have been made as a gift; because of the careful execution it appears to be a self-contained work of art.

T.G.

Albrecht Dürer
Saint Anne with Virgin and Child

37
Albrecht Dürer
Nuremberg 1471–1528 Nuremberg
Saint Anne with Virgin and Child
Pen and dark brown ink; 232 x 169 mm (9⅛ x 6⅝).
Provenance: Praun; Esterházy (1965); inv. 76.
Literature: Winkler 1936, vol. 1, no. 222; Panofsky 1948, no. 725;
Oettinger-Knappe 1963, 5, 93, 22, n.; Nuremberg 1971, no. 727;
Strauss 1974, no. xw.222.

The cult of Saint Anne, which originated in the Middle Ages and sought to popularize the notion of her Immaculate Conception, reached its peak from the end of the late fifteenth until the second half of the sixteenth centuries (see Grote 1969, 78; Kleinschmidt 1930). In the decades around 1500 most Northern representations were divided into two main types, seated or standing compositions (Kirschbaum ed. 1973, 185–187); Dürer's drawing is of the latter type. In keeping with her subsidiary role, Mary appears disproportionately small next to the monumental Saint Anne holding the Child.

The unified group of three intimate, expressive figures appears before a flat, decorative landscape. The careful, evenly executed drawing technique indicates that this is a mature stage, a final concept for Dürer's composition. The clearly delineated, fine contours and the economic use of shading establish the silhouettes of the figures. All these are characteristic elements of preparatory drawings for stained glass. Dürer's drawing was done for a portion of the window in the Sebaldus church in Nuremberg, dated 1515 (still extant). The Pfinzing family of Nuremberg commissioned the large project, the first such major Renaissance one of its kind in that city, consisting of thirty-two sections of stained glass. Dürer prepared not only the drawings but the cartoons too, and the workshop of the elder Veit Hirschvogel (1461–1525) executed the windows (Hirth 1908, pls. 69–70).

Only one of the cartoons is still extant and is now in Leningrad (Nuremberg 1971, no. 731). The Saint Anne composition was used again later, in 1522, when a window was placed in a chapel of the Saint Gumbert church in Ansbach (Röttinger 1926, pl. 48).

The Budapest drawing must have been produced much earlier than the Sebaldus stained glass windows, however. A drawing of a Madonna and Child in London, dated 1503 (Strauss 1974, no. 1503/19), and several sheets from the *Life of the Virgin* woodcut series (B. 83, 87) offer close similarities, which suggest a date for the Budapest drawing of 1502–1503. This dating is supported also by a woodcut that appeared in 1503 in a publication, the *Salus Animae* (Dodgson 1909, pl. XIII, fig. 89), which is a reduced studio version of the Budapest drawing. Dürer regarded his drawings as self-contained works of art, carefully preserving them and sometimes utilizing them much later for new projects. During the first years of the sixteenth century the earliest experiments in the synthesis of the late naturalist Gothic tradition and the results of the Italian Renaissance left their mark on his drawing style. We can see here Dürer's effort to arrange details based on the observation of nature in a cohesive unit. Thus the ample garments fall only occasionally into playful creases, while the long folds of the fabric lend a marked majesty to the figures.

T.G.

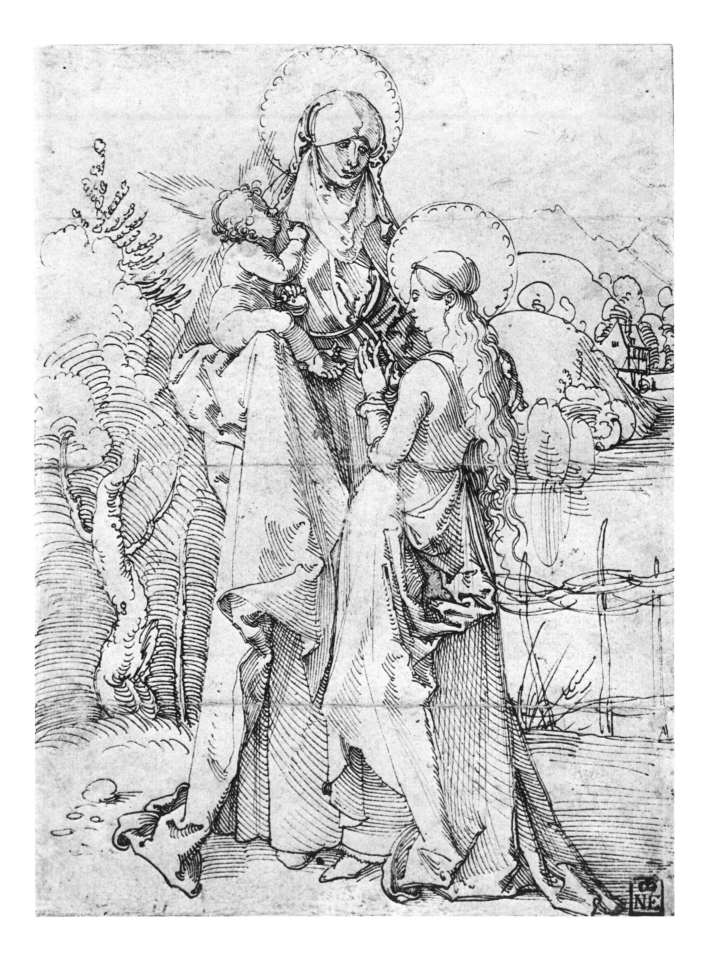

Hans Baldung Grien
Christ with the Instruments of Torture and a Donor

38
Hans Baldung Grien
Schwäbisch-Gmünd 1484/1485–1545 Strasbourg
Christ with the Instruments of Torture and a Donor
Pen and gray ink; 282 x 199 mm (11¹/₁₆ x 7¹³/₁₆).
Provenance: Praun; Esterházy (Lugt 1965); inv. 36.
Literature: Koch 1941, no. 5; Oettinger-Knappe 1963, 7, 8, 48, 54, 59, 68, 85, 92, nn. pp. 38, 77, 94, 96, 101, 189, and no. 17, fig. 68.

Hans Baldung Grien joined the Dürer shop in Nuremberg in 1503, at the age of eighteen. He worked there with Hans von Kulmbach and Hans Leonhard Schäufelein until Dürer's trip to Venice in 1505. Dürer allowed his collaborators considerable independence in painting as well as in preparing woodcuts and stained-glass windows. After 1500 he generally entrusted all the stained-glass work to Baldung, having observed the young artist's remarkable gifts for that type of work. The Budapest drawing of *Christ with the Instruments of Torture* might have been a design for a small glass panel, dating from 1503–1504. It was probably commissioned by the Scheurl family of Nuremberg, for the kneeling donor at left is the famous juror and humanist Christoph Scheurl as a young man. (Scheurl can be identified from a portrait formerly attributed to Lucas Cranach [Hoffmann 1935, 139–140, fig. 2]. The rosary beads in his hands indicate a series of prayers venerating Mary [Künstle 1926, 638].)

The Budapest drawing is the earliest among Baldung's numerous representations of this theme. The suffering Christ and the instruments of his torture (the cross, lance, sponge fastened on a reed, whip, scourge, and crown of thorns) were meant to inspire deep religious meditation on the Passion (Berliner 1955, 35). The main figure may have been inspired by Dürer's print of the *Suffering Christ* (B. 20; c. 1500), in which the muscular upper torso, short legs, straight nose, and chiseled features resemble those in the Budapest drawing. Here, though, the artist turned the body in three-quarter profile in a pose he favored for standing figures, with one leg turned slightly outward and the other bent. This motif might also have been borrowed from Dürer, as can be observed on the Saint Eustachius painting in Munich (Alte Pinakothek), dated 1498, showing a similar motion but lacking such accentuated contrapposto.

The Budapest drawing represents a significant step in Baldung's development, for in this work the nude figure and the pose of the leg described above appear for the first time. This pose would often be used later by the artist, as in the woodcut of the *Martyrdom of Saint Sebastian* (B. 36; 1512).

Baldung's use of the late Gothic formal devices of the flapping loincloth and the playfully snaking streamer (*Spruchband*) indicates the importance of decorative quality in his art. This is equally expressed in the fine, wirelike contour lines that surround the subjects with ornamental beauty. The short parallel strokes used to shape the inner structure also show ornamental forms and have an intrinsic purpose: to establish highly effective contrasts with the empty white patches of paper that themselves make decorative forms. All of these characteristics prove that despite Dürer's presence during his Nuremberg years, Baldung developed his own personal artistic style early.

T.G.

Hans Springinklee
Judith and Holofernes

39
Hans Springinklee
(?) Nuremberg 1490/1495 – c. 1540
Judith and Holofernes
Pen and dark brown ink; 291 x 420 mm (11⁷⁄₁₆ x 16⁹⁄₁₆).
Provenance: Esterházy (Lugt 1965); inv. 257.
Literature: Schönbrunner-Meder, no. 220.

As a member of the younger circle of Dürer followers, the "Kleinmeister" Hans Springinklee mainly produced woodcuts—independent sheets as well as series of Bible and prayerbook illustrations. With Dürer he participated in only one project: he cut several sections, among them six battle scenes, for the woodcut series of the *Triumphal Arch of Maximilian I* (Vienna 1885–1886, figs. 19, 20, 25, 26). The Budapest page relates to these and probably served also as a design for a woodcut.

Springinklee depicted two scenes from the Old Testament story of Judith within one picture, according to medieval tradition. The artist selected a high horizon and high vantage points, and the space is fairly shallow. The events are shown in sequence, moving from background to foreground. In the background at left the widow Judith from the besieged town of Bethulia and her servant are shown in the barricaded wagon camp of the Assyrians, standing before a splendid tent. They hide the severed head of Holofernes, the enemy leader, in a sack. In the foreground the results of Judith's heroic deed are visible: the starving defenders of

Bethulia, after having displayed Holofernes' head on a pole on a tower, drive the frightened Assyrians from their camp.

The composition is similar to the battle scenes Springinklee executed for the woodcut series of the *Triumphal Arch of Maximilian I*: in the spatial concept of the hill, the two groups of clashing troops with their rhythmically distributed masses of lances, the enormous and effective empty spaces created by the banner, and the details of dress, armor, and hardware. The drawing is closely related to two woodcuts in the so-called *Beschlossen Gart* (Hirth 1881–1890, vol. 2, nos. 639–640), a combined effort of the book illustrators in the earlier Dürer circle. They also show two scenes from the story of Judith on each cut. The Budapest sheet conforms stylistically with the works of the Dürer circle, though certain elements—the row of trees framing the background or the somewhat theatrical grouping of the houses—refer to its connection with the Danube School (see cat. 43). The balanced composition and liveliness of this drawing lead us to consider it one of Springinklee's most successful works.

SZ.B.

Jörg Breu the Elder
The Story of Lucretia

40
Jörg Breu the Elder
Augsburg c. 1475–1537 Augsburg
The Story of Lucretia
Pen and black ink and slight gray washes on blue paper;
inscribed on the frieze, *Der Erben Frauen Lucretia Gschit*; color
indications on the garments of the left group; 213 x 312 mm
(8⅜ x 12¼).
Provenance: Praun; Esterházy (Lugt 1965); inv. 62.
Literature: Benesch-Buchner [n.d.], 370; Beenken 1935, 65, fig. 1.

The compositional sketch by the Augsburg painter Jörg Breu the Elder is for a painting finished in 1528 (Alte Pinakothek, Munich). Inspired by the Italian Renaissance, it is one of his most balanced works. The composition was ordered by Prince William V of Bavaria (reigned 1579–1597) for his Munich residence, along with works with subjects drawn from classical history, painted by different masters.

Early in his career Breu painted dramatic works full of movement and with grotesque figures, but around 1520 there was a noticeable change in his art that resulted in a merging of late Gothic conventions and the lessons of the Italian Renaissance. In this drawing the artist clearly strove toward a clear composition and a festive effect. Despite the drama of Lucretia's story, the theatrical postures and gesticulations are quiet and calm. Breu was influenced by Hans Burgkmair's (1473–1531) works as well as by those of Italian artists. The open hall and the square in the background surrounded by houses suggest a fifteenth-century Italian scene and a profound knowledge of the laws of perspective. (A copy by Breu [British Museum, London; Dodgson 1916, 183] after a print by Girolamo Mocetto [c. 1458–1531] of the *Calumny of Apelles* exhibits a similar architectural space.)

Unlike other sixteenth-century artists who treated the subject of Lucretia, Breu depicted her not only as a symbol of purity and fidelity and showed not only the dramatic moments of the violence committed against her person (Pigler 1974, 403–408, 435–437; Stechow 1951, 114). Following the fifteenth-century Italian narrative tradition and looking also to *cassone* panels (Schubring 1923), he described in many scenes the entire tragic story of the unfortunate Roman woman, referring also to the historic consequences of her rape and subsequent suicide. The suicide, committed in 510 B.C., led to the exile of Tarquinius and (according to Titus Livius) to the birth of the Republic of Rome. Breu depicted five events on this sheet: the violence, the suicide, the oath of revenge, the funeral, and Brutus' speech. The artist emphasized two of the five scenes: at left, surrounded by relatives, Lucretia plunges the dagger into her heart; at right the men gather around her corpse, swearing to avenge her death. Breu just hinted at the other three scenes connected with the tragedy: at the left edge, between two pillars, Lucretia is shown in bed, while only the back of a man, the king, Sextus Tarquinius, is visible. The funeral and Brutus' speech condemning the king are only sketchily indicated in the background. The figures in the foreground, decoratively attired, are energetically drawn but not carefully detailed. The clear, simple contours and the bold shadings testify more strongly to the painter's approach to Italian formalism than the finished, somewhat uneasy picture in Munich.

T.G.

Hans Burgkmair the Elder
Thetis Taking Achilles to the Island of Skyros

41
Hans Burgkmair the Elder
Augsburg 1473–1531 Augsburg
Thetis Taking Achilles to the Island of Skyros
Pen and gray ink with white heightening on gray prepared paper;
dated at left middle edge, *1518*; 205 x 150 mm (8¹⁄₁₆ x 5⅞).
Provenance: Praun; Esterházy (Lugt 1965); inv. 305.
Literature: Gerszi 1956, 137–142; Winzinger 1967, 18, fig. 9.

Burgkmair, the leading master of the Augsburg Renaissance, produced a large graphic oeuvre, mostly for Emperor Maximilian I (reigned 1493–1539). Unfortunately, very few of his preparatory drawings for woodcuts have survived. The emperor, wishing to strengthen and extend the influence of his family, commissioned a genealogical study of the Holy Roman emperors that included a family tree reaching back to the Trojans (see Laschitzer 1888). This rather romantic and self-aggrandizing research served the imperial family and their ambitions well, and also caused a resurgence of interest in the Trojan legends as is proved by a number of publications from that time (Muther 1884, 285). E. Tietze-Conrat has shown that the Budapest drawing illustrates a scene from the *Historia Trojana* by Guido da Columna: Thetis and her attendant, with Achilles sewn into a sack, are being taken by dolphins to the island of Skyros where Thetis will hide the child, disguised as a girl, so he can escape his predicted hero's death (Tietze-Conrat 1923, 411–412).

The German fifteenth-century illustrations showing Thetis and her companion seated on dolphins gave only a starting point to Burgkmair. He drew elegant, standing female figures whose balanced proportions, floating gar-ments, and lively movement reflect his own Italianate taste. This same taste is evident in Burgkmair's woodcut illustrations for the romances *Theuerdank* and *Der Weisskunig.* Our drawing seems even more painterly due to the very popular German Renaissance drawing technique combining dark pen and ink lines and brilliant white heightening on prepared paper. Few drawings by Burgkmair in this technique are known, though it would have been well suited to the decorative leanings of his artistic temperament. His art seems to have developed from the German late Gothic style in the direction of the gay and glowing Venetian and Ferrarese Renaissance.

The imperial commissions not only brought him into close contact with German humanist circles but also influenced the direction in which his art developed. In those representational works he turned more and more consciously toward the new achievements of Italian art. These courtly representations, the humanist erudition, and the effects of the splendor of the Italian Renaissance left their mark also on this drawing, which fits in well with the works inspired, directly or indirectly, by Maximilian's commissions.

T.G.

Lucas Cranach the Elder
Saint George

42
Lucas Cranach the Elder
Kronach 1472–1553 Weimar
Saint George
(verso: *Three Heads and the Head of Medusa*)
Pen and gray ink with brush and white gouache on gray
prepared paper (verso: pen and brown ink); 214 x 99 mm
(8⁷⁄₁₆ x 3⁷⁄₈).
Provenance: Praun; Esterházy (Lugt 1965); inv. 70.
Literature: Fenyö 1954, 44, fig. 24; Rosenberg 1960, 35, no. A 3;
Schade 1974, 378 n. 95; Basel 1974–1976, vol. 1, 51, 758 n. 90,
fig. 14.

This drawing, made in c. 1505, dates from a period when a great change took place in the life and art of Lucas Cranach. After a six-year sojourn in Vienna during which his art was characterized by harsh, grotesque forms, he accepted the invitation of the Elector of Saxony, Frederick the Wise, to move to Wittenberg as court painter. His voyage there took him through Nuremberg whose artists (particularly Dürer) influenced his *Saint Catherine Altar* of 1506 (Gemäldegalerie, Dresden; Schade 1974, fig. 33), his woodcut of *Saint George* (B. 67), and the drawing in Budapest. In the latter work, the stance of the saint, the carriage of his head, and the position of his feet all indicate a definite familiarity with Dürer's *Paumgärtner Altar* (just before 1500) (Alte Pinakothek, Munich). In fact, Cranach selected his model for Saint George from this work. He took not Dürer's elegant Renaissance figure of the saint but the somewhat more Gothic figure of Saint Eustachius. Instead of employing Dürer's plasticity, however, Cranach used a decorative, painterly solution that resulted in a completely original work of art, despite the obvious debt to Dürer. In the Budapest drawing, the white highlights, applied with a brush, create patches that dominate by their almost vibrating effect. They also provide painterly contrasts to the dark pen strokes and the gray ground. The drawing of the gleaming armor offers the same decorative impression as the depiction of the dragon, which seems to melt into the figure and the orna-mental character of the outlines. This drawing of c. 1505 is a transitional work between the Viennese and Wittenberg periods. The execution of the drawing and the head types further relate to earlier drawings, as well as to other examples executed on colored prepared paper from the years 1503–1504, such as *Saint John the Baptist* in Lille and the *Saint Martin* in Munich (Rosenberg 1960, nos. 4, 5). These two saints also show faces with stump noses, heavy lips, and curly hair—all characteristics of Cranach's Vienna years. However, there is something new in this drawing: a sober and reserved inner expression and a calmness that point to an important, imminent change around 1505–1506. In his early tenure as court painter at Wittenberg, he adopted a special style to suit official requirements marked temporarily by the influence of Dürer. This is most clear in the artist's woodcut of *Saint George* in which he combined the spirit of medieval chivalry in the Saxon court and Renaissance self-consciousness. The veneration of Saint George had been encouraged when Emperor Frederick III (reigned 1440–1493) founded the Order of Saint George in 1468–1469 in response to the Holy War being waged against the Turks and when Maximilian I (reigned 1493–1519) created the Fraternity of Saint George and the Saint George Society in 1503 (Basel 1974–1976, vol. 1, 62). The Budapest drawing seems to be the first work in Cranach's oeuvre to express the knightly idealism of the court.

T.G.

Albrecht Altdorfer
Sarmingstein on the Danube

43
Albrecht Altdorfer
Regensburg c. 1480–1538 Regensburg
Sarmingstein on the Danube
(verso: *Studies of a Tree and Two Female Heads with Pen Lines*)
Pen and gray ink; dated in upper middle, *1511*; inscribed on the
verso, *stos* (?) *den hans*; 147 x 207 mm (5¾ x 8⅛).
Provenance: Praun; Esterházy (Lugt 1965 on the verso); inv. 21.
Literature: Winzinger 1952, 27, 74, no. 28, pl. 28; Oettinger 1959,
42, 43, 47, 48, 66, 77, 79, 80, 133; Linz 1965, no. 67.

Around 1500 a new style of art centered on landscape developed in the Austrian-Bavarian Danube region between Vienna and Regensburg and around Salzburg and Innsbruck. It came to be known as the Danube School and was characterized by the use of landscape not only as a setting, but as the main theme and most important painterly component of the work of art. Its founders included the young Lucas Cranach the Elder in Vienna, Albrecht Altdorfer who worked in Regensburg, and Wolf Huber in Passau. The Budapest view of Sarmingstein deserves attention for two reasons: first, it is a pure landscape drawing and thus along with Wolf Huber's *View of Mondsee* from 1510 (Winzinger 1979, no. 15) is an art-historical milestone. Second, it is a landscape portrait and though not objective or topographically accurate, the principal structure of the land is clearly recognizable. Altdorfer may have traveled to Sarmingstein when he was seeking to commission the altar in Saint Florian; this sheet and its mate, the noted *Alpine Scene with Willows* (Albertina, Vienna; Winzinger 1952, no. 29) could have been produced during that trip. The vantage point is well above water level which shows that the work was not done from nature but from memory. This is also confirmed by the fact that the gentle Danube mountains are most artistically transformed into steep, rocky peaks. By altering the scale of the landscape and creating dynamically stylized formations Altdorfer suggested the power of nature and its constant motion. Although the view is limited by the surrounding mountains, an impression of considerable depth exists due to the diagonally placed embankments. The varied small forms of the right bank symbolize "civilized" landscape, enhanced by man, and contrast effectively with the grim wilderness of the rugged mountains on the opposite bank. There are also noticeable contrasts between the pathos and large scale of the artist's conception of nature and the meticulous technique. Altdorfer's early paintings and drawings indicate that he may have first been trained in a workshop for book illumination: hence his calligraphic manner, clearly visible in this landscape. The outlines are not drawn in simple lines but in small hooks and vibrating zigzag lines of varying width. The even, regularly repeating line-work suggests a pulsating rhythm, while the nervous, zigzag lines of different heights express a dynamic energy.

T.G.

Historia Master
David and Abigail

44
Historia Master
active 1510s
David and Abigail
Pen and gray ink with white heightening on gray prepared
paper; dated at top center, *1514*; 214 x 155 mm (8⁷/₁₆ x 6¹/₁₆).
Provenance: Praun; Esterházy (Lugt 1965); inv. 27.
Literature: Winzinger 1952, 104, fig. 139; Benesch 1957, 130,
no. 15; Oettinger 1959, 119–123, fig. 51; Linz 1965, no. 240;
Gerszi 1981, 148–149, fig. 1.

The drawing was first assigned to Altdorfer and then
considered a copy after one of his works, until Hermann
Voss (1907, 195–196) published the connection with an illu-
minated manuscript, the *Historia Friderici et Maximiliani*
(Haus-Hof und Staatsarchiv, Vienna; HS Böhm 24, sign.
B. 9). The oeuvre of this painter, though directly influenced
by Albrecht and Erhard (c. 1486–1561) Altdorfer, demon-
strates that he achieved an independent artistic personality.
Between 1514 and 1516 he produced the preparatory draw-
ings for the illustrations for Joseph Grünpeck's history of the
lives of Frederick III (reigned 1440–1493) and Maximilian I
(reigned 1493–1519) ordered by the latter; it served as a text-
book for the emperor's grandson, Charles V (reigned
1519–1556).

Only a few years younger than Albrecht Altdorfer, the
Historia Master, a temperamental personality, was inclined
toward a genrelike, narrative style that achieved an imme-
diacy of action, evident here. The lady dismounting from her
donkey presents a goblet to the knight, whose mount stops
short with stiffly planted forelegs. The theme has been prob-
lematic (it has been described as a "Knight and Lady,"
"Knightly Scene," or "Welcoming Scene") because the artist
has presented a biblical tale of David and Abigail with a
fairytale-like perception of the chivalrous world. The draw-
ing depicts the moment when Abigail tries to mollify the
furious, vengeful David with a gift, which follows traditional
medieval iconography (Aurenhammer 1959, 16–17).

Through its figures dressed in contemporary garments,
the drawing is related to Cranach's 1509 woodcut of David
and Abigail (B. 122), where both figures appear, as in this
drawing, without attendants and standing. During the late
Middle Ages David was considered a virtuous knight, one of
the "nine pure heroes" (*Reallexikon* 1954, 1110). During the
sixteenth century this interpretation of David had become
widely accepted. The glorification of the charitable, forgiv-
ing soldier-knight type in the beginning of the sixteenth
century served the interests of the bourgeoisie, which tried
to spread the idea of the value of civic virtue. Perhaps the
great diffusion of this theme in Northern art of the first half
of the sixteenth century is responsible for the existence of an
identical drawing in the Berlin print room (Oettinger 1959,
fig. 52).

T.G.

Wolf Huber
View of Urfahr

45
Wolf Huber
Feldkirch c. 1480–1553 Passau
View of Urfahr
Pen and brown ink; 133 x 148 mm (5 ¼ x 5¹³⁄₁₆).
Provenance: Praun; Esterházy (Lugt 1965); inv. 189.
Literature: Halm 1930, 2, 6, 7, 49, 56, 86, no. 11, fig. 2;
Oettinger 1957, 75, 77, 90, fig. 132; Winzinger 1979, no. 14.

Wolf Huber, court painter to the archbishop of Passau, was next to Altdorfer, the most prominent master of the Danube School. The two artists became acquainted early and influenced one another. Huber was the more innovative of the two in developing the rendering of space to a logical conclusion. Already in his works of c. 1510 he expressed the impression of deep, open space. His compositions exhibit not only a solid knowledge of perspective but also a skill in achieving illusionistic effect based on the juxtaposition of opposing elements.

Here he created an impression of airy vastness by contrasting the cumbersome roofs in the foreground at right with the small, meticulous motifs of the city view in the distance at left. The view of the bridge is interrupted by the roof of the house in the foreground, and through this narrowing of the distance between the spectator and the picture, the viewer feels a part of the pictorial space. At an early age, toward the middle of the first decade of the sixteenth century, Huber must have seen the results of contemporary northern Italian art; the works of Mantegna (1431–1506) in particular influenced the development of his depictions of

deep space (Oettinger 1957, 95–96). Dürer's landscape drawings, characterized by objectivity, also seem related to Huber's topographical pictures.

Huber probably passed by Urfahr, which lies opposite Linz on the Danube, during the trips he took while he was seeking altar commissions. Whether or not the drawing was done from nature or after earlier studies or sketches is open to speculation. Reduced to the bare essentials, the work is one of such masterly abstraction that it is difficult to imagine it was drawn from nature.

Franz Winzinger suggested that the sheet was cropped on all sides and that its format originally resembled his 1510 *View of Mondsee* in Nuremberg (Germanisches National-museum; Winzinger 1979, no. 15). In its concept of space as well as technique the Nuremberg sheet is close to the Budapest *View of Urfahr.* Both works are not only important examples of German but of European landscape art as well. Through their unified, monumental spatial concept, achieved through economy of line and the incorporation of patches of untouched paper, a new kind of art was born.

T.G.

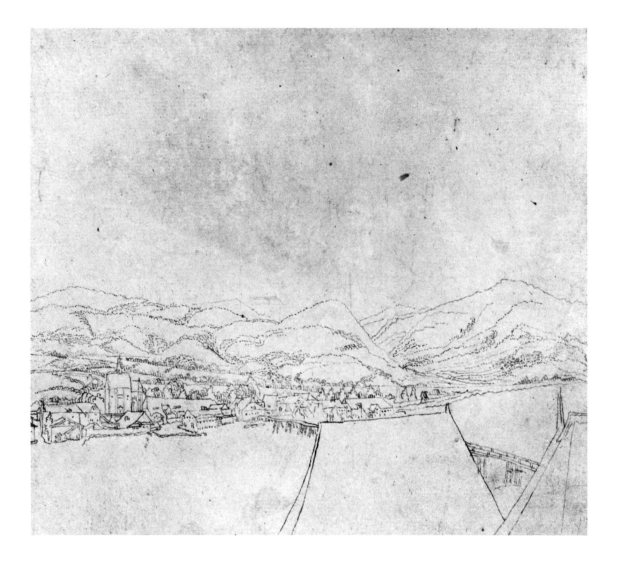

Wolf Huber
Landscape with Willows and a Mill

46
Wolf Huber
Feldkirch c. 1480–1553 Passau
Landscape with Willows and a Mill
(verso: *Head of a Man in Profile*)
Pen and brown ink; dated at upper right, *1514*; 154 x 208 mm
(6¹⁄₁₆ x 8³⁄₁₆).
Watermark: Fragment of crown (similar to Briquet 4902).
Provenance: Praun; Esterházy (Lugt 1965); inv. 191.
Literature: Halm 1930, 86, no. 13, fig. 6; Oettinger 1957, 31;
Winzinger 1979, 31, no. 23.

In 1514 Wolf Huber traveled through the region of the lower Alps, presumably while negotiating commissions for altar paintings. He probably produced this drawing and its pendant (also at Budapest; Winzinger 1979, no. 24), which are among his most remarkable sheets, during this trip. Other related works, some of them unfortunately known only through copies (Winzinger 1979, nos. 22, 24, 25, 26, 168, 169, 170, 171), probably belonged to the same sketchbook Huber used on the trip. The homogeneous group of nature studies is marked by the use of a low vantage point and simple, easily comprehensible compositions. These drawings differ greatly from Huber's early fantastic works and from those later ones in which reality and fantasy merge. His style is based on a novel approach to the observation of nature and on a selective, sparing use of objects. He was able to create an effective feeling of space without allowing the view to dissipate into the far distance.

Among the works in this sketchbook, some of which are revolutionary, the Budapest drawing seems to be the most daring. There is an attention to simple elements in the foreground, which are then integrated with the background. As in Huber's earlier drawings there is an impression of silhouetted elements but also a strong plasticity as well as an attempt to differentiate surfaces. The trunks of the willow trees, which are among the artist's favorite motifs, gradually diminish diagonally toward the rear, thus establishing a successful illusion of space while the bare, rising branches create a graphic latticework that barely suggests the continuation of the scenery. The somewhat meticulous, calligraphic rendering of the soil contrasts with the large-scale, energetic drawing of the branches, which through their dynamism build up a vehement rhythm—the forces that move nature. This drawing depicts the beauty and energy of vegetation, which constitutes the foundation of Huber's later landscape art in which the magnificence and vastness of the world are eloquently expressed.

T.G.

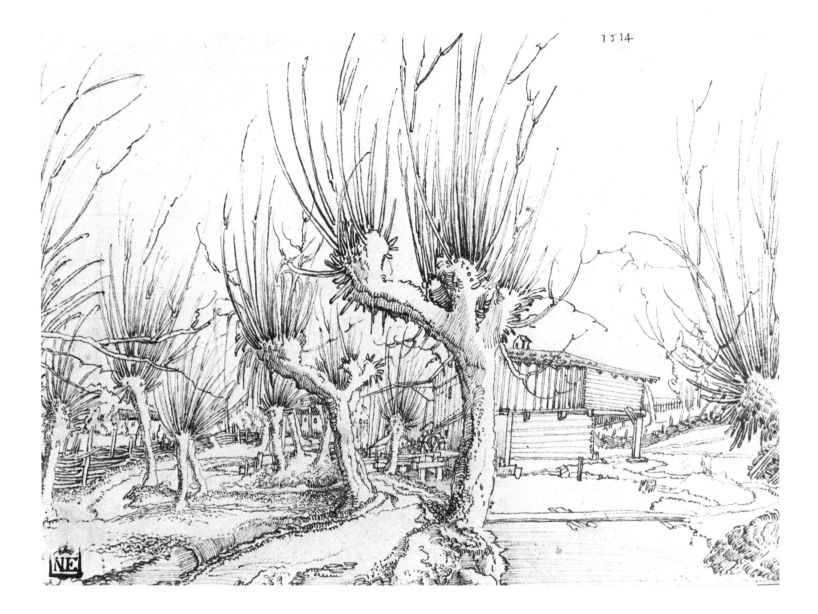

Wolf Huber
Tree Studies

47
Wolf Huber
Feldkirch c. 1480–1553 Passau
Tree Studies
Pen and brush and dark brown ink with white heightening on
prepared brown paper; dated at upper edge, *1519*; 219 x 162 mm
(8⁹⁄₁₆ x 6⅜).
Watermark: Fragment of crown (similar to Briquet 4902).
Provenance: Praun; Esterházy (Lugt 1965); inv. 25.
Literature: Winzinger 1979, 32, no. 63.

Around 1515 a marked leaning toward naturalistic repre-
sentation emerged in Wolf Huber's landscape art, while his
sensitivity to the rendering of vegetation also increased. The
outlines he employed in his earlier drawings seem ornamen-
tal, particularly those in the foliage, and only his renderings
of tree trunks show an attempt at realistic, plastic representa-
tion. In the Budapest *Tree Studies* he expresses the different
structure of plants and trees, all this indicating his profound
study of nature, in spite of a certain decorative stylization.

The drawing was catalogued as the work of Albrecht
Altdorfer in the Praun collection, and only recently Franz
Winzinger (1979) recognized in it the hand of Wolf Huber.
Through its theme, technique, style, and purpose, it is con-
nected to another Budapest drawing, dated 1517 (Winzinger
1979, no. 277), which was used for the *Christ Leaving Mary*
(1519; Kunsthistorisches Museum, Vienna; Winzinger 1979,
no. 277). The sheet of 1519, however, was not made for a
particular painting, but the character of its vegetation and the
technique utilizing small patches and hooks convincingly tie

it not only to the Vienna painting but also to the landscape
parts of the Anne altar in Feldkirch (Winzinger 1979, nos.
279, 286).

Huber first established the forms by applying the lead
white with the brush; only later did he reinforce certain
contours with the pen and dark brown ink, and outline single
leaves and entire sections of the foliage to enhance their
shadings and to produce plasticity through color contrasts,
thus ensuring a painterly effect. The foliage in his paintings,
indicated by a mass of dark, paler, and white patches, is so
close to that of the two drawings at Budapest that they must
be preparatory studies. This sheet is further characterized by
the massing of the various trees and shrubs on one plane. Only
the few brushstrokes in the far distance denoting mountains
produce a hint of depth, but no organic contact with the
vegetation is established. The tension created by the flat
decorative depiction of the trees and the mountains in the
background is strangely unresolved.

T.G.

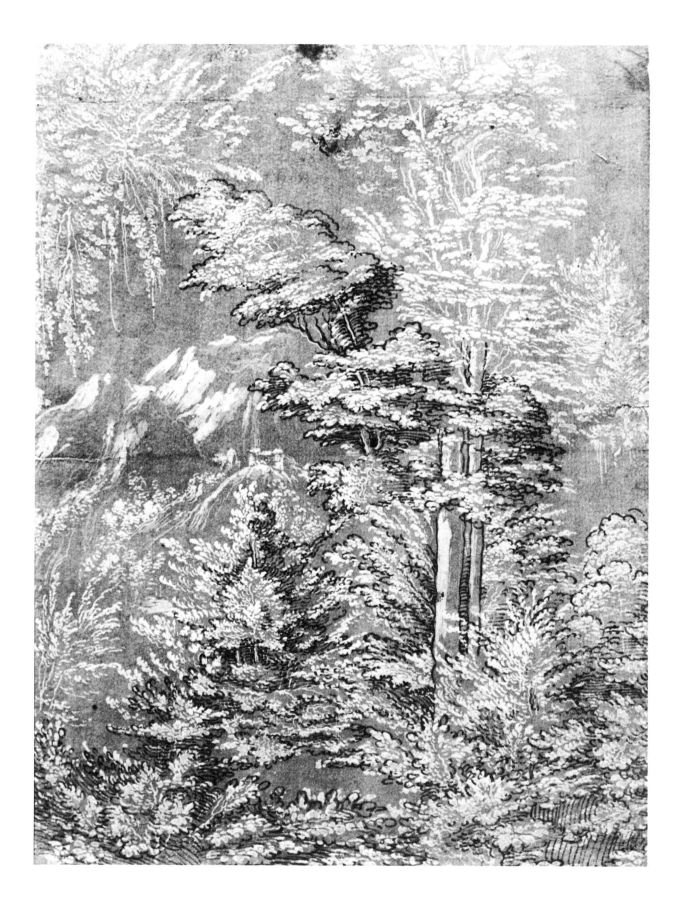

Hans Leu the Younger
Saint Jerome

48
Hans Leu the Younger
active Zurich c. 1490–1531 Gubel
Saint Jerome
Pen and dark gray ink with white heightening on brick-red
prepared paper; 171 x 253 mm (6¹¹/₁₆ x 9¹⁵/₁₆).
Provenance: Praun; Esterházy (Lugt 1965); inv. 307.
Literature: Gerszi 1955, 28–34, fig. 21.

Hans Leu's works are related in many ways to the art of
Dürer, Hans Baldung Grien, Albrecht Altdorfer, and Wolf
Huber. His travels between 1507 and 1513 brought him into
contact with the great German painters of his time: he may
have spent longer stretches with Dürer in Nuremberg and
with Baldung in Freiburg. But he was drawn more and
more toward the art of the Danube School developing in
the southwestern part of the Austro-Hungarian Empire,
because of the importance it gave to the observation and
representation of nature.

Here, Leu seems most concerned with the rocky land-
scape setting, while the venerable hermit saint is relegated to
the extreme right edge of the picture. Nevertheless, man and
nature appear harmonious and inseparable.

In the construction of space and in technique this
drawing differs markedly from the works of Altdorfer and
Huber in whose art space and air are the most important
artistic and mood-creating factors. Here the elements of the
composition do not observe the laws of perspective, yet this
uncertainty seems purposeful. Nor is Leu's technique at all
similar to the calligraphic drawing style of the aforemen-
tioned Danube School masters.

During his years in the Dürer shop, Leu developed a
solid, taut drawing style that remained with him throughout
his life. Artistic debts to Dürer and Baldung appear in
various details of the Budapest Saint Jerome sheet: the two
opposing cliffs and their foliage recall Baldung's woodcut of
c. 1511 (B. 35) and Dürer's *Saint Jerome* of 1512 (B. 113).
Leu made a copy of the latter print on the verso of a sheet
with *Tree Studies* (Germanisches Nationalmuseum, Nurem-
berg; Zink 1968, no. 137). However, this copy is not
faithful, because the figure and head in Dürer's print are
modified and in fact resemble those of the Budapest drawing.
At the time when this drawing was made, around the
middle of the second decade of the sixteenth century, signif-
icant changes occurred in Leu's oeuvre. Painterly elements
seem to have become more important, his drawing style
looser and more bold, and the use of color-grounded paper
more frequent. This evolution, which led to a completely
new phase, is noticeable in this drawing in the energetic
large-scale line-work in the trees and shrubbery as well as in
the unusual marriage of the brick-red ground and lead white
heightening, which offers an increased painterly effect.

T.G.

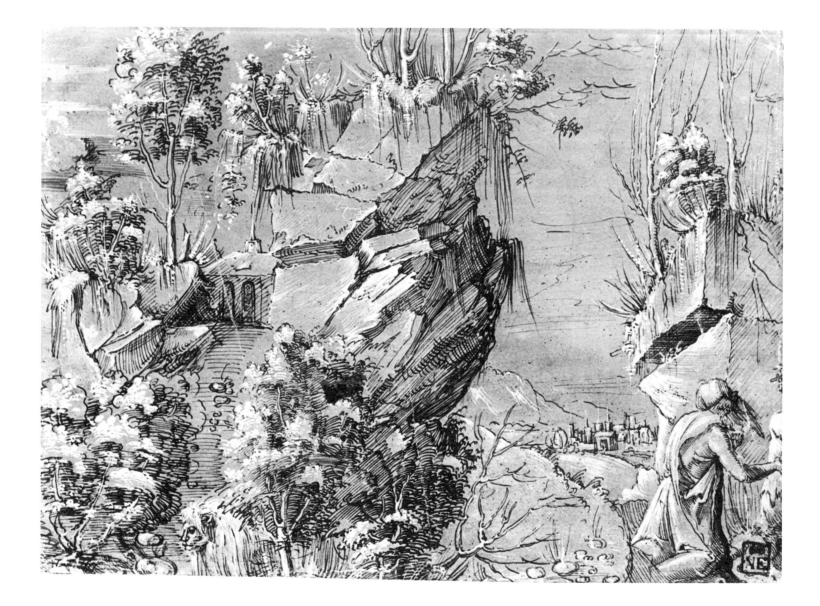

Augustin Hirschvogel
Fishing Party

49
Augustin Hirschvogel
Nuremberg 1503–1553 Vienna
Fishing Party
Pen and brown ink; 165 x 238 mm (6½ x 9⁵⁄₁₆).
Provenance: Praun; Esterházy (Lugt 1965); inv. 119.
Literature: Schwarz 1917, 207; Peters 1979, no. 54, fig. 31.

Augustin Hirschvogel, of the noted Nuremberg family of glass painters, became famous not only as a practitioner of this craft but also as a much-traveled map designer and, from 1544 on, as a printmaker in Vienna. In Nuremberg he absorbed the style of the artists of the Dürer circle and that of the draftsmen of the Danube School as well.

The fruit of Hirschvogel's Nuremberg years is the splendid and encyclopedic set of fifty-three pages of illustrations of the art of hunting. Hunting scenes were popular in Northern art of the early sixteenth century; Maximilian I (reigned 1493–1519) commissioned several. This collection, which is preserved at Budapest, consists of twenty-seven square and twenty-six circular compositions that describe numerous ways to capture or bring down wild boars, stags, and bears; how to hunt small game; and the art of falconry. Included also are scenes depicting festivities connected with the sport. Most subjects appear in two versions, the first a sketch in a square or rectangular format and the second in a circular and more carefully worked out one.

Because there are four glass roundels made from the preparatory drawings at Budapest (Schwarz 1917, 75–76; Peters 1979, fig. 22), we can assume that the set of hunting drawings was produced for a stained-glass project. Supposedly the roundels were partially completed by Hirschvogel. A fifth oblong stained-glass window (Peters 1979, fig. 27) with a hunting scene, probably a shop work, is also extant, but it is of inferior quality. Its importance lies in its date of

1537, which presents a *terminus ante quem* for the hunting series. The stained-glass panels were produced after the rectangular drawings, not after the splendidly finished circular ones, which were probably made somewhat later.

In this series Hirschvogel seems to have taken as his model daily life (he introduced a novelty, the hunting rifle) and by offering a great variety of activities, he has left us a significant document. The Budapest *Fishing Party* is probably the most developed example among the rectangular drawings; conceived and executed with brio, it is scarcely less finished than its round counterpart. This is the only pair of the entire series where women are depicted. They wear modish, elegant clothes and hats decorated with leaves as they stand in the river helping the equally well-dressed men catch crabs and lift the nets and drums.

The rhythmically placed clusters of figures and the decorative quality achieved by the calligraphic design of details such as vegetation, or even the playful flounces on the garments, are typical of preparatory drawings for stained glass. The dominant role of the landscape, the airy atmosphere, and the lively figures suggest that the influence of the Danube School is strongly felt. Moreover, certain motifs such as the trees and shrubbery point up Hirschvogel's connection with the Dürer circle. The figures in the foreground were borrowed by Jost Amman (1539–1591) for his woodcut of fishing (Hirth 1881–1890, vol. 3, no. 1348).

SZ.B.

Augustin Hirschvogel
Squirrel Hunt with Crossbows

50
Augustin Hirschvogel
Nuremberg 1503–1553 Vienna
Squirrel Hunt with Crossbows
Pen and dark brown ink; 247 x 254 mm, diam. of the drawing
236 mm (9¹¹⁄₁₆ x 10, diam. 9⁵⁄₁₆).
Watermark: Crown (Briquet 4979).
Provenance: Praun; Esterházy (Lugt 1965); inv. 111.
Literature: Schwarz 1917, 208; Peters 1979, no. 38.

Erroneously described by Karl Schwarz (1917) as a sparrow hawk hunt, this sheet and the preceding one (cat. 49) belong to the same series. The mistake was caused by the fact that the hunter's quarry is not shown. Jane S. Peters (1979) correctly identified the subject on the basis of the rectangular version of this scene where the same hunter points his bow at a squirrel.

In this small-scale drawing Hirschvogel attempted to create the illusion of a deep forest through the repetition of densely placed tree trunks, the tops of which are not visible. The vertical lines of the trunks and the diagonal ones of the branches are mirrored in the pronounced bend of the hunter's torso. Depth is achieved by an opening at left and by the diminishing tree trunks on the same side. The limited space and the round format of the drawing determine the placement of the three figures. The artist indicated the plasticity of the bodies and the gnarled trees with small, closely spaced, parallel pen strokes. The line-work in the spaces between the trees suggests the mystery and dimness of the deep forest. The admirable decorative solution of the line-work, as well as that of the curly foliage and the tiny hooks describing the trees' irregularities, are typical of preparatory drawings for stained glass, as are the strong contour lines and roundel format.

SZ.B.

Hanns Lautensack
Landscape with Bridge and *Landscape with Cross*

51
Hanns Lautensack
? Bamberg c. 1520–1564/1566 Vienna
Landscape with Bridge
(verso: *Landscape with Cross*)
Pen and brown ink on gray prepared paper (verso: pen and
black ink on gray prepared paper); signed at upper left *HSL* and
dated *1550* (verso: signed *HSL* and dated *1551*); 203 x 152 mm
(8 x 6).
Provenance: Praun; Esterházy (Lugt 1965); inv. 225.
Literature: Schmitt 1957, no. 84.

Lautensack dated and carefully executed both landscape drawings on this sheet. Annegrit Schmitt (1957) determined that it and its five companion drawings (also at Budapest) are from the same sketchbook of preparatory material for prints. Known as an engraver and designer of medals, Lautensack was above all a master etcher. Only three authentic drawings by him in addition to the seven compositions at Budapest are known. Lautensack worked in Nuremberg where he soon became a follower of the two great artists of the Danube School, Albrecht Altdorfer and Wolf Huber. Their influence can be detected not only in Lautensack's compositional solutions and drawing manner, but also in his borrowing of motifs, with slight variations, produced by the aforementioned masters between 1515 and 1525. In his earliest prints almost no changes were made to the borrowed models. But in the series of drawings at Budapest he exhibited a degree of independence. These are original, well-composed pictures in which the elements taken from Altdorfer and Huber harmonize with his own ideas.

Lautensack's early works were drawn from the imagination, and only later did he begin to create landscapes observed from nature. Among the Budapest sketchbook pages the *Landscape with Bridge* appears the least schematic, and its compact composition is pleasing to the eye. The scene is dominated by the monumental stone bridge and the fortresslike building above it. The monolithic effect of this heavy masonry structure is counteracted by gently caressing trees, fragile shrubbery, and playful waves executed in flowing pen strokes. The space is divided by the bridge and building into two planes connected by the bubbling, diagonally placed stream. Lautensack borrowed from a print by Altdorfer (B. 68), with only small changes, the distant landscape with mountains and a castle viewed through the arch of the bridge. The shaded arch seen from below recalls a painting by Altdorfer (Winzinger 1975, fig. 18) and drawings by Huber (for example, Winzinger 1979, fig. 42).

The *Landscape with Cross* on the verso follows even more faithfully the prototypes established by the Danube School: in contrast to the elevated section in the left foreground is a panoramic view of a mountain range in the background with a town on the banks of a river. (Compare to Altdorfer, *Rocky Landscape,* B. 69.) The drawing technique of the foreground contrasts strongly with that of the background: Lautensack treated the rough road and trees with passionate strokes of the pen, using quiet, slender lines to show the distance. Employing the varied tools of perspectival space, he successfully accentuated the depth of this image.

SZ.B.

Recto

Verso

Hans Hoffmann
Bullfrog, Bullfrog, Green Grasshopper, and *Cross Spider*

52a–d
Hans Hoffmann
? Nuremberg c. 1530–1591/1592 Prague

a *Bullfrog* (*Rana esculenta L.*)
Brush with opaque colors on vellum; 78 x 77 mm (3¹⁄₁₆ x 3).
Provenance: Praun; Esterházy (Lugt 1965); inv. 174.

b *Bullfrog* (*Rana esculenta L.*)
Watercolor with white heightening; 60 x 65 mm (2⅜ x 2⁹⁄₁₆).
Watermark: Fragment of a building with two towers (similar to Briquet 15942).
Provenance: Praun; Esterházy (Lugt 1965); inv. 181.

c *Green Grasshopper* (*Locusta viridissima L.*)
Brush with opaque colors on vellum; 55 x 78 mm (2⅛ x 3¹⁄₁₆).
Provenance: Praun; Esterházy (Lugt 1965); inv. 180.

d *Cross Spider* (*Epeira diademata L.*)
Watercolor with white heightening; dated *Aug. 30 1578*;
54 x 44 mm (2⅛ x 1¹¹⁄₁₆).
Provenance: Praun; Esterházy (Lugt 1965); inv. 175.

Hans Hoffmann, presumably born in Nuremberg, was the preeminent master of the so-called Dürer renaissance that occurred in Germany and The Netherlands during the second half of the sixteenth century (Kauffmann 1954, 18–60). Until he began a temporary court service in Bavaria in 1584, he lived in Nuremberg where he was able to study and copy Dürer's drawings. At the invitation of Dürer's great admirer Emperor Rudolf II (reigned 1576–1612), he left in 1585 for Prague where he worked until the end of his life.

Among the numerous extant works by Hoffmann there are many faithful copies after Dürer's drawings and watercolors as well as variations on the latter's works; he also produced assemblages of unrelated Dürer-like elements. Through his copies of Dürer's nature studies as well as through his own plant and animal drawings, Hoffmann ties into the mainstream of sixteenth-century scientific naturalism (Kris 1926 and 1927) that originated around 1550 as the result of the interest in the objective, faithful representation of nature. Also, the great sixteenth-century geographical explorations contributed to the strong interest in scientific studies. Rare and exotic plants were greatly coveted; for the possession of a precious or unknown specimen, owners of gardens would compete passionately. Interest in flora and fauna also burgeoned, resulting in increased efforts to classify and catalogue plants. Artists formed a bridge between the arts and sciences: they not only rendered the objects faithfully but at the same time classified them.

Joris Hoefnagel (1542–1600), commissioned by Emperor Rudolf II, designed a four-volume zoological study (*The Four Classes of the Animal World*) (Langemeyer in Münster 1979–1980, 28). Hoffmann's interest in animal and plant drawings was similar to Hoefnagel's. He found a rich source in Dürer's nature studies, which provided him with models that he then transformed according to his own taste into more contemporary naturalistic illustrations. Two frogs of the same species, but in different phases of development, are shown here, in painstaking detail, from different angles. This characteristic is evident in all four animal representations included here. The life-size reproduction of an object and the accuracy of shading and color were the criteria on which illustrations of this kind were judged. Hoffman used the larger of the two studies of frogs in another composition on vellum reflecting Dürer's influence (Pilz 1962, 259, fig. 8). The main animal in that work, a variant of Dürer's famous rabbit (Albertina, Vienna), is surrounded by a multitude of flowers, reptiles, snails, and insects. Hoffmann's sheet, dated 1582, represents rare plant speciments, one brought to Europe from Mexico after 1573 and another from Armenia. The arrangement, showing each item from an unobstructed and most advantageous viewpoint, is similar to that used in still lifes by other painters such as Ambrosius Bosschaert (1573–1621), Jacob Hoefnagel (1575–1630), and Ludger tom Ring the Younger (1522–1584) (Münster 1979–1980, figs. 1, 2, 7).

SZ.B.

a

c

b

d

Joseph Heintz the Elder
Allegory

53
Joseph Heintz the Elder
Basel 1564–1609 Prague
Allegory
Black and red chalks, incised with a stylus; 371 x 235 mm
(14⅝ x 9¼).
Provenance: Esterházy (Lugt 1965, 1966); inv. 82.
Literature: Gerszi 1958, 36–40, fig. 25; Stuttgart 1979, vol. 1,
no. B 21.
Color illustration: page 8.

Joseph Heintz, a Swiss painter and one of the most outstanding draftsmen of his time, spent a number of years in Italy and Prague as court painter to Emperor Rudolf II (reigned 1576–1612). This drawing was made in Prague in c. 1600. It seems to be a preparatory sketch, as the incised contour lines would seem to indicate, perhaps for a sculptural relief or for a work of applied art. For this meticulously finished drawing a sketch is known (Múzeum Narodowe, Gdansk) where the arrangement and movement of the figures are less clearly defined. Another elaborate and somewhat more expanded version of our drawing is in Vienna (Albertina; Benesch 1964, no. 101).

The subject of this drawing and of the related sheets remains unclear. The Budapest drawing may have been made on the occasion of the birth of a noble child. The celebrated infant, seated in the center of the composition, is surrounded by mythological figures who offer gifts and good wishes and represent happy and successful life. Following Josef Meder, Heinrich Geissler (in Stuttgart 1979) connected the figures on the right with the seasons. The male figure at right who wears a wreath of grape leaves and offers grapes to the child may be a Bacchus. A second figure at right wears a wreath of wheat and presents a plant to the infant; perhaps he symbolizes earthly prosperity. Below him Ceres, goddess of fertility, clutches the horn of plenty. The male figure in the foreground recalls the well known river-god type; he carries a platter with the gifts of the sea, which may indicate the region where this event takes place. At left, three intertwined female graces symbolize the three good deeds—giving, receiving, and rewarding (Wind 1958, 31–56)—that render life more pleasant and beautiful. In the Vienna version the three graces are presented in accordance with iconographic traditions: one is shown frontally, another from the back, and the third from the side. The woman, who could be derived from the statue of the "Kneeling Venus," probably represents Venus, goddess of love and beauty.

In addition to these references to classical figures, sixteenth-century Italian inspirations are abundant in the drawing: the sensuous female bodies evoke Correggio's art, the delicate and painterly modeling brings to mind Barocci (c. 1535–1612), while the outlines that softly caress the forms recall those in the works of Federico (c. 1540–1609) and Taddeo Zuccaro (1529–1566). The debt to Taddeo Zuccaro is affirmed by a comparison of the three graces with the back view of the woman (Ceres) who holds the horn of plenty in a drawing by Taddeo in the Louvre (Gere 1969, no. 170, fig. 110). Heintz incorporated these different tendencies into his personal style, characterized by a refined sense of form, sculptural modeling, rhythmic movement, and decorative outlines.

He achieved here an impressive array of exquisitely rich gradations of tones that show the sensuous beauty of the surfaces of the human body. The contrast between these effects and the forceful outlines heighten the painterliness of the drawing.

T.G.

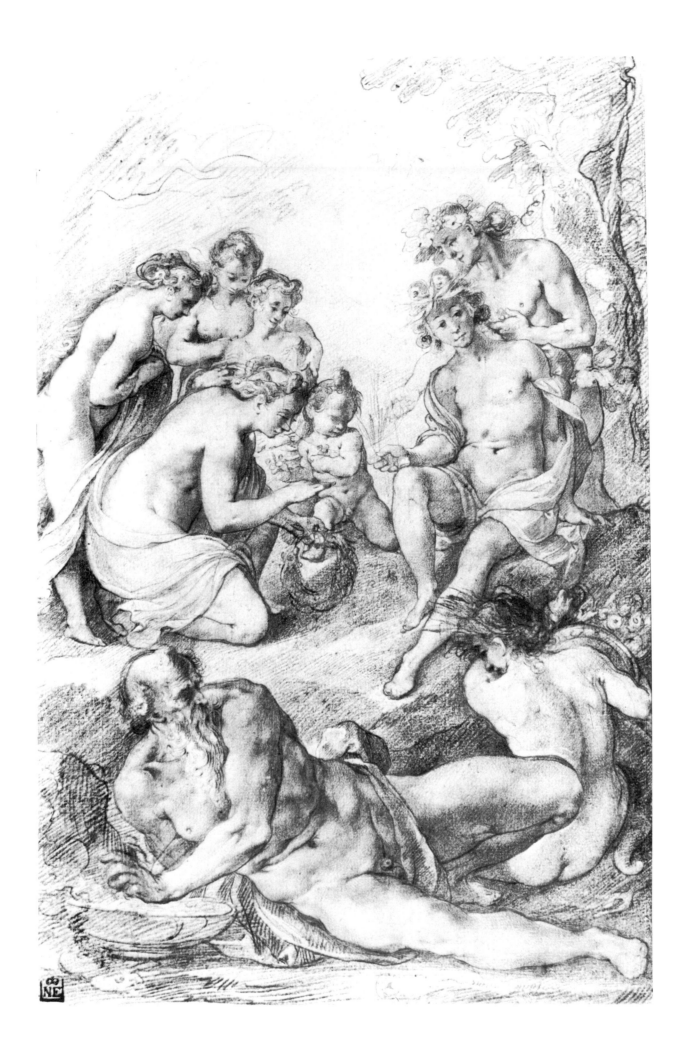

Matthias Gundelach
Jupiter and Callisto

54
Matthias Gundelach
? Kassel 1566–1654 Augsburg
Jupiter and Callisto
Pen and brush and brown ink and brown and blue washes over
red chalk with white heightening; signed and dated at upper right,
M. Gundelach F. 1613; 239 x 168 mm (9⅜ x 6⅝).
Provenance: Delhaes (Lugt 761); inv. 81.
Literature: Budapest 1963a, no. 85.

Gundelach was already working in Prague when, after Joseph Heintz' death in 1609, he was appointed court painter to Emperor Rudolf II (reigned 1576–1612). He was a faithful follower and assistant to Heintz. This drawing, which dates from the latter part of his Prague years, represents one of his favorite themes, the mythological love story. His imperial patron Rudolf II, keenly interested in the beauty of the human body and eroticism, seems to have preferred pictures representing the tender passions between gods and mortal subjects.

Callisto (follower of Diana, goddess of hunting) is approached by Jupiter, disguised as Diana, while she rests in a grove. The painter selected the moment from Ovid's *Metamorphoses* (417–445), when Jupiter begins his passionate assault. Here, contrary to the classical text and similar to other contemporary representations of the theme, Callisto does not struggle to defend herself. In the middle distance two female figures, Callisto's companions, beg her to join them; this episode is from another part of the story. The floating Mercury acts, as usual, as the messenger of love.

Gundelach arrived at a creative solution for the depiction of the two principal characters: the figure of "Diana" turns her back to us and leans with her right arm on the almost-recumbent nymph. The two figures form a wavy, entwined unit. The movement of Callisto's right arm, which opposes "Diana's" right, helps to integrate the two bodies. The contours surrounding the sinuous figures flow smoothly into one another.

The female types depicted by Gundelach, characterized by round faces, high foreheads, and wide-eyed expressions, reflect the influence of Correggio and Barocci. The figure of Callisto recalls one in the painting of *Venus and Adonis* by Heintz (Kunsthistorisches Museum, Vienna) while "Diana's" pose was inspired by a similar figure in another painting by Heintz, *Amor Taking Leave of Psyche*, in Nuremberg (Zimmer 1971, no. A 24, fig. 62, no. A 113, fig. 35). The sensitive, soft shading creates form and depth, and an almost rococo ease and dreamlike quality. Gundelach used only two colors in his washes, brown and blue, but in varied shades, with the addition of white heightening. Brown is the dominant color in the foreground where pen lines play forcefully, while in the distance blue washes are strongest and the forms are designated only with brushstrokes. The preparatory red chalk lines shine through the washes, adding greatly to the pictorial effect. The subdued palette with its refined colors is typically mannerist. Most such painterly, finished drawings in Gundelach's oeuvre are preparatory works for small paintings on copperplates.

T.G.

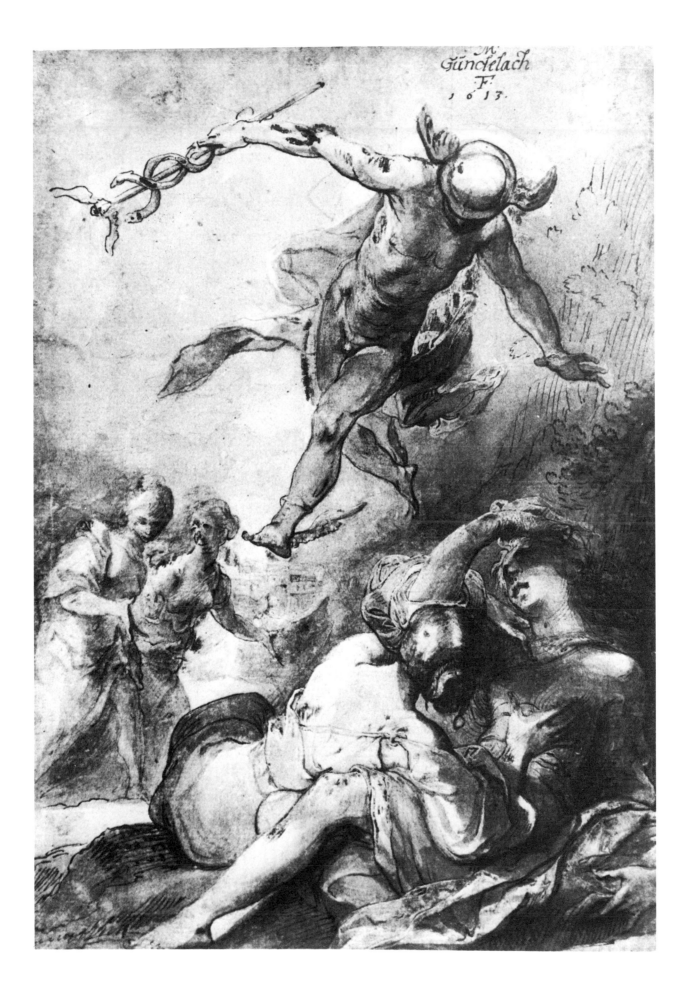

Hermann Weyer
Crucifixion

55
Hermann Weyer
Coburg 1596–after 1621
Crucifixion
(verso: *Christ Victorious over Evil*)
Pen and black ink and brown and gray washes with white
heightening on brownish paper (verso: pen and black ink);
267 x 201 mm (10½ x 7⅞).
Watermark: Flower in circle.
Provenance: Inv. 502.
Literature: Vienna 1967, no. 59.

Hermann Weyer, an important German mannerist draftsman about whom almost nothing is known, was from a family of painters in Coburg. His oeuvre was published by Hanna Mayer (1932), who established his authorship through the numerous drawings signed with the monogram *H E W*. He represented biblical, historical, or battle scenes in which events occur in landscape settings. Except for a few pure landscapes, figures dominate his drawings; the stylized landscapes are of secondary importance. Netherlandish mannerism strongly influenced Weyer's landscape inventions and his selection of types after c. 1610. From that moment on his concept of light and shade also became much more painterly. Most of his work bears witness to his knowledge of the art of Abraham Bloemaert (1564–1651); however, the Budapest *Crucifixion*, particularly in the use of chiaroscuro, seems to refer rather to a Judith and Holofernes (Benesch 1928, no. 461) by Paulus Moreelse (1571–1638).

Despite the symmetrical arrangement of the cross at center and the figures, the scene is very much alive. The slender figures of Mary and Saint John, their gestures quietly expressing deep suffering, step forward and turn toward the cross; while Mary Magdalene reacts emotionally to the event. Significant contrasts are present in the composition: the highlights on the four principal figures are achieved with lead white, while the deep shadows are denoted with dense, parallel pen strokes. Contrasts are also inherent in Weyer's handling of the figures' clothing: broad areas of clinging garments are played off against more decorative, windblown draperies. The reference to the wind, together with the stormy sky, confirms the tragedy of the event. The drawing was catalogued as the work of Bartholomäus Spranger (1546–1611) until Edith Hoffmann recognized Weyer's hand (note in Budapest card catalogue). This *Crucifixion* comes close to two sheets in Braunschweig that are dated 1613 and 1615 (Mayer 1932, pl. 16; Stuttgart 1979, vol. 1, no. E. 39, respectively).

SZ.B.

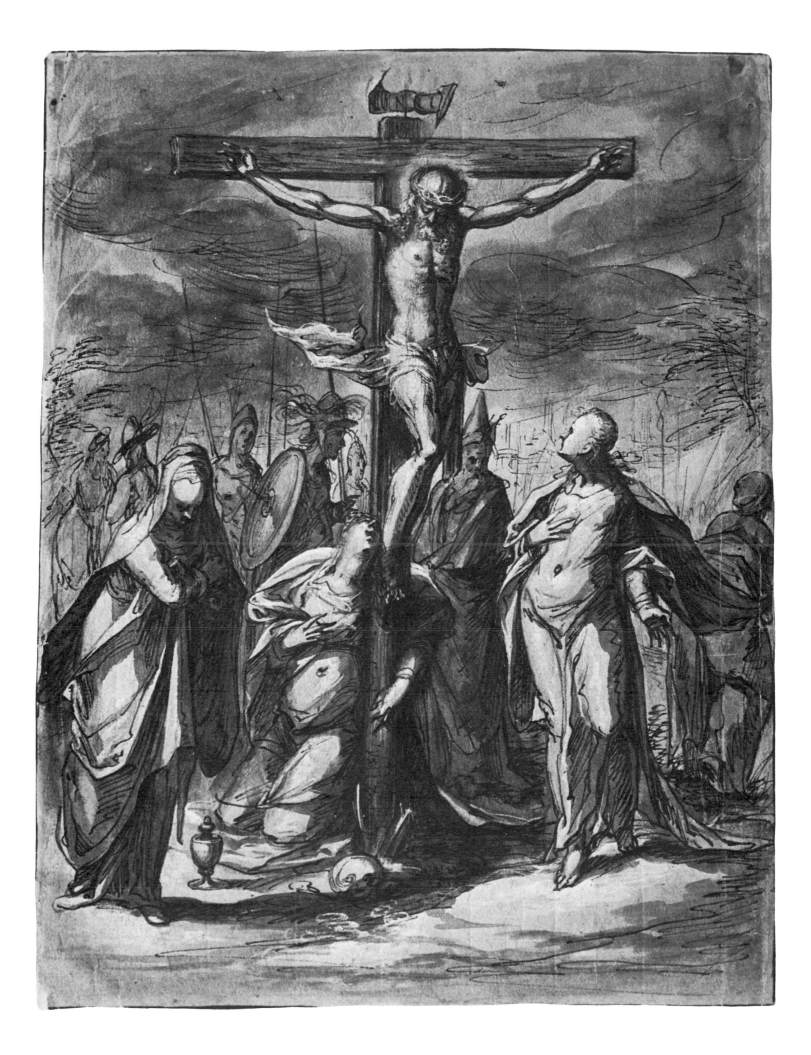

Franz Anton Maulbertsch
Apotheosis of Saint Stanislas

56
Franz Anton Maulbertsch
Langenargen 1724–1796 Vienna
Apotheosis of Saint Stanislas
Pen and brown ink with gray and brown washes; 398 x 239 mm
(15 ⅝ x 9 ⅜).
Provenance: Delhaes (Lugt 761); inv. 738.
Literature: Pigler 1927, 174; Garas 1960, 211; Garas 1974, 62, 256;
Garas 1980, no. 44; Salzburg 1981, no. 32.

Maulbertsch was an outstanding eighteenth-century ceiling painter of Swabian descent who settled in Vienna. He left an immensely rich oeuvre of frescoes, altarpieces, and oil sketches, as well as a considerable graphic oeuvre. For his large paintings in Austria, Czechoslovakia, and Hungary he made many preparatory sketches and drawings, a number of them conserved in Budapest, which show the various stages of his development. This pen and wash drawing, because of its subject and format, must be for an altarpiece and should be placed with Maulbertsch's works from the 1760s.

The theme and style of the *Apotheosis of Saint Stanislas* and the figure's similarity to the *Saint Narcissus*, also by Maulbertsch (Barockmuseum, Vienna), caused scholars to connect the two works. However, that noted masterpiece resembles the Budapest drawing only in a general sense, while the differences are so substantial that they preclude any possibility that the drawing in Budapest is a preparatory sheet for the *Saint Narcissus*. In the painting, color, light, and shadow merge with details in an almost fantastic manner, while in the drawing the presentation of the event is distinct and more straightforward. The identification of the scenes in the lower register of this drawing has allowed us to determine that the drawing depicts Saint Stanislas in apotheosis. In the lower left corner, the saint resurrects a dead person from the grave, while at right he is killed by King Boleslaw's henchmen as he prays before the altar in the Kraców church.

Whether or not Maulbertsch ever completed a painting of this subject is not known. The subject was less popular in Austria or Hungary than in Poland and the old province of Galicia, where the commission may have originated. That the Budapest drawing was a project for a commissioned work seems assured by the format of the sketch; this sort of modello-like drawing was used by the artist when he was involved in contractual negotiations as well as in the initial stages of preparation for a work.

Maulbertsch, like most eighteenth-century painters, used the pen for this kind of task. He sketched the outlines with light and liquid strokes, indicating the secondary details with loose zigzags and small, fleeting lines. Then, with the brush and gray or brown ink he established contrasts between the dark areas and the paper that was left white. Thus the desired picturesque effect and an animated play of light were achieved. Most of Maulbertsch's drawings, including the *Saint Stanislas* at Budapest, are picturesque creations; even with a palette limited to black and white he brought the pictorial elements to our attention.

In his very early paintings, as well as in his playful graphic oeuvre from the 1750s and 1760s, the lines are mere indications of direction, and do not encompass the forms. Some details are accentuated while others are barely distinguishable. This kind of execution, seen also in the Budapest *Saint Stanislas*, is characteristic of Maulbertsch's sketches from the 1760s such as the *Farewell of Saint Peter and Saint Paul* for the church at Erdberg (Hradek, Czechoslovakia) now in the Albertina, Vienna, or the preparatory drawing (1766) for the *Saint Hyppolit* altar in Pöltenbert (Hradiste, Czechoslovakia), now in a private collection.

K.G.

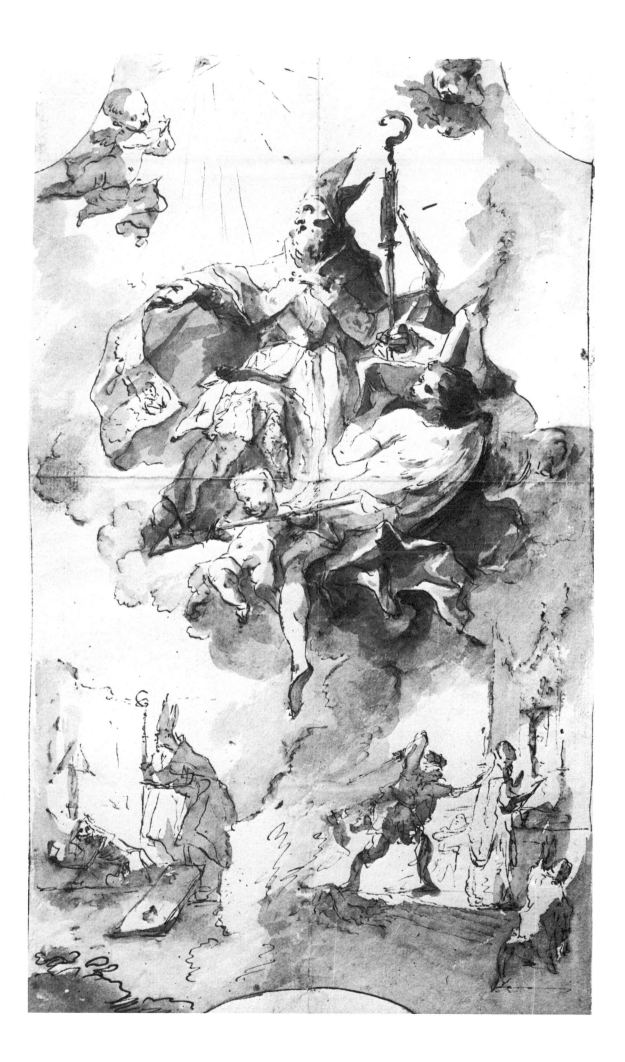

Paul Troger
Mary Enthroned with the Christ Child and Saint Bernard

57
Paul Troger
Zell bei Welsberg 1698–1762 Vienna
Mary Enthroned with the Christ Child and Saint Bernard
Pen and brown ink with brownish-gray and gray washes;
320 x 210 mm (12⁹⁄₁₆ x 8¼).
Provenance: Delhaes (Lugt 761); inv. 862.
Literature: Jacobs 1930, 150; Aschenbrunner-Schweighofer 1965,
103, no. 30; Heffels 1969, 260; Garas 1980, no. 14; Salzburg 1981,
no. 16.

Paul Troger learned to paint in his native Tirol and in Italy, where he remained for about fifteen years. His Italian experiences allowed him to develop a late baroque style of decorative art, and he became one of the most sought-after painters for the newly built monasteries, churches, and castles of central Europe. Troger lived in Vienna but his activities took him all over the territories of the old Austro-Hungarian Empire. Not only was he an important artist, but he was also the rector and a professor at the Vienna Academy of Fine Arts. His drawn oeuvre is larger than that of almost any other contemporary Austrian or German artist, partially due to the fact that he taught at the academy. The Museum of Fine Arts owns more than sixty detail studies, compositional sketches, drawings after nature, copies after famous Italian paintings, and modelli for commissions.

Though his technique changed according to the type of assignment, Troger's means are simple, and his drawing style throughout his career is fairly consistent. In his sketches he first traced the outlines with pencil or chalk, and then reinforced the preparatory lines with lively but fine pen-and-ink strokes. The flowing silhouette lines, surface-forming zigzag and wavy lines, shading made up of parallel pen strokes, white areas of the paper, and sparse washes together produce a plastic, clear effect. As in all Troger's well-constructed compositions, the human figure in motion is predominant.

All these characteristics are apparent in the Budapest drawing, one of his most outstanding works from the 1730s. The enthroned Virgin holds the Child who thrusts down the personification of evil, while she also shelters the assembled monks at her feet with the canopy of her throne. This popular baroque theme, symbolizing the protection of the faithful, is not known in Troger's painted oeuvre. However, there is a sculpted variant of this theme in the Cistercian monastery in Zwettl where Troger decorated the ceilings in both the library and the great state room. In 1733 he also recommended to the monks his Viennese colleague Jacob Christoph Schletterer (1699–1774) for sculptural decorations in the church. Among the sandstone carvings in the transept, there are scenes from the legend of Saint Bernard of Clairvaux, including one in which the saint and his companions offer themselves and the order to Mary, Queen of Heaven and Protector of the Faith, for succor. The Budapest drawing seems to be a sketch for this concept, which was then executed by Schletterer using Troger's invention. Schletterer's drawings for this and three other works are in Nuremberg (Germanisches Nationalmuseum) but these are dry, trivial, and stiff in comparison to the Budapest drawing. Schletterer's painstakingly executed works lack the vigor of Troger's—his painterly wealth and shading that are the hallmarks of originality. The softly undulating or inevitably crossing small strokes of the contours give the work its masterful unity.

K.G.

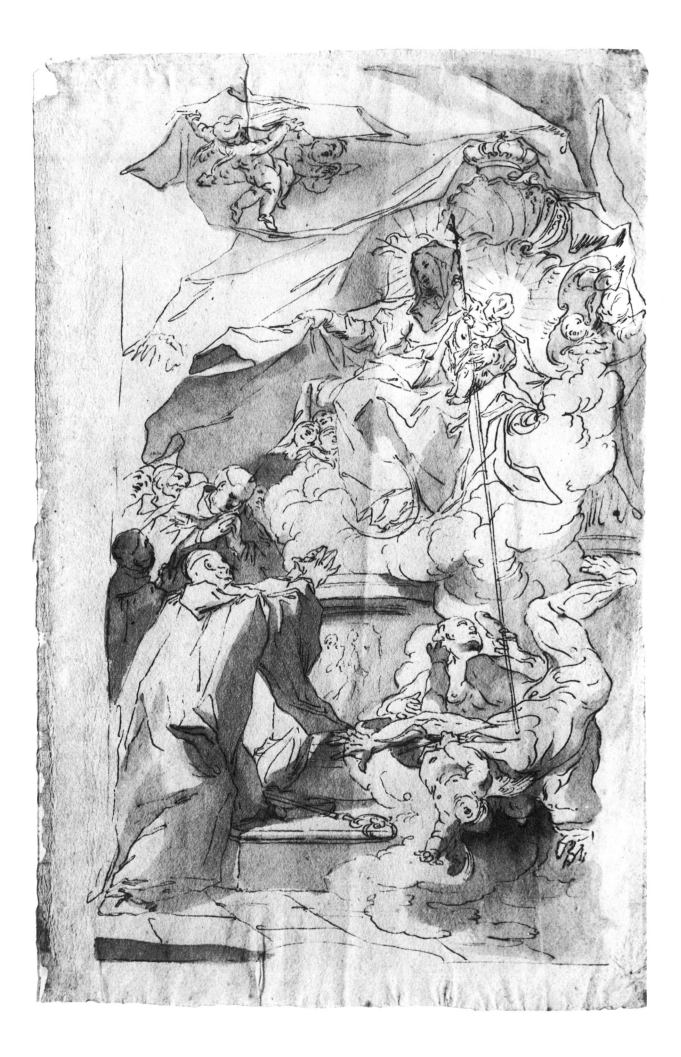

Melchior Steidl
Assumption of the Virgin

58
Melchior Steidl
Innsbruck 1657–1727 Munich
Assumption of the Virgin
Pen and brown ink and brown washes with white heightening on
blue paper; 492 x 302 mm (19⅜ x 11⅞).
Provenance: Transferred from the Országos Képtár (Lugt 2000);
inv. 1019.
Literature: Bushart 1961, 95; Meinecke Berg 1971, 22, 184;
Garas 1980, no. 2.

Steidl was a pioneer among the baroque decorators of churches. An innovative draftsman and an able follower of the great baroque artists Luca Giordano (1632/1634–1705) and Pietro da Cortona (1596–1669), in structure and invention, Steidl adhered to the teaching of his master, the Munich painter Andreas Wolf (1652–1716). This is especially evident in the modeling and the choice of his figural types. He was able to mix various effects to achieve a very personal style that fused the characteristics of fresco painting and drawing.

Unlike his Tirolean compatriots, Steidl worked in Bavaria rather than in Austria. He was employed by the Prince-Elector of Bavaria and was in demand in southern Germany as a decorator of churches and monasteries. His most famous commission, for the decoration of the Schönenberg church in Ellwangen, occupied him from 1710 to 1712. There he executed forty-four frescoes of various sizes for which he made numerous preparatory drawings. The Budapest sketch of the *Assumption of the Virgin* is connected to the large ceiling fresco in the nave of the church, as is made clear by the elliptical format and the blank corners representing areas of the surrounding stucco. The drawing differs slightly from the completed fresco, which is larger and exhibits more pleasing proportions. For this reason the drawing appears to be more crowded than the finished painting. The careful modeling of the figures also suggests that our drawing is surely a compositional study, in which the master worked out the spacing and the relationship of the figures to one another, the organization of the space itself, and the foreshortening.

A crowd of figures gathers around the grave in an arrangement that leads the viewer's eye along a strong diagonal and through the exaggerated foreshortening and startling light effects. The straining figures, the obliquely angled tombstone, and the billowing clouds, effectively heightened with white, draw attention to Mary who is surrounded by a host of angels. Above her one of them holds a palm leaf and the crown. A variation of this subject may be seen in a pen drawing (Kupferstichkabinett, Basel), also by Steidl, which is squared for transfer and is further developed. It represents the artist's next phase, immediately before he began work on the painting. The figures in the ceiling painting are even more finished, and additional persons have been added. Drawings for the *Immaculata* frescoes painted in the choir at Ellwangen are found in Stuttgart, Berlin, and London, while fifteen detail studies and compositional sketches for episodes from the life of the Virgin are also known.

K.G.

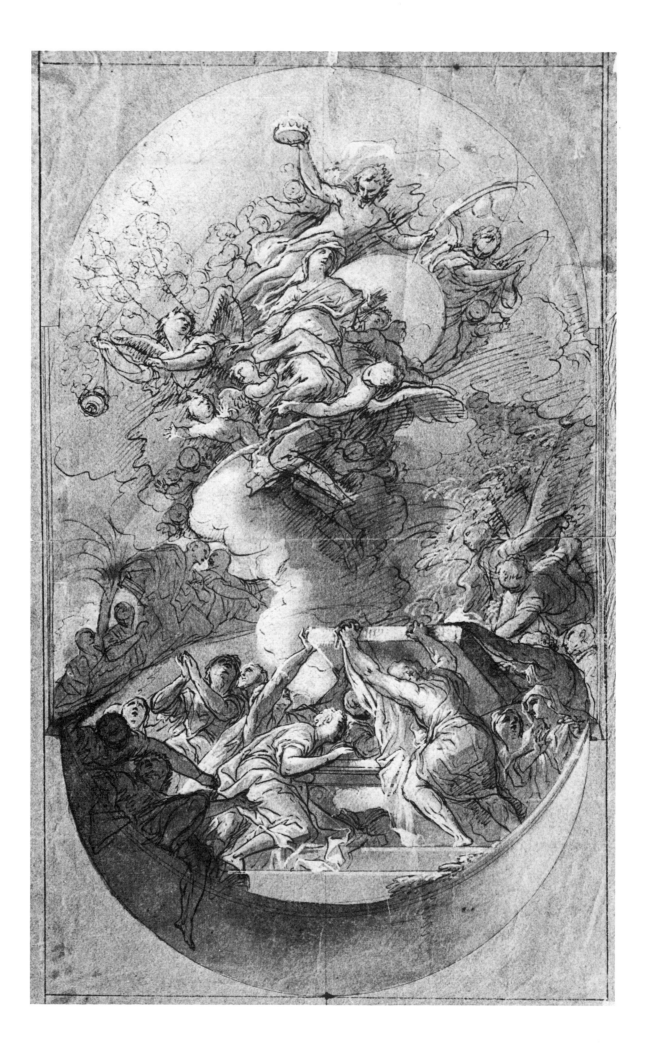

Johann Elias Ridinger
Wild Boar with Its Young

59
Johann Elias Ridinger
Ulm 1698–1767 Augsburg
Wild Boar with Its Young
Pen and brown ink with brown and gray washes, contour lines incised with a stylus; signed at lower right, *J. El. Ridinger inv. et del. 1735. in mens. Jul.*; inscribed at center below, *Eine Bache mitt ihren Jüngen (Frischlingen) im Lage!*; 297 x 415 mm (11^{11}/₁₆ x 16^{5}/₁₆).
Watermark: Coat of arms of Strasbourg with lily (variant of Heawood 1803).
Provenance: Esterházy (Lugt 1965); inv. 818.
Literature: Hoffmann 1929, 138; Garas 1980, no. 31.

The artists of the Ridinger family in Augsburg produced representations of animals and hunting subjects, popular themes in the eighteenth century. Their paintings, drawings, and especially their prints depict the hunt and related hunt feasts and riding events of the nobility, as well as careful observations of animal life. Johann Elias Ridinger, the most famous member of the family, popularized these subjects in large series of etchings. The two splendid sheets in the Budapest Museum of Fine Arts, the *Stag Hunt* and the *Wild Boar with Its Young*, are connected to this series. The latter composition was published in reverse in 1736 in the *Betrachtungen der wilden Thiere mit beygefügter vortrefflicher Poesie des hochberühmten Herrn Barthold Heinrich Brocres.*

In a small clearing in a forest beneath trees and ferns, a peacefully resting family of wild boars appears to have been surprised. The various movements of the immense sow and her offspring are faithfully and meticulously rendered. Small pen strokes indicate the rich vegetation while large dark or light patches are used to construct the tree trunks. Ridinger employed some traditional compositional conventions such as the leaning tree trunks cut off by the picture frame, and he spotlighted the group of animals in the center of the sheet.

The master adjusted his drawing technique to the demands made by the etching technique. The engraver, who is in this case also the inventor, was able to use this design as a pattern for the plate. It is understandable in the creation of a design such as this one, which was ultimately to be engraved, that many detail studies would be required. While making his preparatory sketches the artist seldom had an opportunity to observe his subject closely in its natural habitat. As some contemporary documents relate, the model had to be available for an extended period. Thus we can quote here the words of Prince Liechtenstein's steward, who provided in 1707—with the permission of higher authority—a deer, a doe, a wolf, and an eagle for the painter Franz Werner von Tamm (1658–1724): "Er saget gar gutt geschehen zu sein, dass das Ingeweid herausgenommen und der Wolf mit Stroh ausgeschoppfet worden." (It was good that the innards were removed and the wolf stuffed with straw.) Precisely how Ridinger was able to observe his models is unknown, but he may have used a method similar to the one described by Tamm. He often made notes on his drawings stating that they had been made from nature. He supplemented his overall designs with careful detail studies executed during the hunt. Several pages of head studies by Ridinger are known, as well as impressions of motion and even meticulously drawn representations of skeletons. Some of his prints include the tracks of animals and are accompanied by engraved explanatory inscriptions.

The artist's graphic oeuvre, part of the rich and priceless output of eighteenth-century Augsburg artists and printing houses, had both educational and popular value.

K.G.

Eine Bache mit ihren Jungen im Lager.
Frischlingen.

Franz Kobell
Wooded Landscape

60
Franz Kobell
Mannheim 1749–1822 Munich
Wooded Landscape
Brush and brown ink and gray and brown washes; signed and
dated, *Franz Kobell f. 1799*; 184 x 223 mm (7¼ x 8¾).
Provenance: Esterházy (Lugt 1965); inv. 718.
Literature: Garas 1980, no. 60.

Franz Kobell, younger brother of the eminent German painter Ferdinand Kobell (1740–1799), was a well-known graphic artist. He left a relatively small number of paintings but a large oeuvre of drawings and prints. He traveled from 1779 to 1784 with his brother throughout Italy where he soon absorbed the classical-ideal landscape tradition of Claude Lorrain (1600–1682) and Nicolas Poussin (1594–1665). Toward the end of the eighteenth century human sentiments and passions dominated contemporary art and literature. Landscape pictures became, in Kobell's time, the most favored type of art, and amateurs and ordinary citizens started to acquire them eagerly in every medium: oil paintings, drawings, and prints.

Kobell, who had left his position as a merchant to become an artist, soon decided to specialize in drawings. His contemporaries wrote that he found the painting of landscapes too slow: "...while he sat in front of the easel, hundreds and hundreds of pictures intruded into his mind and urged him to produce faster...." He found that with pen and brush on paper he could express his ideas more freely and much faster than was possible with paints.

In the Budapest *Wooded Landscape* he formed the lush foliage with small, dense lines. Light and dark patches describe the steeply mounting cliffs while menacing, distant thunderclouds signify the power of nature. The artist, with infinite patience, fastidiously described the details, lavishing his attention on the depiction of the forest, the densely covered mountain, the hilly expanse with lakes and rivulets, the wilderness untouched by human hands, where the powers of nature reign. He did not wish to disturb the great feeling of solitude and infinity with human figures; the diminutive "extras"—the shepherd, the two reclining figures at left— are insignificant and seem rather to underline the immensity of nature and its infinite poetry.

About ten thousand drawings have been traditionally attributed to Franz Kobell, and various European collections (Hanover, Nuremberg, Budapest, and elsewhere) own voluminous albums of his work. His technique as well as his subjects are consistent: he first carefully worked out the entire drawing surface with fine line-work and then added modeling with painterly gray and brown washes.

Kobell almost always produced complete views; capricious sketches or detail studies are comparatively rare in his oeuvre, and he signed and dated his works. He etched many of his drawings; in those works, as in his drawings, he accentuated sentimental elements and poetic passages.

K.G.

Johann Heinrich Füssli
Portrait of a Lady (The Painter's Wife)

61
Johann Heinrich Füssli
Zurich 1741–1825 London
Portrait of a Lady (The Painter's Wife)
Pen and brush with graphite and watercolor; 228 x 178 mm
(8¹⁵⁄₁₆ x 7).
Provenance: Baroness North, London (Lugt 1947); museum
purchase, 1912, from a private collection, London; inv. 1914–143.
Literature: Schiff 1973, fig. 1089; Garas 1980, no. 54.

Füssli was a many-sided, unusually gifted artist whose restless nature and extraordinary talent took him far from his native country and the kind of career likely for the descendant of an artistic Swiss printers' family. After a prolonged stay in Italy, he settled in England and there became one of the leading exponents of the literary and artistic *Sturm und Drang* movement that had originated in Germany. His paintings and drawings are filled with fantastic visions populated by creatures from fairy tales and tragedies depicting the dream world and human emotions.

Füssli's contemporaries were enraptured by his art, which was always closely linked to literature (the authors Lavater and Goethe paid tribute to his genius). His works were widely collected and published as prints and in books and journals, while his academic activities and theoretical writings had lasting effects. Many of Füssli's themes were taken from the works of Shakespeare, Milton, or Dante.

His enormous graphic oeuvre is varied and rich in every respect. The Budapest portrait is from a large group of portrait drawings, among them many portrayals of his wife— one of his favorite models—the lovely Sophia Rawlins. He painted the former professional artist's model in countless poses and attires: as a queen of fairies, a dreamy innocent girl; sometimes sulking or angry; she was even portrayed as a demon. In this drawing Sophia faces us in half-length, holding a book and wearing an unusual high, beribboned coiffure. Her face, broad, puffy lips, widely placed eyes, and firm, almost hypnotic gaze are an odd mixture. In a similar pose and the same coiffure, Sophia appears also in a drawing dated 1796 in the Kunsthaus, Zurich, as well as in a portrait sketch in the Germanisches Nationalmuseum, Nuremberg, which exhibits the same traits.

The enigmatic expression and the almost tectonic figural conception contrast strongly with the soft execution, achieved with a great economy of means. The figure and the garment are laid down with a few forceful lines that effectively lift them from the dark background. Little care is lavished on the background, as if the artist did not want to divert our attention from the essence of the picture. With a few sparse strokes of the brush he indicated the table on which Sophia gently rests her arm. With delicate shading in harmonious pale rose and brown tones, the sitter's head, her startling, stiff gaze, and her coiffure are indicated. The same, almost fantastic coiffure reappears in Füssli's work time and again, prompting scholars to propose numerous psychological interpretations. Lavater said of Füssli in 1774, "He is the most original genius I have known, full of power, essence and style. His ghosts are the tempest—his servants fire and flame!"

K.G.

Adolf von Menzel
Church Interior with Pulpit

62
Adolf von Menzel
Breslau (Wroctaw) 1815–1905 Berlin
Church Interior with Pulpit
Carpenter's pencil; signed at lower left, *A.M. 18 Aug. 83*;
325 x 240 mm (12¹³⁄₁₆ x 9⁷⁄₁₆).
Provenance: E. Arnold, Dresden; Majovszky; inv. 1935–2870.
Literature: Pataky 1967, no. 90.

Menzel was the primary exponent of nineteenth-century German realism. Objective observation was the foundation of his art; he repeated often, "Nulla dies sine linea" (Meyerheim 1906, 133). His drawing ability grew out of a profound interest in the graphic arts that began in his father's lithography workshop where he produced occasional orders and later, illustrations. Subsequently, he became interested in etching, and also played a leading role in the development of the modern woodcut. Menzel's oeuvre mirrors the changes wrought by realism on German art of the nineteenth century. In his late works he analyzed the most minute details of his subjects while offering a synthesis of his observed impressions (Forster-Hahn 1978, 255–283). During the last decades of his life he demonstrated a predilection for chalks and carpenter's pencil, and often stumped the soft lines to obtain the desired shading effects—a technique that became more pronounced as he grew older and lent an impressionistic flavor to his drawings.

He traveled abroad often, but during the summers he wandered throughout his homeland, recording the details of various towns—their streets, monuments, and churches. The life of country people interested him passionately, and he drew typical farmhouses, yards, and masterpieces of folk art.

In 1883 Menzel visited Regensburg, then Heilbronn and Augsburg. He passed through the Zugspitze and arrived in Garmisch (Schweinfurt 1981, 219).

The precise location of the church whose interior is shown here is unknown. He often sketched in churches, recording the details of sumptuously carved organs and baroque altars. His interest was apparently attracted by the restless lines of the rococo pulpit depicted here. The selection of his vantage point is curious: the pulpit is seen from below, though the artist could not have been on the church floor but was probably slightly elevated, in a choir stall. The vaulting of the nave and other architectural elements are sketched lightly in soft pencil, while the sculpted ornaments of the pulpit are secured with powerful lines of varying gradation. He achieved an overall impression of glittering, rich gilding. The modeling stands out against the gray of the background, probably made by rubbing the pencil strokes together.

Our drawing is among the most outstanding of Menzel's works from the 1880s, a time when the aging master did not attempt larger oil compositions but executed many drawings similar to this one, each a finished, self-contained work of art.

v.k.

Cornelis Engebrechtsz
Study Sheet with Heads

63
Cornelis Engebrechtsz
Leiden 1486–1533 Leiden
Study Sheet with Heads
(verso: *Drapery Study*)
Brush and pen and gray and brown ink with white heightening
on bluish-gray prepared paper (the four figures in pen and ink
below are by another hand); 121 x 160 mm (4¾ x 6⁵⁄₁₆).
Provenance: His de la Salle (Lugt 1333); museum purchase 1894;
inv. 1413.
Literature: Gerszi 1971a, no. 69/a; Gerszi 1976, no. 1; Gibson 1977,
264–265, no. 26, fig. 18.

Cornelis Engebrechtsz was one of the eminent northern Netherlandish painters in the first decade of the sixteenth century. He had a large studio and produced an important oeuvre of paintings that had their roots in Netherlandish traditions.

The importance of this sheet of head studies lies in the fact that only one other drawing by Engebrechtsz is known. It may be a page torn from a sketchbook, as both sides of the paper were used. The curious headgear worn by the men suggests that the figures were intended for a biblical composition. Such Eastern semitic types as the two heads in the center are seen earlier in the works of Albert von Ouwater (active 1430–1460) and later in those by Geertgen (died c. 1495). The sketches, datable to c. 1515, were used for the four figures in a triptych painted in the Engebrechtsz workshop with a *Crucifixion* at center and two side wings representing *Christ Bearing the Cross* and the *Resurrection* (Národní Galerie, Prague; see Gerszi 1971a, fig. 8).

The softly modeled heads, heightened with white, emerge with a delicate painterly effect from the bluish-gray ground. (The four male nude figures in pen and ink in the lower part of the drawing are not by Engebrechtsz. They were copied from an engraving by Marcantonio Raimondi [c. 1480–1527/1534; B. 35] and differ in technique, style, and quality from the heads above.)

The free, soft manner, especially evident in Engebrechtsz' paintings after 1510, and the elaborate hats point to a contact with the Antwerp School. But the master's most outstanding feature and the one that sets him apart from his contemporaries is the way that he distinguishes the four head's different ages, types, personalities, and moods. Because Engebrechtsz described the events in the triptych in Prague with drama, the characterization of the figures' physiognomy and psychology were of great importance. Karel van Mander (1906, 102) wrote that Engebrechtsz took great pains to depict vividly the changes of human moods. The movements and gaze of the figures in this drawing are lively and vibrating, while their expressions demonstrate the artist's profound insight into human character.

T.G.

Bernaert van Orley
Dividing the Prey

64
Bernaert van Orley
Brussels c. 1488–1541 Brussels
Dividing the Prey
Pen and brown ink with brown, blue, light green, rose, and
yellow washes; inscribed above, *An mennekens dans*; 376 x 577 mm
(14¾ x 22¹¹⁄₁₆).
Provenance: Esterházy (Lugt 1965, 1966); inv. 1365.
Literature: Gerszi 1971a, no. 215; Gerszi 1976, no. 2; Balis
1979–1980, 16; Schneebalg-Perelman 1982, 16.

This drawing is preparatory for a tapestry in the Louvre, one
in a noted series of hunting scenes of Maximilian I (reigned
1493–1519) representing the months of the year. The tapestry
series is a high point in Flemish Renaissance art, and provides
valuable documentation of courtly modes of entertainment.
Van Orley has not used the traditional idealized landscape for
the background but has used instead views of the forests near
Brussels.

The tapestry was commissioned by Charles V (reigned
1500–1558) and according to Balis the scenes could have been
inspired by the *Livre de la Chasse* by Gaston Phébus. Only
five preparatory drawings are known today: the Budapest
sheet, two others in Leiden (Prentenkabinet, Rijksuniver-
siteit), one sheet in Berlin-Dahlem (Tchaf 1970, figs. 8–9;
Berlin 1975, no. 210, fig. 38), and another in Copenhagen
(Kongelige Kobberstiksamling). (There is also a series of
twelve drawings in the Louvre, which are of poor quality and
are probably copies.) All of the drawings were for years
connected with Van Orley though their authenticity has at
times been doubted. (Some authors have accepted the connec-
tion; see Wegner 1973, nos. 82–85, and Benesch 1928, no.
43.) Sophie Schneebalg-Perelman, in her volume on the
tapestries, removed them from Van Orley's oeuvre and on
the basis of newly discovered archival material suggested
instead the authorship of a pupil, Pieter Cocke van Aelst
(1502–1550), for the figurative parts of the set, and the hand
of François Borreman for the landscape. But we believe this
drawing is much closer to the style Van Orley exhibited in his
drawings for tapestries in Munich and Vienna.

The Budapest drawing, representing the month of
November, shows a hunt breakfast taking place in a wide
clearing in a forest. Despite the many activities pictured, the
design is unified and clearly legible. Vigorous movements
enhance the lively, active figures. Raphael's influence can be
detected in the construction of the space and in the depiction
of the figures; between 1514 and 1519 tapestries showing the
deeds of the apostles were manufactured in Brussels after
designs and cartoons by Raphael. Thus the Maximilian
hunting tapestries and the related drawings are a synthesis of
Italian Renaissance and Flemish traditions.

T.G.

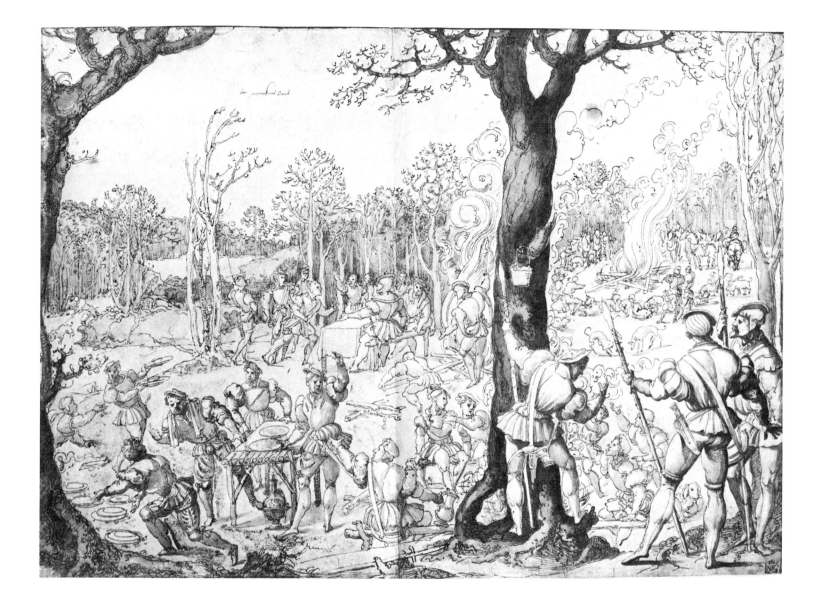

Frans Floris the Elder
Allegory of the Sense of Touch

65
Frans Floris the Elder
Antwerp 1519/1520–1570 Antwerp
Allegory of the Sense of Touch
Brush and grayish-brown ink with white heightening on blue
paper, contour lines incised with a stylus; 204 x 268 mm
(8 x 10⁹⁄₁₆).
Provenance: Esterházy (Lugt 1965); inv. 1333.
Literature: Gerszi 1971a, no. 85; Van de Velde 1975, 95, 432,
no. 46, fig. 45; Gerszi 1976, no. 5.

The leading master in The Netherlands between 1550 and
1570, next to Pieter Bruegel the Elder (c. 1525–1569), was
Frans Floris. A precursor of seventeenth-century Flemish art,
particularly that of Rubens, he was oriented toward Italy and
was the first "pictor doctus" of his land. Influenced by Italian
theoreticians, he considered invention of greater importance
in the creative process than finished execution. Thus he
devoted much of his time to making figure drawings, a
number of which were reproduced as prints by other artists.
Few of his drawings remain today. Among them the
Budapest *Allegory of the Sense of Touch*, the only surviving
drawing from a set of five, is outstanding because of its
beauty and painterly merit. In 1561 Cornelis Cort (1530–
1578) engraved the complete set (Bierens de Haan 1948, 231,
235).

Conforming to traditional custom, animals symbolize
here the human sense of touch: the woman holds a falcon
who pecks at her finger while a turtle crawls on the ground
(Ripa 1630, *Parte Terza,* 58) and a fish, caught in a net,
wriggles on the side of the boat. Animals were frequently
used as symbols of the human senses as it was thought that
men and animals shared many of the same senses. The
symbolism of animals can be traced to observations made in
antiquity, when animal nature was studied, and later classified
in the thirteenth century (Janson 1952, 239). Since the six-
teenth century the universal symbol of the sense of touch,
Tactus, has been a falcon or a turtle.

The source for the female figure in the Budapest allegory
can ultimately be traced to Michelangelo whose concept of
beauty Floris knew; Floris' copies after the Sistine Chapel
ceiling prove his interest and admiration for the great Italian
master. The effect of his travels in Italy (1541–1547), mainly
in Rome, may be seen in this drawing where, in addition to
the Roman-Florentine use of line and modeling, a northern
Italian painterly concept is evident. The linear elegance of
Parmigianino as well as the achievements of Venetian drafts-
men, who employed vibrating highlights on blue paper, are
recalled in this picturesque, decorative work.

T.G.

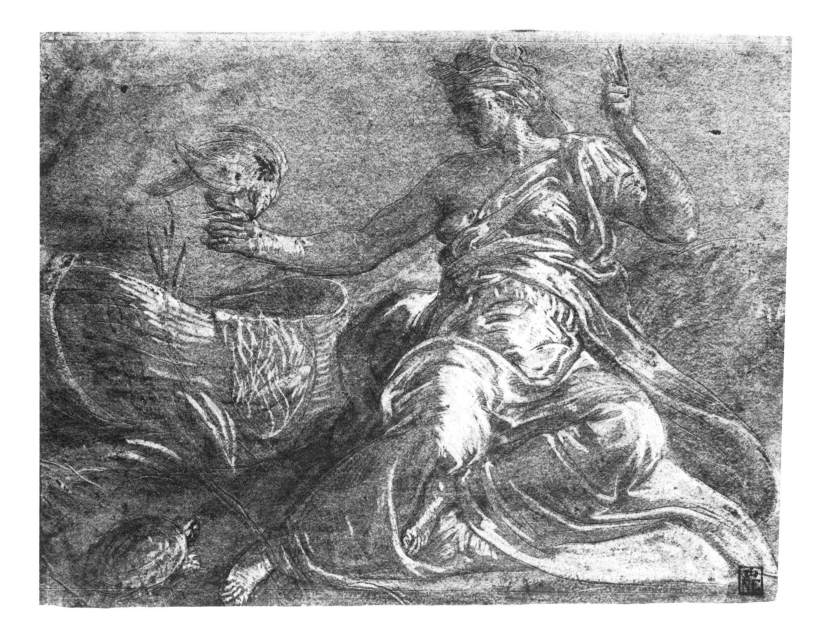

Lucas van Valckenborch
Costume Study

66
Lucas van Valckenborch
Louvain 1535/1536–1597 Frankfurt am Main
Costume Study
Brush with various opaque colors; monogram, *LV.V*;
300 x 201 mm (11¹³⁄₁₆ x 7⅞).
Provenance: Esterházy (Lugt 1965); inv. 1390.
Literature: Gerszi 1971a, no. 286; Wied 1971, 183, no. G 9, fig. 205;
Berlin 1975, no. 268, fig. 186.

Lucas van Valckenborch belonged to the generation of Flemish artists who took refuge abroad to escape the terror of Spanish domination: he worked mostly in Linz and in Frankfurt. Early in his expatriate period he returned from Aachen to The Netherlands for a few years. While in Antwerp he was invited by Archduke Matthias, governor of The Netherlands, to serve as the official painter to his court. The archduke, a younger brother of Emperor Rudolf II (reigned 1576–1612), was governor of the Brussels court for only a few years, from 1577–1581, yet there is strong evidence of his importance as a patron of the arts, including portraits by Valckenborch and a set of costume studies to which the Budapest drawing belongs (eight are in the Albertina, Vienna; Benesch 1928, nos. 303–310; Hummelberger 1965, 112–115, figs. 138–145). Valckenborch may have prepared them in c. 1578 for a triumphal entry to Brussels, or later, for other court functions.

That the Budapest study belongs to this series is certain, as its characteristics, dimensions, and technique are identical to those of the Albertina drawings. Among the Vienna drawings is one of a halberdier who appears to be the same model used for the Budapest drawing. (Thus the theory that he is identifiable as a specific musician from Liège is dubious;

Wied 1971, 183.) The roll of music in his hand and the book under his arm suggest he is a learned person. The garments worn by the figures in the series could have been designed for the members of the court—scholars, poets, or musicians. This costume is in the Spanish taste, which was in vogue in late sixteenth-century Europe, as are those of the eight noblemen in the Vienna drawings and their military clothing. (See Thiel 1968, 310–340.) The man is entirely dressed in black, the most popular color at the time (except for the white cuffs and collar). Black robes were worn by officials, scholars, clergy, and artists. On his head the man wears a high cap with a narrow rim that was very stylish around 1570 in Italy; the same type of hat is shown in some of the drawings in Vienna. This costume differs from that seen in the Albertina drawings in the jacket, which reaches to the middle of the thigh, and by the long black hose rather than short pants. The costume is completed by the traditional accessory of learned men, the wide robe. The figure—its carriage, gesture, and placement in a neutral background—is of the type that would appear in a full-length portrait of the period, which had become widely accepted throughout Europe through the influence of Italian prototypes.

T.G.

148

Jan Speckaert
The Annunciation

67
Jan Speckaert
Brussels c. 1530–c. 1577 Rome
The Annunciation
(verso: *Fugitives*)
Brush with brown ink and pen with grayish-brown ink and
preliminary black crayon; inscribed, *Spekert*; 241 x 194 mm
(9½ x 7⅝).
Provenance: Museum purchase, 1916; inv. 1916–34.
Literature: Gerszi 1968, 158, 164, 165, 167, fig. 27; Gerszi 1971a,
no. 227; Gerszi 1976, no. 11.

Jan Speckaert was one of the most influential Northern
painters living in Italy in the 1570s. He did not randomly
imitate Italian works, but was deeply stimulated by his sur-
roundings. Only a few paintings by Speckaert are known
today and thus our knowledge of him must come from his
drawn oeuvre (see Zalentiner 1932, 163–171; Béguin 1973,
9–14). Middle Italian influences are expressed in the clarity of
form and the well-accentuated plasticity of the figures. The
art of Parmigianino seems responsible for the elegance of the
movements and the billowing folds of the garments. Toward
the end of Speckaert's life, when he produced this sheet,
pronounced elements of late Gothic Northern art became
evident in his style.

In several aspects *The Annunciation* differs from Speck-
aert's earlier works. The figures here seem more elon-
gated, more vertical, and as in other late works the composi-
tion and details betray a growing decorative tendency. In his
modeling of Mary and the angel, a Michelangelesque monu-
mentality as well as Parmigianino's concept of motion play
an important role. The figures are highly stylized; their wide
cloaks form independent decorative entities. The slightly *di
sotto in su* viewpoint creates an impression of imposing stat-
ure, and although the figures are quietly posed there is a
hidden dynamism in their gestures.

Also in marked contrast to Speckaert's earlier drawings
is the shift of importance from the pen to the brush, lending
an increased painterly character. The dark patches, produced
with forceful brushstrokes, set off the highlights, while the
washes do not always stay within the contour lines and thus
give additional vigor to the drawing.

T.G.

Spekert

Hendrik Goltzius
Prophet

68
Hendrik Goltzius
Mühlbrecht 1558–1617 Haarlem
Prophet
Pen with dark brown ink and brown washes with white
heightening; 152 x 119 mm (6 x 4^{11}⁄₁₆).
Provenance: Delhaes (Lugt suppl. 761); inv. 1294.
Literature: Gerszi 1964, 65–68, fig. 51; Gerszi 1971a, no. 94;
Gerszi 1976, no. 16.

The Budapest *Prophet* is a typical work of the late Northern mannerist period, epitomized during the years around 1580 by the works of Bartholomäus Spranger (1546–1611). Goltzius, one of the most celebrated draftsmen and engravers of his time, produced prints after compositions by Spranger from the mid-1580s. For a period after that time even his own inventions followed the Prague master's style. The Spranger drawings, brought from Vienna to Holland by Karel van Mander (1548–1606), inspired Goltzius to adopt an expressive, ornamental style. This influence was intensified around 1587, and it was probably at that time that Goltzius made this drawing. It might have been a preparatory sheet for a series of prints that were probably never executed.

Several drawings of prophets and heroes taken from the Old Testament are from the master's early period. Not only thematically but also stylistically, they are close to the Budapest page. The works, favorites of the engravers and publishers, recall medieval iconographic traditions. The Budapest *Prophet* has a suggestive inner force and expression that set it apart from other drawings such as those of the Prophet Daniel, Prophetess Hulda, or David, Judith, Samson, and Jahel (Reznicek 1961, K 22, K 23, K 16–19, figs. 84, 90–93, 95). The figure, excited by religious fervor, holds the book of scriptures, suggesting the strained, explosive atmosphere that existed in Holland between the Roman church and the Protestants. The prophet is poised to leap, his body turned to the side, with an impassioned facial expression. His tension is expressed in every part of his body. The somewhat low vantage point lends to the image a monumentality that is magnified by the twisting, vehement pen strokes. The boldly applied white heightening against the dark washes considerably intensifies the total painterly effect of this drawing.

T.G.

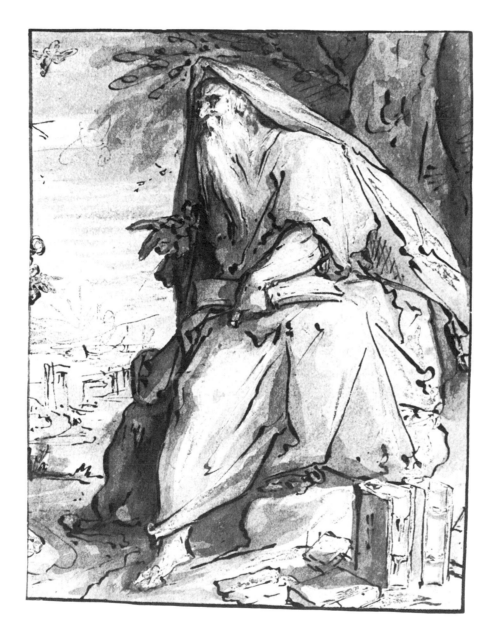

Jacob de Gheyn the Younger
Hippocrates Visiting Democritus

69
Jacob de Gheyn the Younger
Antwerp 1565–1629 The Hague
Hippocrates Visiting Democritus
Pen and brown ink (with greenish paste stains); 173 x 228 mm
(6¹³/₁₆ x 8¹⁵/₁₆).
Provenance: Esterházy (Lugt 1965); inv. 1335.
Literature: Regteren Altena 1936, 43; Gerszi 1971a, no. 92;
Judson 1973, 38; Gerszi 1976, no. 17.

Jacob de Gheyn the Younger, a pupil of Goltzius, is considered one of the foremost draftsmen around 1600. He is known not only for the high quality of his works but also for his important contributions to the evolution of art in Holland. The style of this sheet corresponds to that of his late drawings, which influenced even the young Rembrandt. It probably dates from c. 1620. Unlike his youthful works in which he used tight pen strokes and strongly modeled forms, here he took a more painterly approach, with bundles of heavy line-work contrasting with the clear patches of untouched paper. The placement of the figures in a landscape and the importance given to the animals lend to the scene its genre character.

It is possible that the sheet was inspired by a theater performance in 1603 of a piece based on a passage from the apocryphal letters of Hippocrates (Möller 1954, 1249): Democritus, the "laughing" philosopher who is usually seen in company with the melancholic philosopher Heraclitus (Blankert 1967, 31–125), becomes so involved in his anatomical research that his friends fear he is mad. They summon the famous doctor Hippocrates for help. De Gheyn illustrated the moment when the disturbed Democritus attempts to slaughter a sheep to calm his thirst for knowledge. Though it was a very popular theme among the painters in the Rembrandt circle and even earlier, the artist produced an original version.

During the years De Gheyn spent in Leiden he prepared many plant and animal studies as well as anatomical sketches (Judson 1973, 14–18). His interest in anatomy is evident in the variously grouped animals, some of them bound with ropes, and in the severed head of a sheep and a bone at the seated Hippocrates' feet. De Gheyn often visited the great Leiden botanist C. Clusius who was also occupied with zoology; he also had the opportunity to attend lectures on anatomy. He closely observed the scholars' habits and attitudes, which allowed him to depict with insight Democritus' pensive mood—his face and his slightly stooped bearing mirroring his concentration and determination. The figure of Hippocrates is drawn after one on a sheet in Haarlem (Teylers Stichting; Judson 1973, fig. 8) that aptly illustrates the interest of the young doctor who seems to be amused by the passion of his "patient." His art is based not only on the study of the surrounding world but on his deep knowledge of human nature as well, and in this way too he is a precursor to Rembrandt.

T.G.

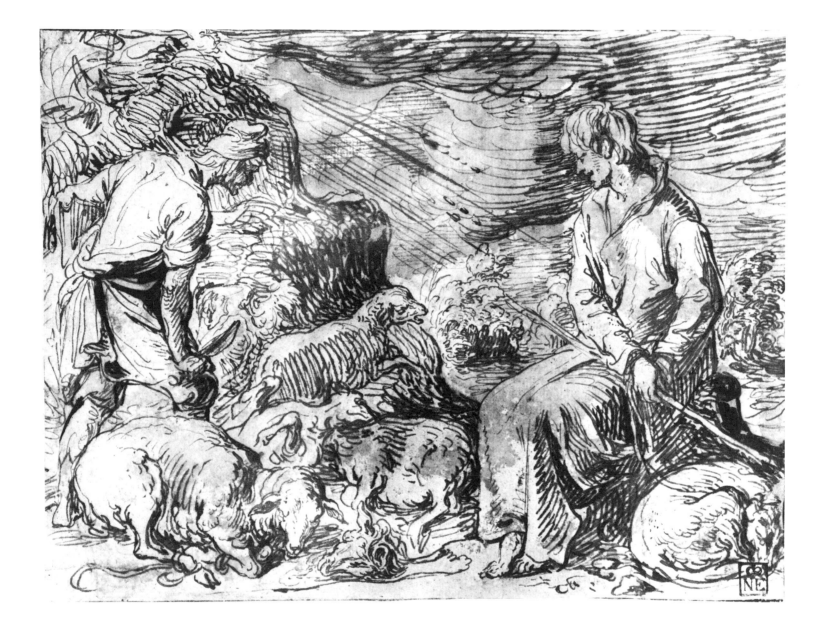

Jacob Savery the Elder
Winter Landscape

70
Jacob Savery the Elder
Kortrijk 1569/1570–1603 Amsterdam
Winter Landscape
Pen and brown ink; inscribed (twentieth century) at lower left,
R. Savery; 167 x 229 mm (6½ x 9).
Watermark: Fragmentary coat of arms, Briquet 1356.
Provenance: Esterházy (Lugt 1965); inv. 1606.
Literature: Gerszi 1965, 101–103, fig. 10; Gerszi 1971a, no. 221;
Berlin 1975, no. 215, fig. 243; Gerszi 1976, no. 7.

Jacob Savery belongs to the group of Flemish artists who went to the northern Netherlands at the end of the sixteenth century. Their art is characterized by a focus on the simple motifs and atmospheric peculiarities of their homeland. In 1591 he settled with his younger brother Roeland in Amsterdam where he remained until his death. Savery should be regarded as an important link between Pieter Bruegel (c. 1525–1569) and seventeenth-century Dutch landscape artists. The fine line-work and dots of *Winter Landscape*, dating from the late 1590s, show that this work is very close to the so-called "small landscapes" by Bruegel (see Tolnay 1952, nos. 31, 32, 33). These village views depicting the sunlit, vibrating atmosphere of the Flemish countryside exerted a strong influence on Dutch artists around 1600.

This is a typical, intimate, Netherlandish landscape: some houses, a section of a small village on a plain, a church and a winding, frozen river, and the small, stocky skaters so like those of Bruegel. Savery could have been inspired by Bruegel's picture, *Winter Landscape with a Bird Trap* (Musées Royaux des Beaux-Arts de Belgique, Brussels). Together with his *January* painting (Vienna), these are the first "modern" landscapes; they were frequently used as models by late sixteenth- and early seventeenth-century masters. Here, as in the Brussels painting, Savery created a sense of depth by using zigzag diagonals accentuating the design and receding tonal values toward the background, resulting in an effective depiction of space. The two large, mysteriously shaped trees in the foreground contrast with the simple, everyday scene they effectively frame. Savery arranged trees similarly in the large *Winter Landscape* drawing in Vienna (Benesch 1928, no. 276a), which seems slightly later than the Budapest example; it probably dates from the early 1600s. The highly stylized trees, of a type seen often in works by Hieronymus Bosch (c. 1450–1516) and Bruegel, are the most decorative elements of the drawing. Echoes of Savery's fantastic trees can be found in the works of seventeenth-century masters like Denis van Alsloot (1568–1625), Gysbrecht Lijtens (1586–1656), and Jacques van Geel (c. 1585–c. 1638).

T.G.

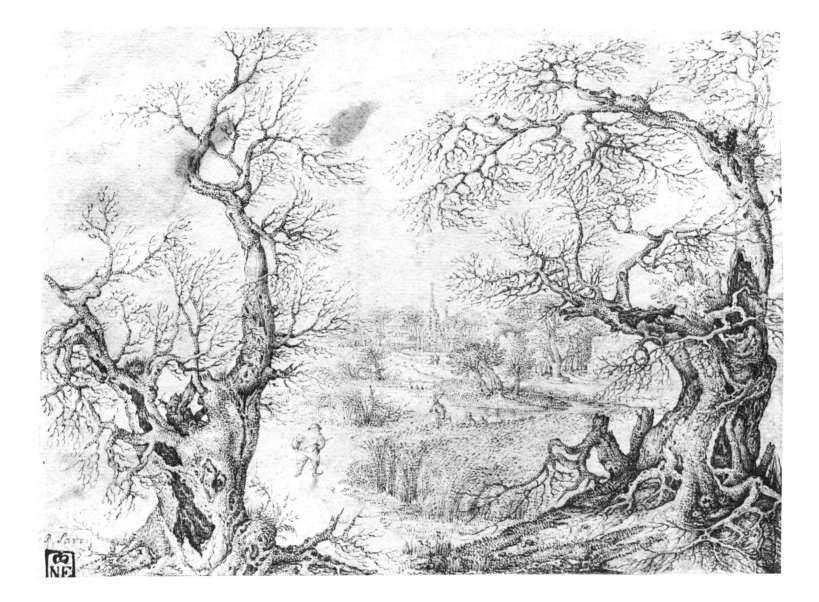

Paulus van Vianen
River Landscape with Raft

71
Paulus van Vianen
Utrecht c. 1570–1613 Prague
River Landscape with Raft
(verso: *Four Roman Ruins*)
Pen and brown ink with blue and brown washes (verso: pen and
brown ink); later number at lower left, *No. 16.*; 197 x 297 mm
(7¾ x 11¹¹⁄₁₆).
Provenance: Esterházy (Lugt 1965); inv. 1405.
Literature: Gerszi 1971a, no. 309a; Gerszi 1982, 25, no. 11.

Paulus van Vianen was a noted goldsmith who after traveling abroad settled for a short time in Salzburg (1601–1603) where he worked for Archbishop Wolf Dietrich von Raitenau. Later, at the invitation of Emperor Rudolf II (reigned 1576–1612), he went to Prague where he remained a distinguished court artist until the end of his life.

He is less well known for his expertly executed landscape drawings that place him among the leading landscape artists of his time. Few works from c. 1600 are known in which the observation of nature plays such a principal role as it does in Vianen's drawings. Most of his extant landscapes are from sketchbooks, the sheets of which were later scattered, that he used in Salzburg; today sizeable numbers of them are found only in Budapest and Berlin. The subjects as well as the manner of drawing in the Salzburg works are quite varied: topographically accurate Alpine panoramas, views of towns, forest details, and river scenes, as well as detail studies, executed with a naturalist's exactitude, with rocks, trees, and river beds.

Vianen was a supreme master with the pen, with or without washes, as the *River Landscape with Raft* amply dem-onstrates. One of his more elaborate, finished compositions, it is from the Salzburg sketchbook and represents a view somewhere on the upper Salzach River. In this large-scale composition with the diagonally placed river producing a powerful spatial illusion, the debt to an etching after Pieter Bruegel (c. 1520–1569) is obvious (Münz 1961, no. A3, fig. 155). Vianen's fine-lined pen manner, too, follows that of Bruegel (Gerszi 1982, 22–26), though the realization of details and his painterly solution are completely individual. The artist used an exacting pen technique for the trees and plants in the foreground, providing an effective contrast to the impressionistic, spirited brushwork in the mountainside. Vianen achieved through the contrasts of light and shade an effective re-creation of the atmosphere of the scene, with its vibrating sunlight and humidity. The details of the mountainside are hazy and the large rocky masses almost weightless. Vianen, in recognizing the importance of changes of light in nature, thus anticipates one of the principal problems with which succeeding generations of artists would grapple.

T.G.

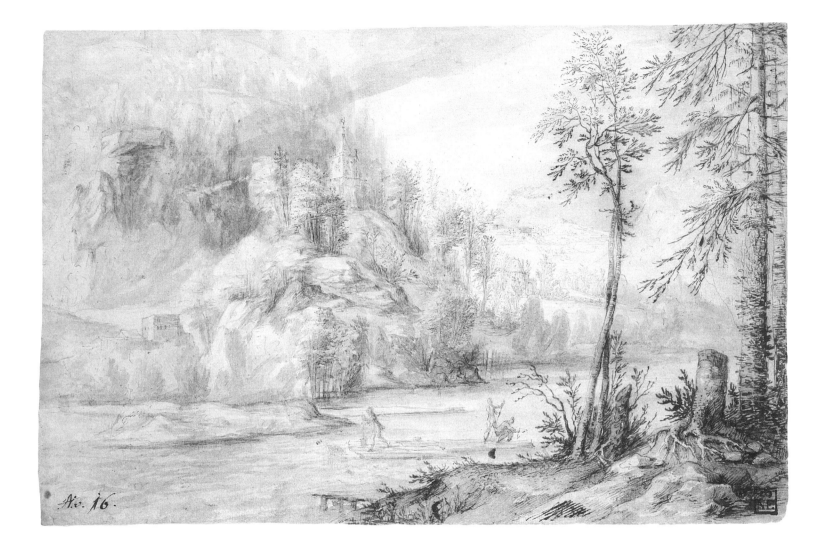

Ao. 16.

Jan Brueghel the Elder
Landscape with Tobias and the Angel

72
Jan Brueghel the Elder
Brussels 1568–1625 Antwerp
Landscape with Tobias and the Angel
Pen and brown ink with light brown, bluish-gray, and blue
washes, contour lines incised with a stylus; signed, *J. breugel F.*
(verso, *H. Breugel Feci*); 202 x 313 mm (7¹⁵⁄₁₆ x 12⁵⁄₁₆).
Provenance: Prince Hohenzollern-Hechingen or Romanoff
Nikolaivitch (Lugt 2087); museum purchase, 1894; inv. 1307.
Literature: Gerszi 1965, 108–112, fig. 13; Gerszi 1971a, no. 30;
Berlin 1975, no. 117, fig. 217.

Jan Brueghel occupies a key place among the Netherlandish landscape painters around 1600 because he made an important contribution to the development of the Rubensian as well as the Dutch realistic landscape style.

He took the achievements of his father, Pieter Bruegel the Elder, as a point of departure, though he continued to develop new types of compositions in the different branches of landscape. The *Landscape with Tobias and the Angel,* while based on the elder Bruegel's art, marks the appearance of a new compositional type in Jan Brueghel's oeuvre. (Its popularity was assured by the print engraved by Aegidius Sadeler as the first in a new landscape series; Hollstein a, vol. 3, 44.) The motifs and the composition can be traced to two pictures by Pieter: a drawing of a *Hilly Landscape with Donkeys and Goats* known only through old copies, and the etching *Milites Requiescentes* (Berlin 1975, no. 46, fig. 77; Bastelaer 1908, no. 17). Jan Brueghel considerably simplified and thus modernized the elder Bruegel's composition by adding large trees to the left, thus blocking the view on that side. The work was done in c. 1595–1596, at the end of his Italian trip

(1590–1596) or shortly thereafter, when his drawing style was characterized by a virtuoso pen technique. The lively depiction of the trees and foliage through the use of generous brushwork suggests a much more accurate observation of nature than that seen in his earlier works and indicates also the influence of Girolamo Muziano (1530–1592).

The horizon is very elevated, and the fore-, middle-, and backgrounds appear quite separate. This type of composition, seen in a number of drawings and paintings from different periods, occupied the master for years. It led ultimately to more unified spatial construction, a lower horizon line, more realistic treatment of details, and a more sensitive unfolding of atmosphere. The Albertina (Vienna) sheet *Trees on a Hill* represents the next step in its development, along with the *Road Leading to the Market* of 1601 (formerly Kaplan collection, London), followed by a sheet dated 1604 in Vaduz (Liechtenstein collection) and another of 1606 (Sotheby's, London; Ertz 1979, 146, fig. 149, nos. 78, 105 and fig. 147, no. 136), all later variants of the Budapest drawing.

T.G.

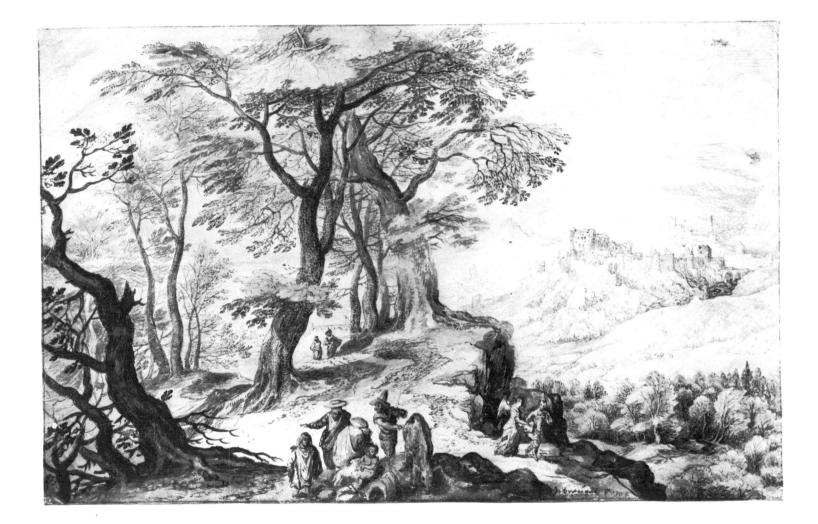

Hendrick Avercamp
Landscape with Ferry

73
Hendrick Avercamp
Amsterdam 1585–1634 Kampen
Landscape with Ferry
Brush and watercolor with pen and brown ink with white
heightening; inscribed at lower left, *Stomme von Campen*;
94 x 313 mm (3¹¹⁄₁₆ x 12⁵⁄₁₆).
Provenance: Esterházy (Lugt 1965); inv. 1474.
Literature: Gerszi 1976, no. 28; Welcker 1979, no. T 92.
Color illustration: page 17.

During the first three decades of the seventeenth century, Hendrick Avercamp and the painters Willem Buytewech (1591/1592–1624), Esaias van de Velde (1590/1591–1630), and Hercules Seghers (1589/1590–c. 1638) made considerable contributions to the creation of the quintessential Dutch landscape school. Avercamp, a deaf mute, lived in the small town of Kampen, far from the great artistic centers. After serving his apprenticeship, though, he remained in touch with the artistic circles of Haarlem and Amsterdam. After coming under the influence of David Vinckboons (1576–1632) for a short time, he experimented with the realistic representation of space and atmosphere, which Pieter Bruegel and Jan Brueghel had begun. Next to the seashore, the subject he represented most frequently was the river landscape, which was also very popular in Flanders in c. 1600. Pictures of this type by Jan Brueghel had met with remarkable success earlier.

In *Landscape with Ferry*, however, Flemish antecedents are not in evidence. Rather, the artist's solution for this traditional subject is a novel one even in its format. A parallel can be observed in Dutch seventeenth-century art, where the extended horizontal format is used quite often, especially in the drawings and prints by Buytewech, Esaias and Jan (1593–1641) van de Velde, and Seghers, as it is especially well suited for conveying the horizontal nature of the peaceful, Dutch flatland.

The extreme reduction of motifs seen in the Budapest drawing is rare even in Avercamp's oeuvre. The artist's refusal to populate the foreground with figures is especially curious, as they render the rest of his works very much alive. Except for the animals and a few people on the boat, only a few small figures can be discerned in the distance. They blend into the landscape without disturbing its unity and tranquility. The gentle, almost imperceptible diagonal of the river, with its wide berth, and the strip of sky govern the composition. Between the river and the sky is a green, wedge-like strip of land with delicately graded colors. The field is executed in carefully varied brushstrokes, while the buildings and trees on the horizon are articulated more strongly. The small brown, red, and blue-green patches worked into the dominant green bear witness to the artist's superior sensitivity. The subtle, veiled quality accurately describes the muggy river atmosphere. This watercolor technique had already been used by sixteenth-century Netherlandish painters, but no artist before Avercamp had used it so masterfully to depict the characteristic atmosphere of the land.

T.G.

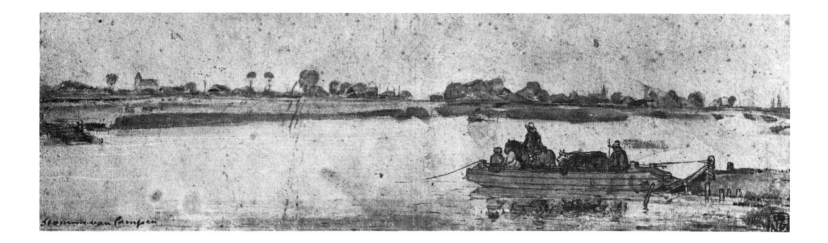

Aelbert Cuyp
Landscape with Flock of Sheep

74
Aelbert Cuyp
Dordrecht 1620–1691 Dordrecht
Landscape with Flock of Sheep
Black chalk and graphite with yellow and gray washes;
signed, *A.C.*; 190 x 308 mm (7⁷⁄₁₆ x 12⅛).
Provenance: J.C. Spenger (Lugt 1434); purchased from Colnaghi,
London 1896; inv. 1495.
Literature: Gerszi 1976, no. 33.

By the age of eighteen or twenty Cuyp had produced a number of important paintings and drawings. The Budapest sheet, an early work, prefigures the achievements of Dutch landscape art to be made around the middle of the seventeenth century. The drawing can be dated to 1642–1644 and connected through its composition and subject to other works by Cuyp such as a painting in Besançon dated 1639, a picture in the Czernin collection (Salzburg; Reiss 1975, vol. 1, no. 11) and a painting in Pella (Central College; Gelder-Jost 1969, 102, fig. 9) made after 1640. To these we can add the drawings of 1642–1644 in Rotterdam and Berlin (Dordrecht 1977–1978, no. 49; Bock-Rosenberg 1930, 112 [inv. 5443], pl. 84).

Even in his earliest painting, *Landscape with Cows* (Besançon), Cuyp's aspirations to create an airy, wide foreground are clear; he placed his main motif in the middle ground; then, toward the background, he opens only narrow vistas. In the Budapest drawing, just as in the earlier compositions we have mentioned, he created the illusion of space with slightly accented diagonals, which he then balanced with variously lighted strips of land running parallel to the edge of the picture. The spacious foreground with its deep field; behind it the compact masses of trees; and finally in the distance a chain of mountains with gentle contours: all this contributes to a large-scale, harmonious composition. Unlike the aforementioned works, this sheet exhibits a classical, simple, and well-balanced composition, achieved through an economy of means and an eminently tectonic structure. The delightful yellow washes applied with delicate gradations of shading lend to this work a warm tone and a cheerful mood frequently seen in Cuyp's early paintings.

Among the Dutch painters Cuyp was the first to use regularly the graphite pencil (especially evident in the distant background of this sheet) because it allowed him to produce finer and paler lines which, when compared to the forceful dark chalk lines in the foreground, create a sense of depth and an increased painterly effect. There is a special vitality in his trees and the whirling foliage, for which he utilized the methods of Jan van Goyen (1596–1656) and Pieter Molijn. Because of Cuyp's effective use of light, though, his trees appear much more sculptural. Light plays a dominant role in his work: there are few shadows and the entire landscape is bathed in a warm atmosphere.

T.G.

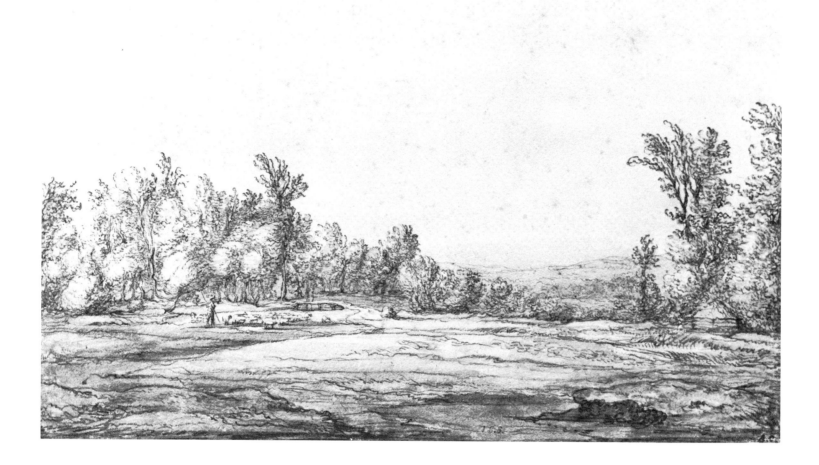

Gillis Neyts
Landscape with Houses

75
Gillis Neyts
Ghent 1623–1687 Antwerp
Landscape with Houses
Brush and multicolored washes with pen and brown ink; signed,
g. Neyts .f (verso: *St Jan Lenau ... bisschop hol.*); 141 x 195 mm
(5⁹⁄₁₆ x 7¹¹⁄₁₆).
Provenance: Museum purchase 1915 from C. G. Boerner;
inv. 1915–2363.
Literature: Gerszi 1976, no. 26.

Gillis Neyts, a landscape painter and etcher who worked in Antwerp during the second half of the seventeenth century, was famous among his contemporaries because of his skill as a draftsman. Lucas van Uden (1595–1672/1673), a painter of Rubensian landscapes, may have been his master. The Dutch painters, too, may have inspired Neyts who was concerned with the play of light and the rendering of atmosphere. He was particularly interested in topographical and city views in which he could place his favorite elements—ruins or clusters of small buildings. His rather intimate pictures are pervaded by his deep love of nature.

Neyts preferred small-scale works and a delicate, painstaking pen technique, but there are also more ambitious landscapes and spontaneous, pure watercolors in his oeuvre. Toward the middle of the seventeenth century few artists produced watercolors and thus Neyts' pages were in demand. Neyts also used a combined pen and wash technique, in which the *Landscape with Houses* is executed. This sheet is probably from a series of drawings now in the Albertina. A highly finished, signed sheet, the Budapest drawing was intended for sale. Neyts concentrated primarily on his painterly execution and was less concerned with coloristic effects. Here green is predominant, enhanced by the random placement of brown and yellow spots that help to increase the intensity of the overall green impression. Neyts applied strong, full colors with his brush or barely touched the paper with thin veils of color when a delicate passage was required to lead into the white sections left on the drawing. Thus he achieved a plenitude of sunlight and a pleasing delicacy. The brushwork was then completed by differentiated pen work, which gives more rigidity to the forms: slender, sweeping lines establish the motif in the foreground; fine parallels and small dots make the slightly waving tree crowns; dots and tiny semicircles indicate the blurred tree shapes of the distant mountainside. Gillis Neyts joined a drawing tradition which, following Jan Brueghel, Roeland Savery (1576–1639), and Joos de Momper (1564–1635), can be traced back to Pieter Bruegel.

T.G.

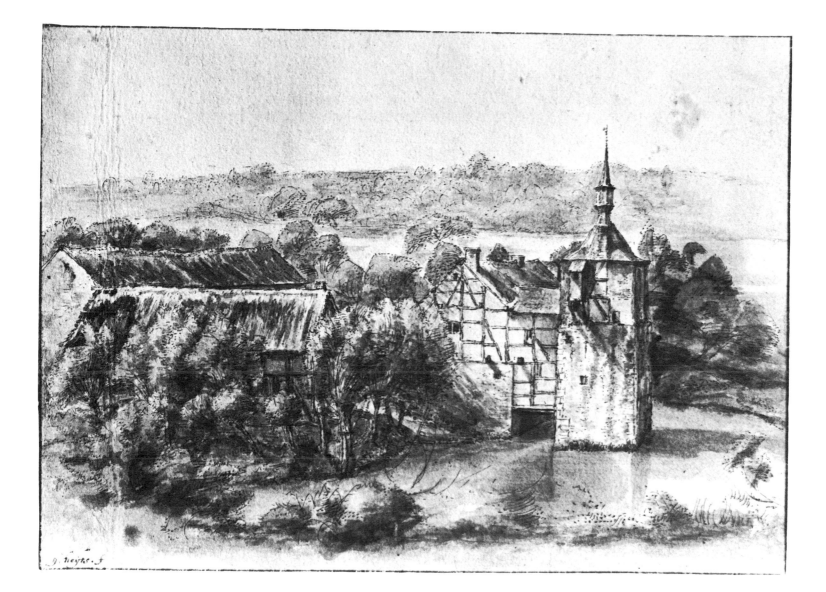

Rembrandt van Rijn
Dutch Farmhouse

76
Rembrandt van Rijn
Leiden 1606–1669 Amsterdam
Dutch Farmhouse
Pen and brown ink with brown washes; inscribed at bottom
(later), *Rembrandt*; 162 x 225 mm (6⅜ x 8⅞).
Watermark: Coat of arms with lily (similar to Heawood 1768–69).
Provenance: Nowohratsky-Kollowrath; Esterházy (Lugt 1965);
inv. 1576.
Literature: Benesch 1954, vol. 2, 107, no. 464, fig. 524;
Amsterdam 1969, no. 47; Gerszi 1976, no. 40.

The young Rembrandt concentrated his attention almost
exclusively on people. Only after the death of his wife Saskia
in 1641, in the ensuing years of loneliness and grief, did he
move closer to nature and begin to produce landscapes. This
view of a Dutch farmhouse can be dated to c. 1636, a time
when he produced very few landscapes. The master immor-
talized here a section of the dwelling, which he later drew
from a distance in another drawing (also in the Budapest
Museum of Fine Arts [Benesch 1954, vol. 2, no. 463, fig.
523]) and in a view in the Fitzwilliam Museum, Cambridge
(Benesch 1954, vol. 1, no. 57a, and vol. 2, fig. 519) made
from a different angle and distance and rendered in a fleeting
manner. Of the three drawings, this one represents the peak
of the artist's expressive powers, carrying in every pen stroke
the excitement of his painterly vision. When Rembrandt
reached the vantage point from which he made this drawing,
the sunlight had already touched the house from another
angle, the highlights were less vibrating, and the shadows
deeper than in the later drawing. The broad, dark, almost
solid walls contribute to the tranquil, restful mood.

In comparison, the vines appear more lively: they creep
over the roof while the foliage almost trembles from the
effects of the sunshine. Here and there spots of shadow appear
on the roof, almost competing with the sunlight (denoted by
the white spots on the paper). There is a sharp contrast
between the shadows of the solid, geometric forms of the
walls and the irregular, interwoven lines of the vines with
their light shadows. The creation of contrasts of form and
mood is accentuated also by different kinds of pen strokes:
the house, except for the sun-bathed gable, is established with
powerful verticals, while the creeping vines and the foliage
are treated with delicate and capricious line-work.

T.G.

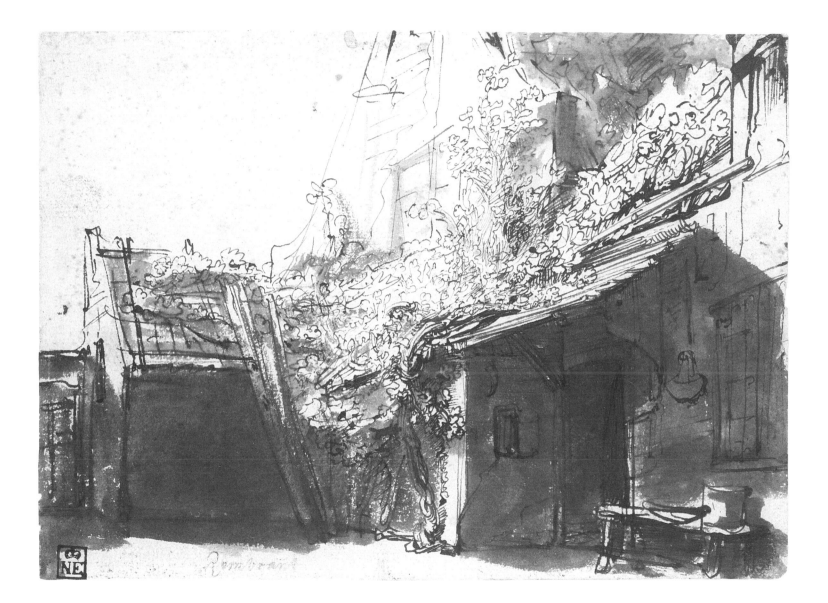

Rembrandt van Rijn
Woman with Crying Child and Dog

77
Rembrandt van Rijn
Leiden 1606–1669 Amsterdam
Woman with Crying Child and Dog
Pen and brown ink; inscribed at lower right (later), *Rembrandt*;
182 x 145 mm (7⅛ x 5¹¹⁄₁₆).
Provenance: Nowohratsky-Kollowrath; Esterházy (Lugt 1965,
1966); inv. 1589.
Literature: Benesch 1954, vol. 2, 93, no. 411, fig. 460; Rotterdam-
Amsterdam 1956, no. 44a, fig. 74; Gerszi 1976, no. 41.

After he married Saskia van Uylenburgh in 1634, especially after the birth of their children, Rembrandt's life changed radically. The master entered the realm of women and children who were to him a fascinating novelty. Documents attest to this fascination: 135 drawings from Rembrandt's estate representing women and children entered the collection of the marine painter Jan van de Cappell (1624/1625–1679) (Scheidig 1962, 31), though less than half of them are known today. The master was not exclusively interested in depicting his own family, and he treated various related subjects as well. His impressions were vigorously drawn in pen and chalk, media well-suited to describe the momentary episodes of everyday life. These drawings, like most others by the master, were not conceived as preparatory sketches. Rather, they served to nourish his imagination and to help him to break through conventions and reach new artistic solutions.

Here Rembrandt recorded his impression of a simple street scene. He analyzed the intimate relationship between a mother and her child in a brilliantly observed, refined, and emotional picture full of lively bravura. The dog which stretches its head toward the child in a gesture of friendship; the frightened, crying child and the mother who kneels down to protect him; and the person who has come to the window to discern the reason for the commotion in the street all have a concerned and sympathetic air that suggests this sketch must have been made from life. But we know a sketch in the Lugt collection (Benesch 1954, vol. 2, no. 403, fig. 466) which may precede the Budapest drawing. In the Lugt sheet the actions are undeveloped and the relationship is unclear; it must have been drawn at the scene. The Budapest drawing represents a more developed synthesis of observation and artistic sensation: the tightly knit group of three figures with the basket form a pyramid within which the mother and child together form an oval. The street and the house are indicated with rapidly set down but eloquent lines. There is no trace here of the dramatic contrast of light and shading and of the baroque sensationalism characteristic of Rembrandt's compositions of the 1630s, though this drawing must be dated also toward the middle of that same decade. For this intimate scene the master employed the simplest tools: pen strokes of varied intensity and width and some cross hatching, through which he successfully delineated space, air, light, plasticity of form, and the specific gestures and emotions of the figures.

T.G.

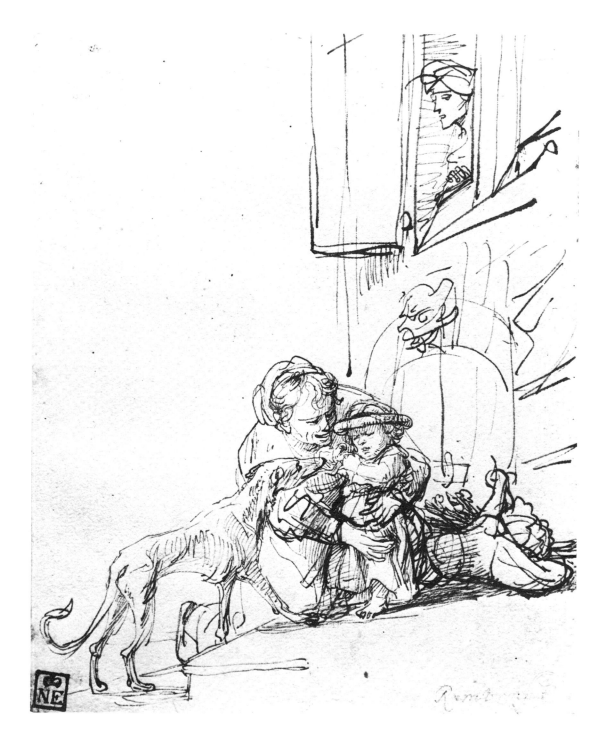

Rembrandt van Rijn
Female Nude

78
Rembrandt van Rijn
Leiden 1606–1669 Amsterdam
Female Nude
Black chalk with white heightening; inscribed at lower right
(later), *Rembrandt*; 253 x 162 mm (9¹⁵⁄₁₆ x 6⅜).
Provenance: Poggi (Lugt 617); Esterházy (Lugt 1965); inv. 1575.
Literature: Benesch 1955, vol. 4, 192, no. 713, fig. 855; Gerszi 1976,
no. 42.

According to the inventory taken after Rembrandt's death, one portfolio contained only male and female nude studies, confirming the master's keen interest in the human figure. As a teacher, he occupied himself constantly with this subject. He began to make drawings of female nudes in 1631 when he moved to Amsterdam, though the finest examples of this theme date from the late 1650s. The Budapest nude dates from c. 1646 and is similar in style to the *Seated Man* in Besançon and the *Recumbent Female Nude* in the Hamburg Kunsthalle (Benesch 1955, vol. 4, nos. 711, 712, figs. 854, 856).

Like the figure in the Besançon drawing, the Budapest nude emerges from the darkness of a room like a vision; the plasticity of the form is indicated by modulated shadings, with transparent areas as well as strong, sharp, chalk lines. In concept the nude deviates considerably from the naturalistic depictions of the 1630s, which are void of all attempts at embellishment or improvement; this is evident already from the model's more harmoniously proportioned body. Here the master did not concentrate on details but focused his attention on the larger concept.

Beginning in his works of c. 1640 Rembrandt's efforts to produce well-balanced, firmly structured compositions become generally noticeable. The new tendency is expressed here through the static pose of the model and the summary portrayal of the female body. Rembrandt strove constantly, even in his studies of the nude, to present his models' outward appearance and inner expression as a unified whole. The posture, movements, disappearing profile, and the radiating harmony and sensitivity of the body point to the model's spiritual and emotional state.

Unlike Rembrandt's early works, this drawing is quite restrained, its lines calm and curving. The often repeated, soft contour lines marry the figure to the surrounding atmosphere, rather than delineate firmly the silhouette. Works of Rembrandt and the Dutch artists in general, even when depicting a single object or figure, are characterized by the integration of atmosphere and environment.

T.G.

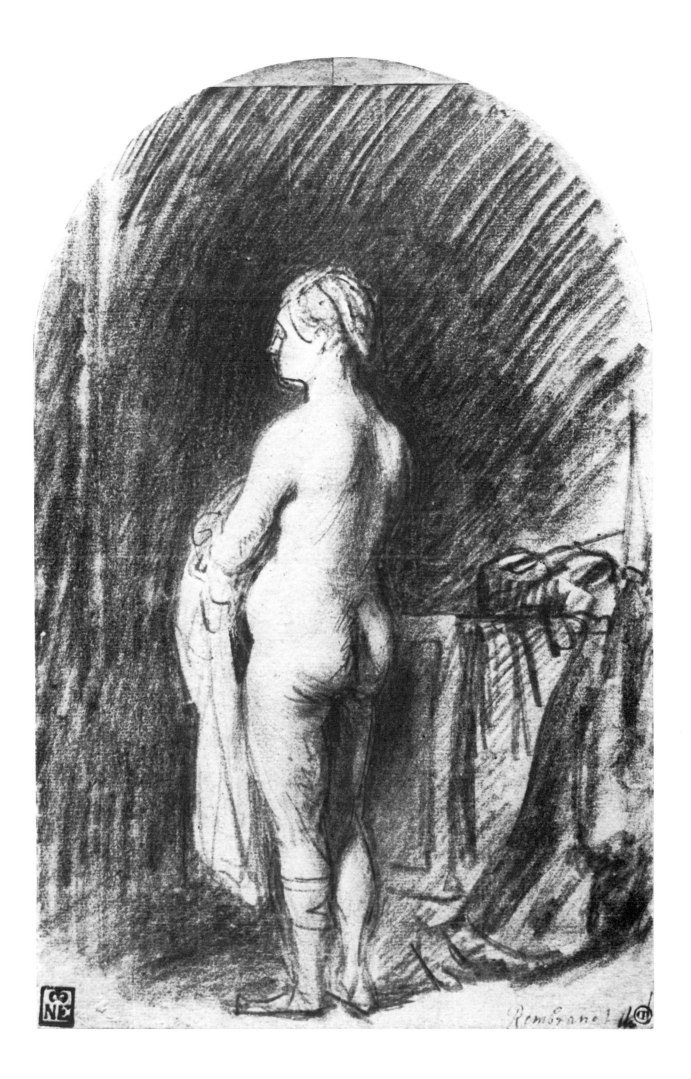

Pieter Molijn
Landscape with Harvesters

79
Pieter Molijn
London 1595–1661 Haarlem
Landscape with Harvesters
Black chalk with brown washes; signed at upper right,
P. Molijn 1658; 190 x 292 mm (7⁷⁄₁₆ x 11½).
Watermark: Horn with letters (similar to Heawood 2669).
Provenance: Purchased from C.J. Wawra, 1894; inv. 1548.
Literature: Gerszi 1976, no. 32.

Molijn must be considered one of the innovative landscape artists of the Haarlem school on the basis of a few remarkable paintings he executed in c. 1620. His later works, however, are more conservative and show his attachment to Flemish traditions and Dutch mannerism. Proof of his traditionalism is found in the fact that even during the middle of the century Molijn prepared series of the months, to be either reproduced in prints or sold outright. His most meticulously rendered chalk drawings always give the impression of finished works regardless of their purpose. Many of his dated drawings are known, most from the 1650s; the Budapest view (1658) represents the month of July and recalls another example in a series of months in the Teylers Stichting, Haarlem (Scholten 1904, nos. 60–71).

In the Budapest landscape depth is achieved by the usual zigzag, diagonal lines; the road leading into the background, with the diminishing trees, and the fence, figures, and wagons further accentuate the receding lines. The structure of the composition and its subject are related to the *Harvest* of 1614 by Jan Brueghel (Private coll.; Ertz 1979, no. 281, fig. 45), which exerted quite an influence on the images of the Dutch lowlands. The aforementioned Brueghel painting, however, recalls the noted *Harvesters* by the elder Pieter Bruegel in New York (Metropolitan). Thus the work by Molijn connects indirectly to the Bruegel tradition. The group of three harvesters with a child appears to have been borrowed from supplementary figures in another painting by Bruegel, the *Haymakers* in Prague (Národní Galerie).

Molijn's technique seems to resemble that of Jan van Goyen (1596–1656), but the decorative effect of his chalk drawings is more forceful. Molijn's drawn oeuvre is characterized by a greater attention to detail, especially in the foreground, and a strong graphic quality undiminished by the wet washes where the chalk lines still dominate. Here the white stripes, which constitute effective highlights, not only enhance the drawing's liveliness and decorative quality, but serve to define the structure of the composition and the space. The bright strips, elements of the composition, can be detected in the master's early pictures.

T.G.

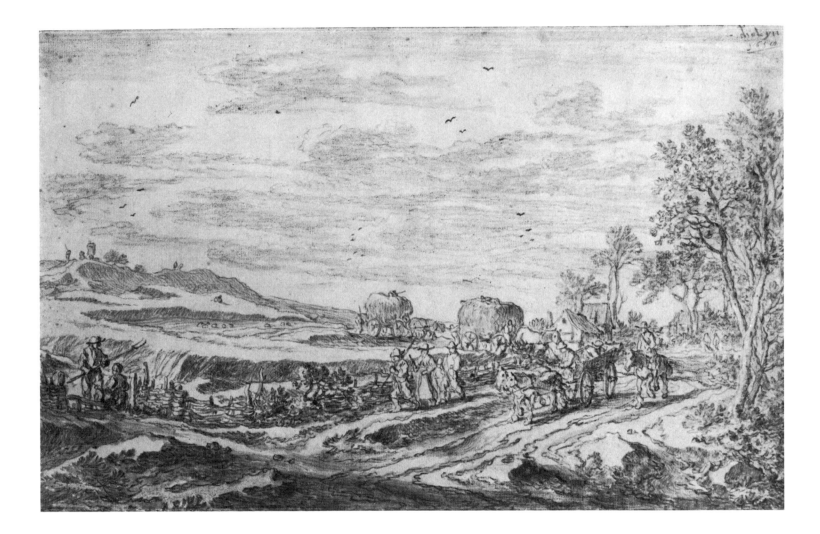

Ferdinand Bol
The Angel Appearing to Manoah and His Wife

80
Ferdinand Bol
Dordrecht 1616–1680 Amsterdam
The Angel Appearing to Manoah and His Wife
Pen and brown ink with washes and black chalk with white
heightening; 183 x 261 mm (7³⁄₁₆ x 10¼).
Watermark: Crosier (similar to Heawood 1197).
Provenance: Nowohratsky-Kollowrath; Esterházy (Lugt 1965,
1966); inv. 1484.
Literature: Gerszi 1971b, 103–105, fig. 90; Sumowski 1979, vol. 1,
no. 136[x].

Bol, who worked in Rembrandt's studio from 1636 to 1640, became known for the high quality of the drawings he produced. His early works were so close to those of his master that even today it is difficult to determine the authorship of some. (Rembrandt's students, who would often use one of his works as a point of departure, borrowed details and even entire compositions, and closely approximated the drawing style of their master.)

Bol looked to Rembrandt prototypes for inspiration for the figures of Manoah and the kneeling woman, who are especially close to the lean, tall, narrow-faced types found in Rembrandt's works from the early 1630s. The decorative figure of the angel seems to be the most individualistic motif and is very frequently seen in Bol's work. According to Werner Sumowski (1979), this sheet was patterned after a drawing in Rotterdam that represents the same subject, which he attributed to Rembrandt (Benesch 1954, vol. 1, no. 75, fig. 83; Hoetink 1970, vol. 1, no. 72). The style of the drawing certainly approaches that seen in Rembrandt's

drawings from the years 1632–1634, but its decorative landscape details are closer to Bol's hand (Sumowski 1979, vol. 1, nos. 170[x], 178[x], 242[x], 264[x]). If the Rotterdam sheet is by Bol, it can be considered an earlier version of the Budapest drawing, which is also connected through its tight motifs and style to Bol's *Angel Appearing to Hagar* (Amsterdam; Sumowski 1979, vol. 1, no. 8a), datable to the late 1630s.

The impulsive, expressive drawing style and the powerful contrasts of light and shade could suggest a similar date for this work, which introduces the marked picturesque style of the 1640s seen in the *Prophet Elijah Visited by the Angel* (Museum of Fine Arts, Boston), the *Holy Family* (Hessisches Landesmuseum, Darmstadt), and the *Departure of Tobias* (North Carolina Museum of Art, Raleigh) (Sumowski 1979, vol. 1, nos. 137[x], 195[x], 265[x]). Despite its strong debt to Rembrandt, the Budapest drawing is a superb work in which both a personality and a unified artistic conception are well expressed.

T.G.

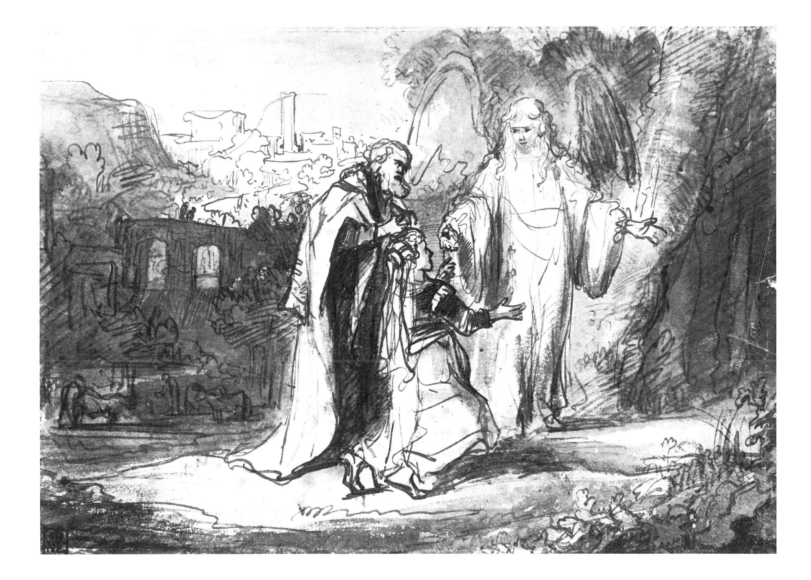

Jacob van Ruisdael
The Customhouse in Alkmaar

81
Jacob van Ruisdael
Haarlem 1628/1629–1682 Amsterdam
The Customhouse in Alkmaar
Black chalk with gray washes; 203 x 300 mm (8 x 11¹³⁄₁₆).
Watermark: Fool's cap (similar to Heawood 2040).
Provenance: S. Feitema; C. Ploos van Amstel; C. Josi; A. de Haas;
museum purchase, 1894; inv. 1605.
Literature: Gerszi 1976, no. 38; Giltay 1980, 154, no. 26.

Jacob van Ruisdael traveled widely in The Netherlands, especially during his youth, recording his impressions in chalk drawings that strike the viewer as finished compositions betraying a deeply emotional personality. Around 1650 Ruisdael and his painter friend Nicolaes Berchem (1620–1683) left Haarlem to explore the German-Dutch border region; slightly later they traveled to Alkmaar, northwest of Amsterdam. Three works in addition to the Budapest drawing resulted from this trip: the *View of the Gasthuis Street with the Groote Church* (British Museum, London) and possibly two views of a *Ruined Bridge* (Historisches Museum, Amsterdam, and Windsor) (Giltay 1980, no. 76; no. 9; no. 101 and figs. 18, 26–27; Slive 1981, nos. 81, 74, 75) were also done in Alkmaar at the same time. They seem to be connected through size, technique, degree of finish, and mood.

Also characteristic of this group of drawings by Ruisdael is their almost monumental scale and an emphasis on architectural elements in sunlight. Because of the latter, the entire group has been dated to the mid-1650s, just before the painter's move to Amsterdam, when Ruisdael tended to emphasize or even to enlarge certain elements in his work. Here the customhouse looms above the tower and the wooden bridge, drawn from a low viewpoint. A substantial part of the tower reaches into the sky and beyond the picture plane, adding to the impression of monumentality.

In contrast to the strong vertical accents of the blocklike customhouse, the horizontal bridge seems a subtle construction. An even more picturesque group is formed by the houses in the background; their gables, the trees, and the masts of sailboats point in various directions. Ruisdael used chalk only to define the contours with soft lines and to block out sections, while space and atmosphere are indicated with gray brushstrokes in various shades. The resulting town, bathed in summer sunshine, is a contemplative, idyllic, dreamlike vision.

T.G.

Jan Both
Trees beside a River

82
Jan Both
Utrecht c. 1615–1652 Utrecht
Trees beside a River
Brush and gray ink; signed at lower left, *J. Both f 1643*;
275 x 326 mm (10¹³⁄₁₆ x 12¹³⁄₁₆).
Watermark: Strasbourg lily (similar to Heawood 1768).
Provenance: Purchased from Artaria, Vienna, 1914; inv. 1914–114.
Literature: Gerszi 1976, no. 53; Burke 1976, 18, 103, 154, 155,
no. D–10, fig. 133.

Among the second generation of Dutch seventeenth-century painters who worked in Italy, Jan Both became influential in the development of Dutch landscape. He was the first to strike a balance between the classical-ideal composition and realistic details. His alleged master Carel de Hooch (d. 1638) may have passed on to him during his Utrecht years the experiences gained by the earlier generation of Dutch Italianate painters and the results of the Haarlem masters (Burke 1976, 45–50). Both then further explored in Italy the architectonic order of nature's large forms, which lent equilibrium and harmony to his classical, tight compositions. By flooding the atmosphere with strong, warm light, he imparted tranquility and brightness to his paintings.

The Budapest sheet's importance lies in the fact that it is the first dated drawing executed by Both after he returned from Italy to his native town. A new subject for him, this is a Dutch scene of a diagonally winding row of trees next to a river in the area around Utrecht. The vigorously drawn, solid trees with spreading crowns give an effect of monumentality, accentuated by the presence of tiny human figures. Trees, important elements of landscape and of his compositions, always play an important role in Both's work— probably never more than here. To a certain degree, this sheet may be based on two similar diagonally constructed paintings in Antwerp and Schwerin (Burke 1976, nos. 12, 197, fig. 93). However, the Budapest drawing is distinguished not by a wide vista but rather by a more intimate view.

The brush technique used here is important in evoking a mood: the master used it not only for shading but also to define certain shapes. The most delicate execution of details and the fine gradations in hue seem almost to presage the rococo. Light, as in all of Both's works, is important, but in the Budapest drawing, unlike his Italian works, there are no strong contrasts of light and shadow. The warm afternoon sun, glittering through the leaves, creates a unified, peaceful mood of serenity.

T.G.

Jan Lievens
Landscape with Shepherd Playing the Flute

83
Jan Lievens
Leiden 1607–1674 Amsterdam
Landscape with Shepherd Playing the Flute
Pen and brown ink on Japan paper; 223 x 370 mm (8¾ x 14⁹⁄₁₆).
Provenance: Esterházy (Lugt 1965, 1966); inv. 1530.
Literature: Schneider 1973, 233, no. z 302; Gerszi 1976, no. 47.

Though landscape paintings are rare in Jan Lievens' oeuvre, his landscape drawings are quite numerous, and most are large, carefully prepared, finished works that he intended to sell. The decorative quality of his work is enhanced by his use of a reed pen on golden, glowing Japan paper, as in this sheet. Lievens found inspiration for his landscapes in Titian's woodcuts, Annibale Carracci's drawings, and the landscapes of Rubens, Adriaen Brouwer, Cornelis Vroom, and Jacob van Ruisdael. He synthesized these various influences to form a wholly personal style that is expressed eloquently in his pen drawings. The Budapest sheet, like most of his other landscapes, is a carefully executed work that was preceded by sketches from nature (Sumowski 1980, 370–373).

The edge of a forest was one of Lievens' favorite subjects. He was attracted by the poetry of the wooded landscape and the sudden appearance of light in an unexpected clearing. The trees on the forest's edge glitter in the sunlight, forming an idyllic scene with a flute-playing shepherd and the peacefully grazing animals. A compositional scheme often seen in Lievens' landscapes is the very narrow strip of ground in front of the forest that almost entirely blocks any view of the distance. The artist may have studied some of Rubens' early landscapes such as the *Shepherd in the Forest* or the *Landscape with Animals at Sunset* (both National Gallery, London), which have an effect of limited space. But Lievens does not dwell upon the plasticity of the trees and the depiction of the edge of the forest is relieflike, creating an exciting rhythm through the varied placement of the light and dark tree trunks. While the trees are Rubensian—tall, slender, and with few limbs—the calligraphic designs of their crowns suggest the influence of Annibale Carracci.

T.G.

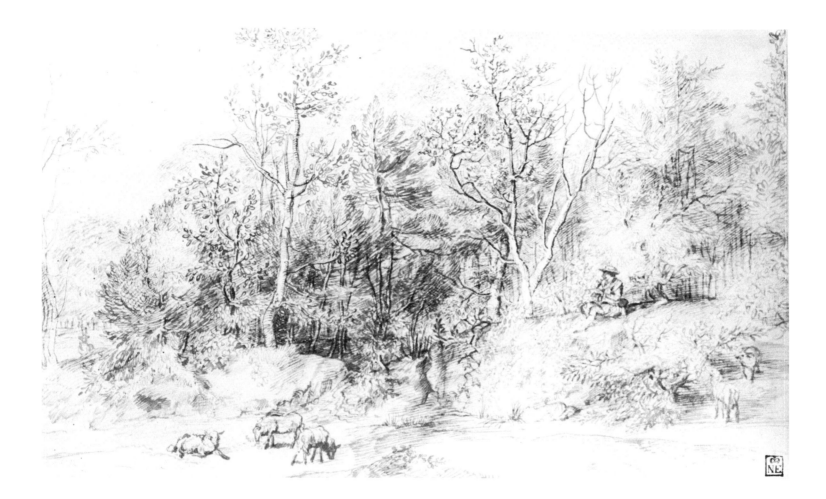

Jacob Jordaens
Genre Scene

84
Jacob Jordaens
Antwerp 1593–1678 Antwerp
Genre Scene
Brush and watercolor with preliminary red and black chalks with
white heightening; 176 x 136 mm (6¹⁵⁄₁₆ x 5⁵⁄₁₆).
Provenance: Poggi (Lugt 617); Esterházy (Lugt 1965); inv. 1524.
Literature: D'Hulst 1974, no. A 214, fig. 229; Gerszi 1976, no. 23.

Jordaens was not only a prolific painter but a passionate draftsman, and he left a very rich drawn oeuvre. His most characteristic type of drawing is the so-called *modello*, a carefully finished compositional sketch in a mixed technique of watercolor, chalks, and lead white. Jordaens used *modelli* rather than the customary oil sketches to demonstrate to his patrons a coloristic impression of planned works. He began his artistic career as a *waterschilder* who prepared pictures in tempera and watercolor on canvas to imitate tapestries, and for this reason he preferred the watercolor technique. The Budapest *Genre Scene* is unconnected with any known painting or tapestry, but its technique and subject bring it close to the eight cartoons for wall hangings representing proverbs that he prepared in 1644 (D'Hulst 1974, nos. A 188–A 192, A 195, A 200, A 416, A 417, figs. 202, 203, 205–207, 210, 439, 440). It can be presumed that this connection influenced D'Hulst to date this and a companion piece in Amsterdam to c. 1645 (F. and N. de Boer Foundation; D'Hulst 1974, no. A 213, fig. 228).

According to D'Hulst, the subject is the *wijnkoop* ceremony, a family feast when a young engaged couple, a few weeks before their wedding, offers gifts of wine and grapes to their parents and ask for assistance in their future life together. The prototype for this composition is found among the pictures of money changers or jewelers from the sixteenth century (the earliest is the *Banker and His Wife* by Quentin Massys; Louvre, Paris); Jordaens depicted rich interiors similar to those in the aforementioned sixteenth-century compositions, showing furniture and the usual family clutter that lend a domestic atmosphere.

Jordaens' interest in everyday life marks his themes, the spirit of his images, and his drawing style. Figures and objects are blocked out in simplified forms; this reduction of drawing is suitable for depicting expressive gestures and the bare essentials of characterization, and infuses the drawing with extraordinary vitality. The Flemish interpretation of baroque sensuality is strongly present in these summary and painterly *modelli*.

T.G.

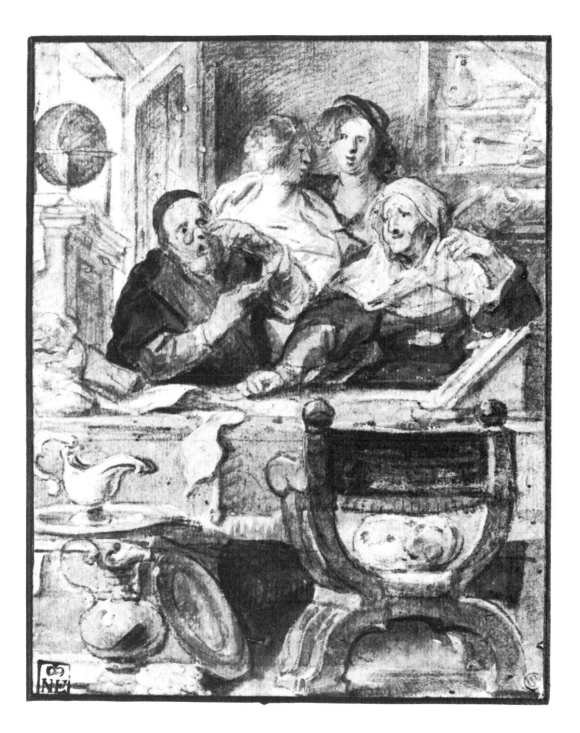

Adriaen van Ostade
Dutch Peasant Family

85
Adriaen van Ostade
Haarlem 1610–1684 Amsterdam
Dutch Peasant Family
Pen and brown ink with gray and brown washes over graphite;
238 x 194 mm (9⁵⁄₁₆ x 7⁵⁄₈).
Provenance: S. Feitama; Poggi (Lugt 617); Esterházy (Lugt 1965);
inv. 1555.
Literature: Gerszi 1976, no. 35; Schnackenburg 1981, 40, 41,
no. 131.

Van Ostade was one of the most active draftsmen among the Dutch painters. His oeuvre includes many preparatory sketches, figure studies, and independent sheets like the Budapest drawing. In contrast to his earlier works, which are full of movement and sharp contrasts of light and shade, this scene of a humble Dutch country family eating oysters has an idyllic, quiet atmosphere. The intimacy of family is enhanced by the picturesque clutter and the fine gradation from dark to light. Van Ostade was inspired here by Rembrandt's studies of light and shade from the 1640s.

The differentiated outlines, a spare inner design, and the double-toned washes not only establish the forms but bring out texture. The date of this drawing is uncertain due to a lack of dated works in this genre. Bernhard Schnackenburg (1981) places it toward 1660, though we believe it is much earlier because of its compositional similarity to the 1647 *Peasant Family* etching (B. 46). A drawing in Paris, the *Woman Peeling Potatoes*, dated about 1650 (Schnackenburg 1981, no. 92), has similar motifs and stylistic affinities as well.

The genre scene in the peasant interior was first introduced by Adriaen Brouwer (1605/1606–1638) who, according to tradition, worked with Van Ostade in the Haarlem studio of Frans Hals (c. 1580–1666). Through Brouwer, Pieter Bruegel's fundamental achievements in peasant genre pictures became known to Van Ostade. Another link to the Bruegel tradition was provided by the works of Flemish followers who had emigrated to Holland like Roeland Savery (1576–1639), Jacob Savery, David Vinckboons (1576–1632), and Adriaen van de Venne (1589–1662; Klessmann 1960, 92–115). Still, direct observation of Bruegel's works must have had the greatest impact. The results of Van Ostade's knowledge of Bruegel may be seen in several traits that he shares with the earlier master: a rigorous geometric composition; solid, lively figures; and a simple domestic setting. Certain motifs and forms, especially that of a family gathered around a fireplace (see, for example, the *Family Group at the Fireplace* in Amsterdam [Rijksprentenkabinet; Schnackenburg 1981, no. 91]), recall Bruegel's print *La Cuisine maigre* (Bastelaer 1908, 154) and provides concrete evidence of Van Ostade's debt to Bruegel.

T.G.

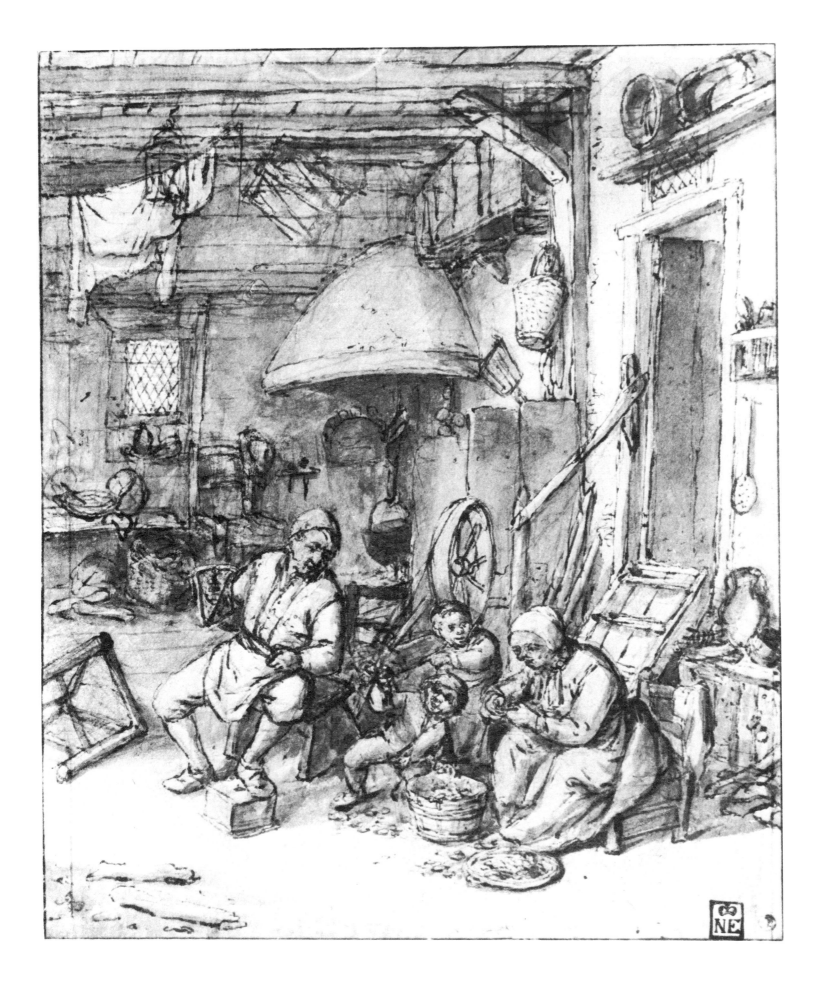

Cornelis Saftleven
Greyhound

86
Cornelis Saftleven
Gorkum 1607–1681 Rotterdam
Greyhound
Black chalk with gray washes; signed with monogram *CSL*
(interlaced) 1644; inscribed at lower left corner (nineteenth-
century), *Cornelis Sagtleven*; 199 x 248 mm (7¹³⁄₁₆ x 9¾).
Provenance: Purchased 1912 from O. Dolch; inv. 1912–1.
Literature: Schulz 1978, 50, 59, no. 298, fig. 97.

The Rotterdam artist Cornelis Saftleven was particularly
drawn to animal representations, which are numerous in both
his painted and large drawn oeuvres. Animals figure prom-
inently in his peasant genre scenes, biblical compositions,
and fantastic pictures.

Saftleven's early works suggest the influence of the
Flemish Roeland Savery (1576–1639), known for his pictures
of animals as well as his landscapes. After a prolonged stay in
Prague, Savery settled (1619) in Utrecht where Herman,
Cornelis' brother, lived. Cornelis probably also worked for
a while in Utrecht and may have known Savery's animal
paintings, which derived from his earlier Prague works.

At this time, the court of Rudolf II (reigned 1576–1612)
was an important center for the emerging study of the
natural sciences. Among the famed imperial collections was a
zoological garden that attracted visitors from all over Europe
and that was frequented by artists who liked to portray the
curiosities kept there. Savery's works resulted not only from
observing live animals, but can be traced back to medieval
pictorial traditions (Bialostocki 1959, 69–92). The emperor's
famous Dürer collection, with its epochal animal drawings,
particularly affected Savery: the greyhound in his painting of
Paradise (Gemäldegalerie, Berlin; Gand 1954, no. 60) was
surely adapted from Dürer's Windsor drawing (Winkler
1936, no. 241; Strauss 1974, no. 1500/1). Saftleven's Budapest

greyhound, seen in profile, resembles the Dürer prototype
in its carriage and attentive stance. The similarity of this
animal to Dürer's seems to indicate that Saftleven melded an
impression from nature with the depiction by the earlier
master. (There are several other instances when, through
Savery, Dürer seems to have influenced Saftleven: the *Head
of a Stag* in Paris not only resembles Savery's Berlin draw-
ing, a fact that Schulz had already recognized [Schulz 1978,
57, no. 332, fig. 94], but also recalls the Dürer example in
Kansas City of the same subject as well as the Bayonne draw-
ing [Winkler 1936, nos. 364, 365; Strauss 1974, nos. 1495/46,
1495/47].)

According to Schulz (1978) the Budapest sheet is the
first in Saftleven's superb series of mature studies of animals
from nature. He also indicated that there are some examples
among the later works that are more or less the result of out-
side influences, mostly those of Savery. Saftleven to a certain
degree followed this artist also in technical solutions, as, for
example, in the combination of chalk lines with washes.
After the gentle preliminary silhouetting with chalk, he
applied the washes to emphasize the form; over this he
added chalk lines to indicate the animal's coat. Like those of
Savery, Cornelis' animal drawings also cover the entire paper
surface and the surroundings are usually reduced to a
minimum, lending greater importance to the animals.

T.G.

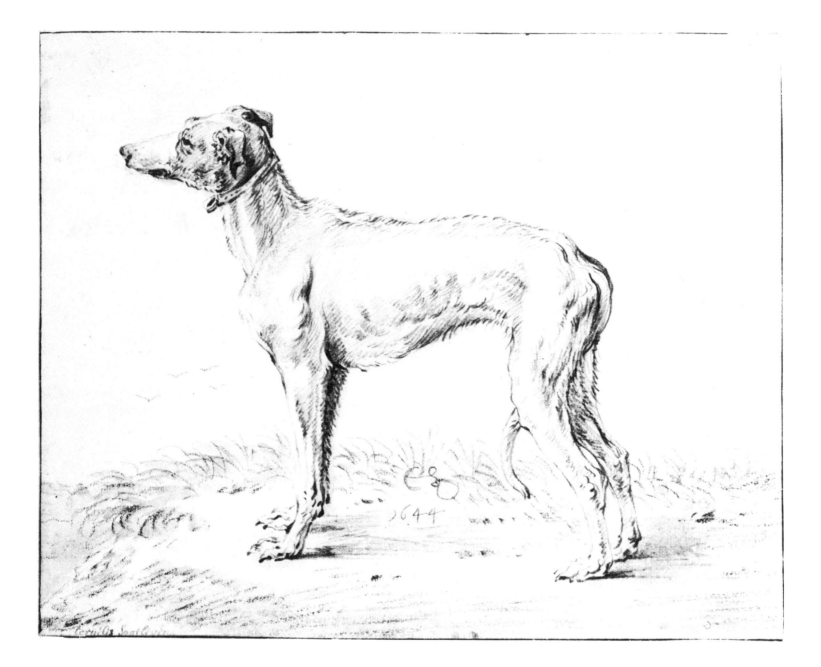

Cornelis Dusart
Peasant Counting

87
Cornelis Dusart
Haarlem 1660–1704 Haarlem
Peasant Counting
Black and red chalks; 294 x 202 mm (11⁹⁄₁₆ x 7¹⁵⁄₁₆).
Watermark: Coat of arms with horn and the letters *RW*
(Churchill 317).
Provenance: Purchased from C.J. Wawra, 1894; inv. 1503.
Literature: Gerszi 1976, no. 60.

Jan van Gool, who described Cornelis Dusart as the best pupil of Adriaen van Ostade, praised the beauty of his drawings. Indeed, he was one of the finest Dutch draftsmen active around the end of the seventeenth century. His close relationship with the master is proved by the fact that as the favorite pupil he inherited Ostade's artistic legacy, including an immense number of drawings. Yet as early as 1680, while still a young artist, he had fully developed a personal style that is probably best seen in his chalk drawings.

Dusart's most attractive sheets are found in the group of single figures in two or three colors of chalk, to which the Budapest sheet belongs. Other examples are in Düsseldorf, London (British Museum), Paris (Dutuit collection), Rotterdam, and the G. Abrams collection (Budde 1930, no. 829; Hind 1926, 80, no. 8, pl. XLIII; Lugt 1927, nos. 25–26; Museum Boymans-van Beuningen, Rotterdam, inv. nos. 4–5; Wellesley 1969, nos. 20–21). These sheets depict mostly unkempt peasant types described in a refined, painterly manner. The artistic quality of the sheet is in keeping with the striving for perfection of form and execution that was so characteristic of Dutch art around the close of the seventeenth century. Dutch art at this time reflected the subtle tastes of the wealthy upper class, which was aware of the achievements of French art. Perhaps the French influence is the source of the artist's predilection for subtle nuances in the shadings of the garment and in the plasticity of the face and hands. The position of the hands and feet as well as that of the head indicate that the figure is active. The exceptionally careful execution leads us to assume that the artist did not intend these drawings as detail or preparatory studies for a particular composition but rather as independent works to be offered for sale.

T.G.

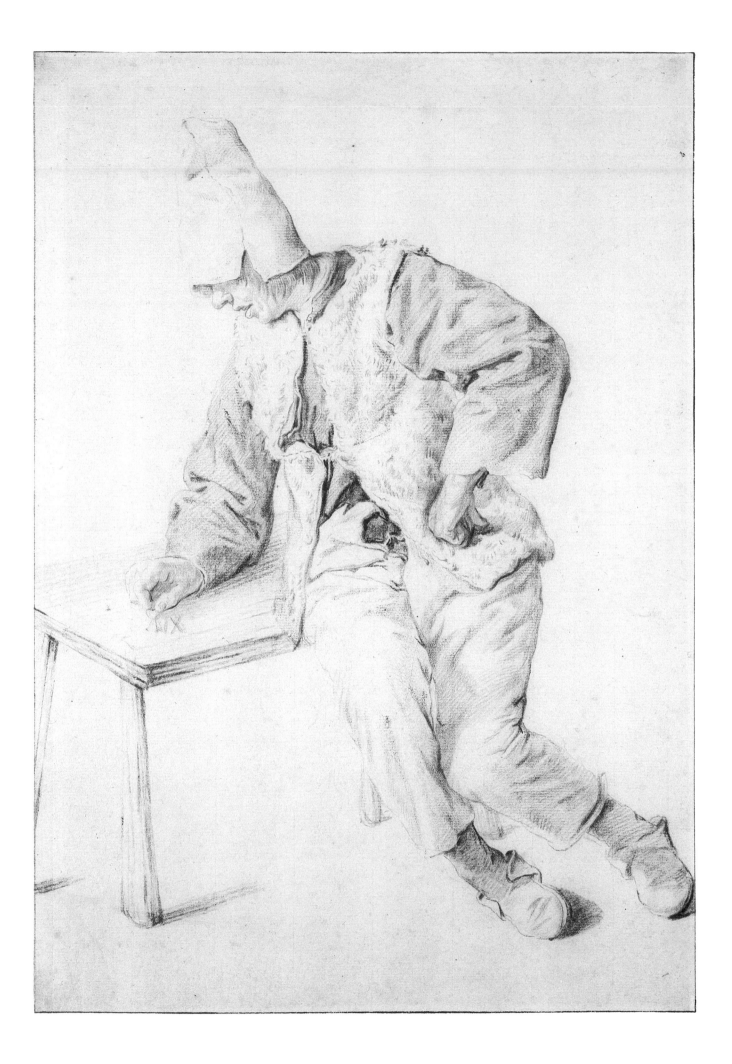

Jacob de Wit
Design for a Ceiling Decoration

88
Jacob de Wit
Amsterdam 1695–1754 Amsterdam
Design for a Ceiling Decoration
Watercolor; signed at lower left, *J. d. Wit invt.* (verso: inscribed
[later], *Plaffon . . . 1745*); 336 x 356 mm (13⅛ x 14).
Provenance: Purchased from G. Nebehay; inv. 1917–201.
Literature: Kaposy 1956, 68, fig. 39; Winther 1973, 42, 46, n. 55.

Jacob de Wit was among the most popular painter-decorators in eighteenth-century Holland. His art, though anchored to the traditions of Rubens and Van Dyck (1599–1641), soon absorbed the stylistic tendencies of his time. De Wit was influenced by the Italianizing Dutch painters, including Gérard Lairesse (1641–1711), and by the great decorator Daniel Marot (1663–1752), a recent arrival from France who had attracted attention with his large-scale interior decorations and paintings. De Wit's drawn oeuvre includes sketches for altarpieces and ceilings for palaces or noble country houses, and smaller grisaille designs for overdoors.

The artist took his subjects for numerous ceiling projects mostly from ancient mythology—Hercules' acceptance among the gods or the story of Pandora, for example—and also painted allegories of such subjects as music. The Budapest drawing, also for a ceiling painting, is a Parnassus scene of a rococo-style bacchanale: Bacchus wears a laurel wreath, Fortuna holds the winged globe, and Pan plays his pipe. They are entertained by bacchantes in colorful dress who play tympani and triangles while a satyr sounds his flute. De Wit arranged the composition in a traditional manner; the figures rest on clouds that entirely cover the space while emphasis is given to a group in the foreground. To achieve airiness, one of the upper corners is empty of figures and is occupied only by blue sky and delicately colored white clouds that become rose in hue. Thus the painter increased the feeling of height and distance and created an illusion of floating figures. When the completed work appeared on the ceiling it must have provided the viewer with the sensation of having entered the world of the gods.

This design was completed in 1745 and can be considered one of the most characteristic works by De Wit. At this time the master's technique had become less rigid than it was during the early 1740s; the floating figures are graceful and the colors are brilliant, shimmering, and clear. Both his compositions and watercolors are imbued with a characteristically French grace (Staring 1958, 190, ills. 57–58).

v.k.

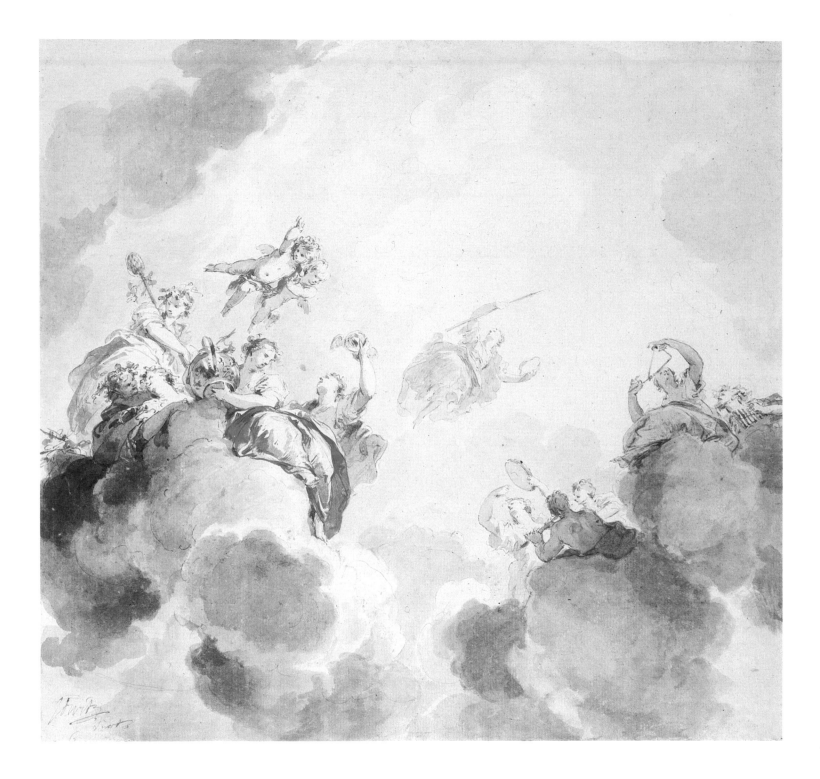

Jan van Huysum
Still Life with Fruits

89
Jan van Huysum
Amsterdam 1682–1719 Amsterdam
Still Life with Fruits
Charcoal with gray washes; 413 x 353 mm (16¼ x 13¹⁵⁄₁₆).
Provenance: Purchased from O. Dolch, 1912; inv. 1912–4.
Literature: Gerszi 1976, no. 64.

Jan van Huysum was the last of the great Dutch flower painters. During his lifetime his works were highly esteemed, and in the nineteenth century writers praised him as the "prince of flower painting." Today we appreciate his fresh, lively drawings. Here various fruits and flowers are combined —a mixture of motifs seen in early seventeenth-century still lifes. The historical antecedent for this genre is found in medieval biblical scenes, in which flowers and fruits have symbolic meaning. During the sixteenth century flower and fruit arrangements began to appear as still-life elements within figure compositions. The demand for pure flower and fruit pictures was fostered by the expanded interest in horticulture, botany, medical science, and by the growing agricultural production (Schneider 1979–1980, 266–288).

The symbolism inherent in flowers and fruits was gradually obscured after the sixteenth century, but a few still-life paintings by Van Huysum retained a sense of their symbolic content. The focus shifted from themes and meanings to formal qualities; at the same time a strong connection remained between the still life and the object.

From Van Huysum's correspondence we learn that he was committed to the idea of painting directly from nature, even to the point of refusing a commission when he was unable to procure a certain rare flower for a particular work (Grant 1954, 14). Van Huysum preferred asymmetrical compositions, strong contrasts, and a richly colored palette. As demonstrated by this drawing, he was a virtuoso with the brush as well as with charcoal. The charcoal lines that define his forms have a decorative quality while the subtle shadings emphasize plasticity. The faint brushstrokes that suggest the background flowers are proof of Van Huysum's uncommon painterly sensitivity. The bouyant composition and vitality seen here recall earlier Flemish still lifes, which exude joy and decorative splendor.

T.G.

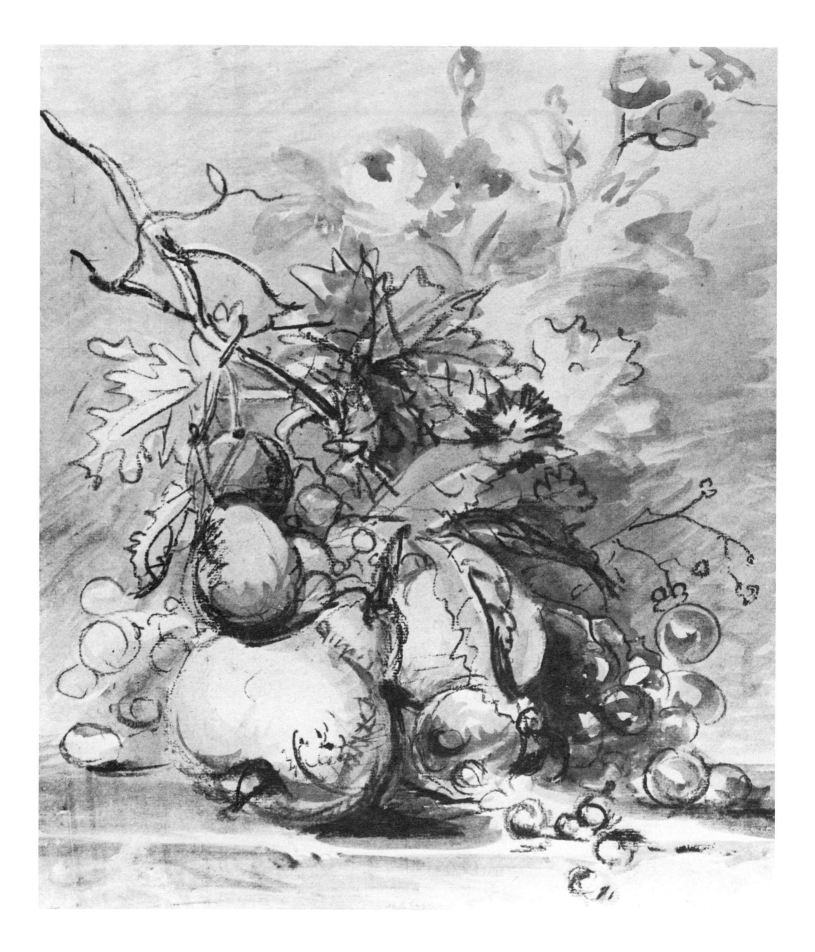

Vincent van Gogh
Winter Garden in Nuenen

90
Vincent van Gogh
Groot-Zundert 1853–1890 Auvers-sur-Oise
Winter Garden in Nuenen
Pen and brown ink with white heightening; signed, *Vincent*;
515 x 380 mm (20¼ x 14¹⁵⁄₁₆).
Provenance: Majovszky; inv. 1935-2791.
Literature: Pataky 1967, no. 85; Vadley 1969, no. 55; La Faille
1970, no. 1130.
Color illustration: page 2.

From December 1883 to November 1885 Van Gogh worked in his parents' residence, the parish house in Nuenen, and during that period he made this drawing of the pastor's garden. The artist carefully organized the drawing, covering the ground with long, parallel lines and then dissecting it with ribbonlike, winding paths. The lines converging in the background provide depth and the dark shading next to the paths defining the edges of the flower beds adds another dimension. The two crooked, barren trees dominate the composition; their skyward-reaching branches constitute a supremely dramatic device. This winter landscape—with scattered patches of snow across the fence and around the distant church—reveals not only the cold atmosphere of winter but the artist's solitude as well. The landscape in the background remains bare and essentially uninterrupted.

These were years of withdrawal and inner searching for Van Gogh. The painter's psychological state can be discerned even in his choice of media—black chalk and pen with brown or black ink—and technique of controlled, sticklike lines of various lengths. La Faille stated that this drawing was executed in March 1884, since Van Gogh mentioned in his April letters several works with winter garden themes (La Faille 1970, 414, no. 1127/a). (There is a horizontal version of this subject in the Van Gogh collection of the Rijksmuseum, Amsterdam [La Faille 1970, no. 1128] and a painting in the Hammer collection, New York, of the same subject that is datable to c. January 1885 [Los Angeles 1982, no. 38; La Faille 1970, no. 67].) This splendid sheet in pen and ink is a fine example of Van Gogh's "dark" Dutch period, before he left for Paris in 1886 where he encountered French impressionism and ultimately joined that movement.

V.K.

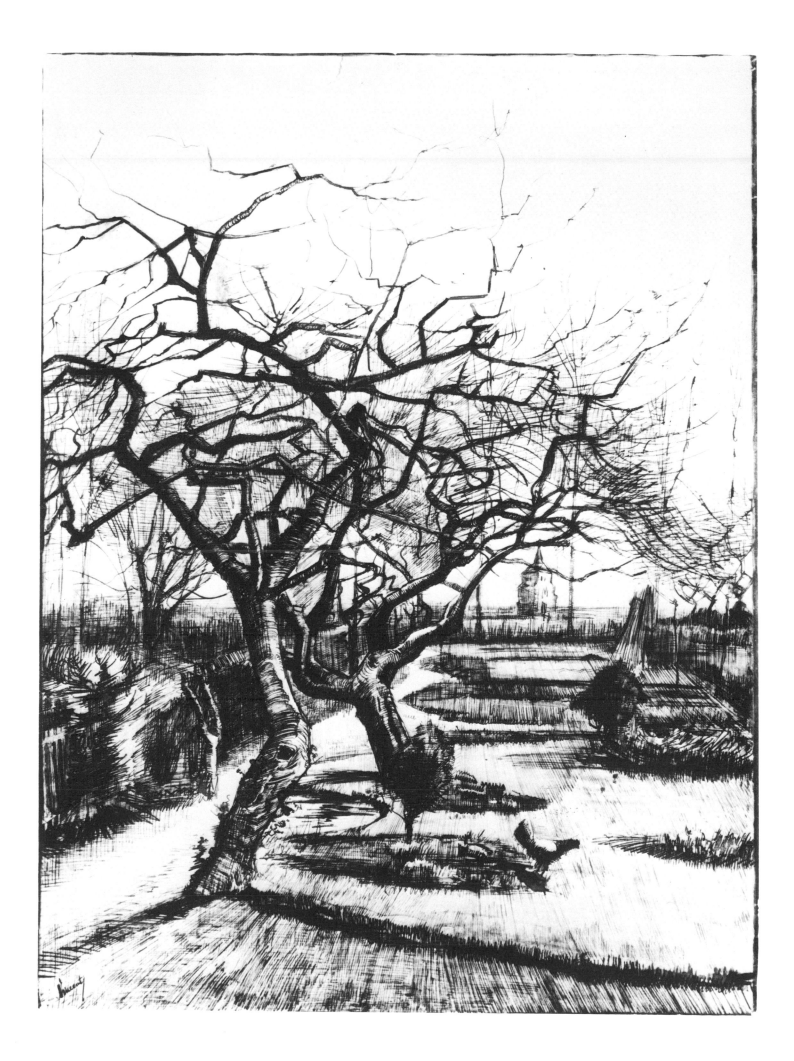

Nicolas Poussin
The Finding of Moses

91
Nicolas Poussin
Les Andelys 1593–1665 Rome
The Finding of Moses
Pen and brown ink with brush and wash; 161 x 245 mm
(6⁵⁄₁₆ x 9⁵⁄₈).
Provenance: Mariette (Lugt 1852); Bourduge (Lugt 70); Poggi
(Lugt 617); Esterházy (Lugt 1965); inv. 2881.
Literature: Hoffmann 1926, 287; Friedländer-Blunt 1939, vol. 1,
5, no. 4; Blunt 1966, no. 13 (no. 3, drawing); Badt 1969, vol. 1,
250, and vol. 2, fig. 43; Thuillier 1974, 103, no. 148; Wild 1980,
vol. 2, no. 132.

Among Poussin's Old Testament scenes, the Finding of Moses appears to be one of the preferred themes. He painted the earliest version in 1638, during his first Roman sojourn; the second was executed when he returned to Italy from France in 1647, and the final one in 1651.

The Budapest drawing is a preparatory sketch for the painting of 1647, done for the banker Pointel and later purchased by Cardinal Richelieu, from whose collection it passed in 1665 to Louis XIV (reigned 1643–1715); today it is in the Louvre. There are two other preparatory sketches for the painting (Paris, Louvre; Friedländer-Blunt 1939, vol. 1, nos. 3, 5) that are closer to the finished work than the Budapest sheet. Together the 1647 painting and the preparatory sheets form an important group of works from the artist's maturity. The drawings attest to Poussin's penchant for revising compositions; as he said in a letter of 1647 to his friend Fréart de Chantelou, "I do not belong to those who sing the same tune over and over . . . I can vary themes, if I want to!" (*Correspondence de Nicolas Poussin* [Paris, 1911, 352]).

Poussin's usual method of drawing, and the one exemplified here, was to apply pen and brown ink to white paper and to use the brush to define forms and the landscape background. Through this technique and the judicious distribution of light and shade a properly balanced composition was achieved.

In his compositions Poussin adhered to the rules of classical symmetry: on either side of the central axis he divided the figures into one or two small groups. The principal figure is Moses (in the basket at center); he is flanked on either side by two tall, standing, female figures (the daughter of the pharaoh and her attendant). The excited gestures of the women around the basket mitigate the formality of the composition and bind the figures together.

The action on the left side is effectively terminated by the powerful oarsman; on the opposite, open side a river god who reclines on a sphinx represents the Nile; behind him a figure leans into the water, concluding the action. The vertical, well-articulated, relieflike, classical figures are connected by an undulating horizontal line. Poussin created a sense of space by including in the middle distance a crocodile hunt on the river; finally, a landscape with trees and houses forms the background.

It has been kindly called to our attention by Andrew Robison (conversation, 1984) that the drawing has been skillfully enlarged at both top and bottom (the original sheet of white paper measured about 67 x 195 millimeters). Robison believes that the additions may have been made while the sheet was in the Mariette collection.

V.K.

Eustache Le Sueur
Study for the Figure of Juno

92
Eustache Le Sueur
Paris 1616–1655 Paris
Study for the Figure of Juno
Black and white chalks on beige colored paper; inscribed (later)
in pencil, *Le Sueur*; 282 x 395 mm (11¹⁄₁₆ x 15⅝).
Provenance: Lempereur (Lugt 1740); Esterházy (Lugt 1965, 1966);
inv. 2876.
Literature: Rosenberg 1972, 63–75, fig. 53.

This drawing was identified by Pierre Rosenberg as a preparatory study for an overdoor painting representing Juno and Carthage (Pinacoteca Manfrediniana e Raccolte del Seminario Patriarcale, Venice; see above) dating from 1652–1655 (Rouchès 1923, 41–42). The painting was one of seven works commissioned from Le Sueur (see description by Guillet de Saint-George in Dussieux 1852–1853, 11–15) in the course of an ambitious program to renovate the Louvre that was launched in the mid-seventeenth century. Many noted painters and architects participated in the project, supervised first by Lemercier (1585–1654) and then, after his death, by Le Vau (c. 1612–1670).

Le Sueur executed the painting for the Appartement des Bains in the Louvre, adjacent to the bedroom of Queen Anne of Austria (1601–1666), mother of Louis XIV (reigned 1643–1715). Le Sueur took the theme of the painting from Book 1 of Virgil's *Aeneid*. The goddess, seated on a bank of clouds, points with her scepter to Carthage, while at her command the winged putto at her foot empties a cornucopia over the city. The putto, in contrast to the meticulously detailed figure of Juno, is indicated with a few cursory but effective lines.

Placed over the faint lines of an underdrawing, the forceful outlines establish Juno's form as it would be seen in the completed painting. Contemporaries recognized Queen Anne's features in Juno's serious, peaceful face. The extended arm enhances the goddess' regal air. Her garment of precious fabrics, gathered with a sash, leaves her right shoulder and arm bare while it clings to her figure. The rich draperies that cover her extended legs and the complicated folds in her lap offer proof of Le Sueur's consummate skill as a draftsman. Note, for example, the way the artist covered the surface with pale, parallel lines and used dark accents to describe the deep folds of the fabric. Le Sueur employed white to model the draperies and indicate the underlying form.

This drawing fuses the influence of Simon Vouet (1609–1649) (Le Sueur was his leading pupil) who encouraged his students to revere the beauty of drawn form as well as the somewhat cooler classicism of Raphael's compositions, which he knew only from prints.

V.K.

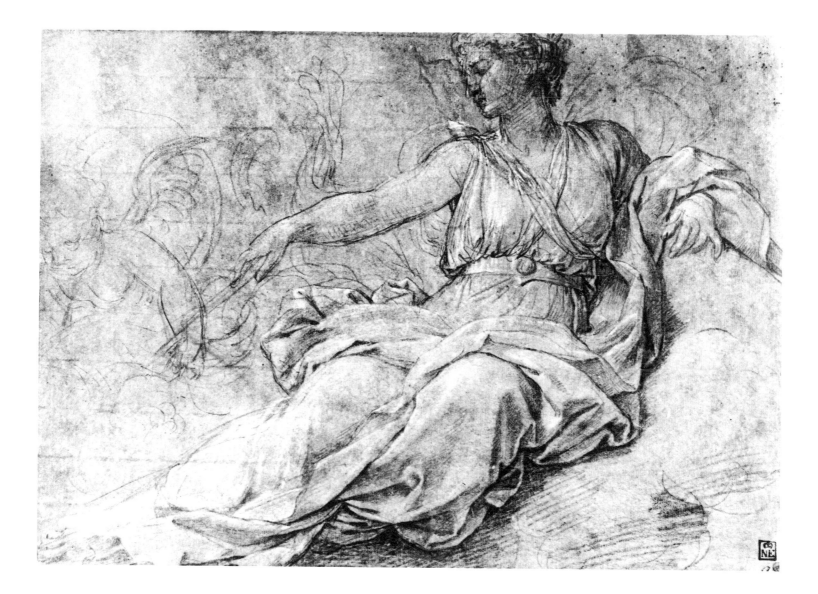

Jean-Antoine Watteau
Two Studies of Women, One Standing, One Seated, with a Drapery Study

93
Jean-Antoine Watteau
Valenciennes 1684–1721 Nogent-sur-Marne
*Two Studies of Women, One Standing, One Seated, with a
Drapery Study*
Black, red, and white chalks on brown paper; 242 x 337 mm
(9½ x 13¼).
Provenance: Gift of Ferenc Kleinberger, Paris; inv. 1912–719.
Literature: Meller 1913, 344–345; Vayer 1957, no. 101;
Parker-Mathey 1957, vol. 2, no. 543.

The young Watteau arrived in Paris around the turn of the century when the "modernists" were reacting against academic art. They were attracted by the great colorists, especially Rubens (1577–1640) and Titian (c. 1488/1489–1576). They also admired the elegant, bold portraits of Van Dyck (1599–1641), while their pictures of everyday subjects were inspired by Flemish genre painters. Watteau's *fêtes galantes*, genre and theater subjects, and virtuoso use of color met with instant success. His great admiration for Rubens and the sixteenth-century Venetian artists is evident even in his drawings, in which he most often combined two or three brilliant colors of chalk on tinted paper.

In his studio Watteau kept clothing and costumes in which he dressed his models. As they moved from one pose to another, Watteau made rapid studies, often combining sketches of a single figure in various poses and in different light on a single page. Seated figures such as the one in the Budapest drawing seem to have interested him especially, and indeed similar figures appear in other drawings (Musée Condé, Chantilly; British Museum, London; Parker-Mathey 1957, nos. 569, 861). Watteau often enhanced the quality and texture of fabrics, which he drew with such great skill, through decorative arrangements of the folds. The carefully executed drapery study at right in the Budapest sheet, drawn only in white and red chalks, shows Watteau taking special pains to express the fall of the stiff material.

Simon Meller (1913, 344–345) attempted to identify the two figures in the Budapest drawing. He believed that the seated female was a study for the lady being helped to her feet by a young man in both versions of the famous *Embarkation for Cythera* (Louvre, Paris, and Schloss Charlottenburg, Berlin; Montagni 1968, nos. 168, 185), while he connected the standing figure with one in the painting of *Promenade on the Ramparts*, which he knew only through an engraving by Aubert (Goncourt 1875, no. 141); the original reappeared later in a private New York collection (Adhémar 1950, no. 24). The figures' gestures in the paintings cited by Meller do not compare precisely with those in our drawing. Meller's theory is also weakened by the fact that several years separate the paintings to which he connected the Budapest sheet of studies. The Louvre painting is dated 1717, while James Mathey placed the New York painting in 1709 and Hélène Adhémar dated it to 1711 (see Montagni 1968, nos. 53 and 168). Watteau is known to have maintained a vast reserve of studies from which he chose figures, changing them to suit the needs of specific compositions. Thus, though similar figures often appear in paintings or drawings, there may be no direct connections among them. For that reason it is difficult to securely date the Budapest drawing.

V.K.

Eugène Delacroix
Horse Frightened by Lightning

94
Eugène Delacroix
Charenton-Saint-Maurice 1798–1863 Paris
Horse Frightened by Lightning
Watercolor; signed, *Eug. Delacroix*; 236 x 320 mm (9¼ x 12⁹⁄₁₆).
Provenance: Baron L. A. Schwiter; Cheramy; Kann;
Bernheim-Jeune; Majovszky; inv. 1935–2698.
Literature: Robaut 1885, no. 101; Pataky 1967, no. 7; Paris 1963,
no. 70; Sérullaz 1981, 42–43.
Color illustration: page 10.

Delacroix gave this watercolor to his friend the Baron Louis Auguste Schwiter (1805–1889) in return for the baron's gift of casts of a medallion collection, which Delacroix reproduced in lithographs in 1825 (Delteil 24–27).

The subject chosen by the young Delacroix is a romantic one, full of poetry. The noble white horse, terrified by the lightning, rises from the stormy, blue-black landscape in the background. The sky is suddenly illuminated; in the horse's ensuing panic his entire body seems to tremble and the muscles to tense; he raises his forelegs and tosses his head to the side. His movement and the wind of the tempest whip his mane while his eyes mirror his fright and urge to escape.

The color contrasts, despite the watercolor medium, emphasize the tempestuous atmosphere, and the impression is very much that of a completed work.

Alfred Robaut dated this picture to 1824, though when it is compared to other early works it seems to be later, c. 1825-1828. The uncontrolled motion of the horse, high drama, and eloquent painterly quality are evident in other works by Delacroix: a watercolor, *Tiger Attacking a Wild Horse* of c. 1825–1828 (Louvre; Paris 1963, no. 71); a lithograph, *Horse Escaping from the Water* of 1828 (Delteil 78); and an oil painting of fighting horses, of c. 1828 (private collection, Paris; Johnson 1981, vol. 1, no. 54, and vol. 2, pl. 46).

V.K.

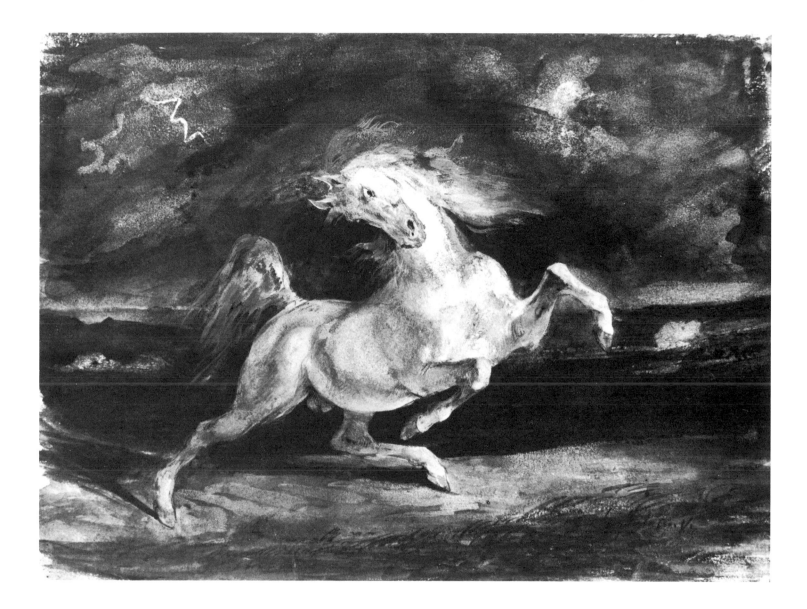

Honoré Daumier
The Side-show (La Parade)

95
Honoré Daumier
Marseille 1808–1879 Valmondois
The Side-show (*La Parade*)
(verso: *Sketches of a Seated Man, Head of a Boy Looking Upward,
and Several Small Figures*, in graphite)
Red and black chalks with gray washes (verso: graphite);
signed at lower right, *H.D.*; 398 x 304 mm (15¹¹⁄₁₆ x 11¹⁵⁄₁₆).
Provenance: Hatvany; inv. 1950–4276.
Literature: Maison 1968, no. 554, pl. 200; Kaposy 1968, 259–273,
fig. 7 and verso, fig. 14.

Daumier often depicted theater and circus subjects. Toward the end of the 1860s he produced a considerable number of paintings, drawings, and prints of artists, athletes, wrestlers, clowns, and village fair comedians. Around 1864 he became occupied with a composition of several circus barkers standing on a platform, shouting at the audience, and urging them to enter the tent. The earliest sketch in the group, a pen drawing in a Santa Barbara, California, private collection, shows an acrobat standing among a number of noisy, costumed, jumping circus figures (Maison 1968, no. 553, pl. 199). The final drawing, in which Daumier's ideas are crystallized, is the famous watercolor of the *Parade* in the Louvre (Maison 1968, no. 556, pl. 201).

The Budapest drawing is one of the most remarkable of Daumier's sketches of barkers. It was immediately preceded by a rather crowded study in the Louvre (Maison 1968, no. 523, pl. 183) in which the viewpoint is lower and the entire composition simpler than in the Santa Barbara drawing. He retained the acrobat pose and added a pointing gesture that may be considered the principal source of the motion seen in the Budapest drawing. In the Louvre sheet a standing man spreads his arms in imitation of the typical weak-kneed clown posture, follows with his eyes the baton of the barker, and looks up toward the poster. The red chalk outlines of the standing man in the Louvre drawing can be seen in the Budapest sheet, but they have been partially obscured by the clown in the plumed hat who bends forward.

An earlier work, a lithograph from January 1839, also played a role in the development of this composition. In the Budapest drawing, the man wearing a top hat and one who invites the public to buy their entrance tickets have been retained. Among the barkers in the lithograph, the caricaturists of *Le Charivari*, a daily popular journal, can be recognized: the flute player is Daumier himself, the man with the top hat pointing toward the suspended poster is G. Aubert (1789–1847), Traviès (1804–1859) sounds the clarion, and C. Philipon (1806–1862) acts as the drummer (Delteil 554; Passeron 1979, 57, fig. 18). (The fourth state, which appeared with a different inscription, is not yet listed in Delteil.)

The searching lines of the Budapest drawing reveal the painter's working methods and his habit of reaching for the most advantageous gesture to assure the right compositional balance. With the change of the principal figure's leg and the revision of the woman's arm pointing into the tent, the three figures are placed on different planes. The effect is to draw the observer's attention across the picture toward the interior of the circus tent, increasing the sense of depth. Thus, the movements of the figures were enlivened while the contorted features were heightened with vigorous draftsmanship. Daumier thus evoked the noisy atmosphere of the fair. The ably drawn outlines lift out the principal forms from the jumble of line-work while the more delicate inner drawing serves to establish the plasticity of the details. The occasionally washed red chalk lines, the use of black chalk, and the rich gray washes result in a drawing that is quite colorful.

Daumier continued to work on the circus barker theme. Later he executed other series of circus subjects in which some of the figures from the Budapest sheet reappear (for example, in the background of the *Drummer*, Philadelphia Museum; Maison 1968, no. 534, pl. 189).

v.k.

Camille Corot
Shepherd Wrestling with a Goat

96
Camille Corot
Paris 1796–1875 Paris
Shepherd Wrestling with a Goat
Black chalk and pencil on bluish-gray paper; signed at lower left
in pencil, *Corot*, and in upper left, *g' in 4° h*; 308 x 238 mm
(12⅛ x 9⅜).
Provenance: Dutilleux; Robaut; Majovszky; inv. 1935-2681.
Literature: Robaut 1905, vol. 4, no. 2881; Molnár 1959, 58–64,
fig. 37.

In 1847 Corot painted a shepherd struggling with a goat (Robaut 1905, vol. 2, no. 503) and exhibited it in the Salon that year. He treated the subject again in the Budapest drawing which, according to Alfred Robaut, dates from 1852 and exhibits a different technique and concept. This drawing is much livelier than the painting, in which the shepherd struggles to subdue the bucking beast. The figures meet at the point where the shady foreground converges with the background of the hill.

Corot worked on a bluish-gray paper with black chalk, creating lighter spots with occasional stumping and sometimes using lead pencil to reinforce the composition. This produces a silver-gray shimmer on the surface of the sheet and at the same time creates an impression of the humid, hazy atmosphere of the forest and a mysterious twilight mood. After 1850 there was a marked change in Corot's drawing style: he abandoned the pen or lead pencil in favor of chalk and charcoal (Paris 1975a, 14). His studies in pen or lead pencil are light, precise, well-defined study sheets; with chalk or charcoal, he explored the possibilities of richer effects of light and shade, forceful plasticity, and more painterly solutions. His works from the period represented by the Budapest *Shepherd* are imbued with an exceptional lyricism.

Twice Corot returned to this theme: in 1855–1860 he painted a version in which the encounter takes place on the shore of a lake (Robaut 1905, vol. 3, no. 1120), and in 1874 he produced a *cliché-verre* after the Budapest drawing (Delteil 95). In that example a small lake is visible beyond the trees and on the hillside, perhaps a reference to his trip to Italy, stands a small building with a cupola. The *cliché-verre* technique influenced Corot's late works, in which he used splintery, zigzag strokes.

V.K.

Jean-François Millet
Motherly Attentions

97
Jean-François Millet
Gruchy 1814–1875 Barbizon
Motherly Attentions
Black chalk; signed on bottom step, *J.F. Millet*; 297 x 215 mm
(11¹¹⁄₁₆ x 8⁷⁄₁₆).
Provenance: Cheramy, purchased from Dr. H. Eissler, Vienna;
inv. 1913–1515.
Literature: Paris 1975b, no. 110.

In brilliant sunshine, before a half-open door, a mother is occupied with her children. The door throws a shadow behind the figures, enabling the spectator to see into the room and exaggerating the figures' relieflike quality. The concerned mother's figure and her bent arm accentuate the plasticity of the forms. The shadows against the sun-drenched wall make brittle arabesques while the leaves of the creepers are somewhat blurred. Areas of shadow are indicated by parallel lines or heavier chalk lines that are occasionally stumped or washed together.

Millet treated this theme twice: between 1855–1857 when he painted a small picture in the Louvre (Paris 1975b, no. 111) and later, c. 1862, when he prepared a *cliché-verre* of the composition (Delteil 27). The Budapest drawing is connected to the Louvre painting, which exists in several versions, though it is uncertain whether this drawing preceded or followed the painting. The two works' compositions, figures, and gestures are identical, and even the details are similar. There are minute differences in such aspects as the bricks in the wall and the basket lying at the steps, but whether the drawing is a meticulously executed preparatory work or an autograph replica of the painting remains unknown. The Budapest drawing is not a free sketch but shows no sign of corrections nor gives the impression of a copy.

The technical peculiarities are typical of Millet's works of c. 1855–1857, which are carefully finished, well balanced, and bathed in sharp, evenly distributed light.

The later sketches that Millet executed in connection with the *cliché-verre* version are of a different kind. Those later sheets, which date from c. 1862, show a normal graphic technique employing stiff lines and cross-hatching in shaded areas. Millet prepared a glass plate of this subject for his friend Eugène Cuvelier (1830–1900) who, like his father, Adelbert, introduced the *cliché-verre* technique to many artists (Paris 1975b, no. 134).

V.K.

Edouard Manet
The rue Mosnier on a Rainy Day

98
Edouard Manet
Paris 1832–1883 Paris
The rue Mosnier on a Rainy Day
Graphite with gray washes and brush with black ink;
190 x 360 mm (7⁷⁄₁₆ x 14⅛).
Provenance: Roger-Marx, according to tradition; P. Cassierer,
Berlin; Majovszky; inv. 1935–2735.
Literature: Pataky 1967, no. 43; Rouart-Wildenstein 1975, vol. 2,
no. 328; Paris 1983, no. 159.

From 1872 to July 1878 Manet rented a studio on the first floor of a house in the rue St. Petersbourg (today rue Léningrad) with windows overlooking the newly built rue Mosnier (now rue de Berne). We know this quiet little street not only from Manet's paintings of 1878 and his drawings, but also from Zola's noted work *Nana* (1880). Before Manet moved from the rue Mosnier, he immortalized the well-known site, which was bustling with activity as Paris prepared to host the World's Fair. Even in this small street, life changed. Manet first painted a view of the cobblestones (*The rue Mosnier with Pavement Workers*, Fitzwilliam Museum, Cambridge; Rouart-Wildenstein 1975, no. 272) and then, in two different versions, the rows of houses decorated with flags for the festive opening of the fair (Mr. and Mrs. Paul Mellon, Upperville, Virginia; Rouart-Wildenstein 1975, no. 270; the second is in the Bührle collection, Zurich; Rouart-Wildenstein 1975, no. 271). The paintings were preceded by preparatory sketches (Paris 1983, nos. 161–163).

The Budapest drawing was probably made before the first painting, on a rainy day; the drawing and painting are done from the same point of view. The vantage point is somewhat, but not excessively, elevated and permits the viewer to observe the street and the figures, which seem to walk toward us. The shape of the drawing is oblong, unlike that of most of the other sketches. Neither the sky nor the end of the street is visible; of the houses only the doors, shop fronts, and the first-floor windowsills of the opposite row of houses can be distinguished. A feeling of spontaneous movement permeates the entire picture—speeding carriages rattle on the cobblestones and pedestrians hurry about their business. The sense of immediacy is strengthened by the wind that blows the garments and turns the umbrella of the man trying to cross the street. The drawing immortalizes a cityscape as well as Manet's impressions, in which the elements of mood are stressed.

Manet often used brush and gray India ink. He began this drawing by sketching out the motifs in lead pencil, then added diluted gray washes to establish areas of shading and, when necessary, he used a fine brush with black ink to accentuate the outlines. The style is very reminiscent of that of Japanese art: fast, broad brushstrokes, irregular patches, and the contrast of black and white, with all of the shades between. The chamois-colored paper adds to the gloomy atmosphere of the rainy day, while the glittering, pale washes indicate wind-swept puddles on the pavement.

V.K.

Georges Seurat
Vagabond

99
Georges Seurat
Paris 1859–1891 Paris
Vagabond
Conté crayon; signed, *G. Seurat*; 311 x 207 mm (12¼ x 8⅛).
Provenance: P. Arnold, Dresden; Majovszky; inv. 1935–2784.
Literature: Hauke 1962, no. 514; Chastel-Minervino 1972, 114,
D. no. 129.

The art of drawing was of prime importance to Seurat after 1881. Only then did he realize that a rich scale of tonalities existed between black and white and see that the contrasts between the two colors were of the greatest importance. Earlier, he was occupied with the effects of light and shadow; later, figures silhouetted against light backgrounds became his concern (Russel 1968, 83). Suddenly the tonality of his drawings became more luxuriant and functioned not only as a tool to establish shape but to create mood as well. From that point on Seurat permitted the white patches of paper to play an independent role while he used them as highlights or to express lighter colors as well. His favorite medium was the conté crayon and his preferred drawing surface grainy Ingres paper.

Seurat's drawings from around 1883, when the Budapest drawing was made, are especially remarkable and diversified.

At that time Paul Signac stated, "One can say that the perfect employment of tonalities render his [drawn] works more brilliant and colorful than many paintings" (Signac 1964, 97). Line as an individual entity ceased to exist, and the artist operated with only patches and tone clusters.

The vagabond emerges from the blue-gray background of the Budapest drawing. His tired, sinking figure, seated on a bench, is drawn with the most restricted tonal nuances. The vagabond's sadness is conveyed by the somber background and irregular mesh of line-work, which allows the penetration of just enough pale light to illuminate the scene. Typically, Seurat did not strive for theatrical or dramatic effects with light and shade. Seurat's achievements are equally evident in his drawings and paintings from this period, such as his famous work *The Bathers* (Tate Gallery, London).

V.K.

Paul Cézanne
Provençal Landscape

100
Paul Cézanne
Aix-en-Provence 1839–1906 Aix-en-Provence
Provençal Landscape
Graphite with watercolor; 313 x 478 mm (12⁵⁄₁₆ x 18¹³⁄₁₆).
Provenance: Majovszky; inv. 1935–2675.
Literature: Venturi 1936, no. 962; Adriani 1981, no. 71.

"Drawing and color are not diverse matters; as much as we paint, to the same degree do we also draw! The more harmonious our colors are, the more precise becomes our drawing. When color reaches its total richness, it is then that form obtains its perfection." Thus spoke Cézanne to his friend Emile Bernard, at the end of his long career (Bernard 1912, 35).

Though Cézanne learned from the impressionists, he did not accept their artistic ideals. From 1880 on he sought to balance in his paintings the roles of color, drawing, tonality, and form. In this spirit Cézanne created his Provençal landscapes such as this late watercolor of c. 1900. The artist first established the forms with a few light pencil lines, and then laid down his colors with broad brushstrokes. He worked on the entire drawing surface at once with uniform intensity, moving from one color patch to another to build the composition. He created perspective solely through color, leading the eye from the houses in the foreground through the valley and from layer to layer into the distance.

Cézanne used a limited palette for his watercolors, comprised mostly of violet and green in addition to yellow and blue. He placed layers of color on top of one another, and in so doing transformed their hues. Thus yellow and green yield a lighter green, and where violet touches yellow the effect becomes one of opalescence. The dense foliage is indicated with violet and blue hues. With yellow he achieves the warm radiance of sunshine on the houses, the mountains, or the peaks of the hills. All colors are evenly distributed over the drawing surface, and even on the different planes of the picture, resulting in a harmonious and well-balanced composition. He never overlooked the importance of the white of his paper, which produces a brilliant, sunlit spaciousness. Cézanne's method of playing with color clusters in various combinations allowed him to establish volumetric relationships among forms.

These delicate but consciously structured watercolors, in which he searched for the essence of nature, indicate the distance between Cézanne and the impressionists.

V.K.

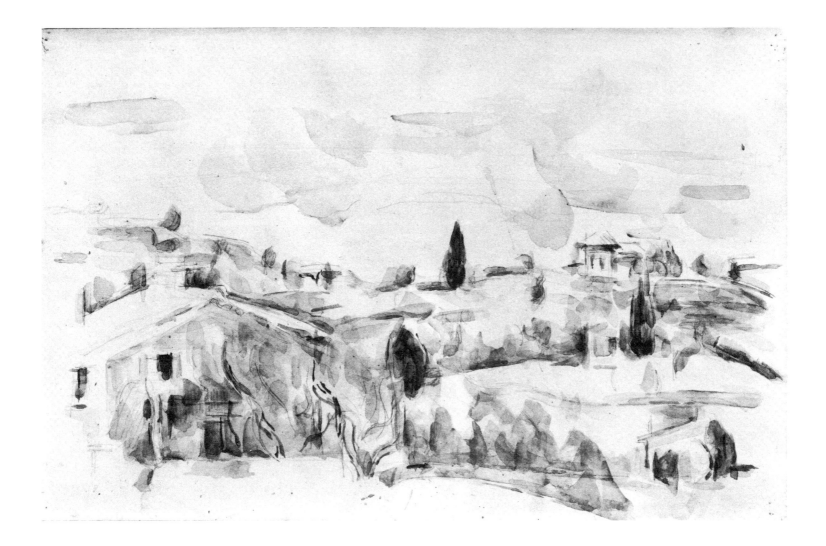

Bibliography

ADHÉMAR 1950
Adhémar, H., and Huyghe, R. *Watteau, sa vie — son oeuvre*. Paris, 1950.

ADRIANI 1981
Adriani. *Paul Cézanne. Aquarelles*. Cologne, 1981.

AMSTERDAM 1969
Amsterdam, Rijksmuseum. *Rembrandt 1669–1969*. Exh. cat. 1969.

ASCHENBRUNNER-SCHWEIGHOFER 1965
Aschenbrunner, W., and Schweighofer, G. *Paul Troger. Leben und Werk*. Salzburg, 1965.

AUGSBURG 1740
Architetture e prospettive dedicate all'Maestà di Carlo Sesto Imperator de' Romani da Giuseppe Galli Bibiena, suo primo ingegner treatrale, ed architetto, inventore delle medesime. Augsburg, 1740. New York, 1964 ed.

AURENHAMMER 1959
Aurenhammer, H. *Lexicon der christlichen Ikonographie*. Vol. 1. Vienna, 1959.

B.
Bartsch, A. *Le Peintre graveur*. 21 vols. Vienna, 1801–1821.

BADT 1969
Badt, K. *Die Kunst des Nicolas Poussin*. 2 vols. Cologne, 1969.

BALIS 1979–1980
Balis, A. "De Jachten van Maximiliaan kronstuk van de hoofse jachticonografie." *Gentse Bijdragen tot de Kunstgeschiedenis* 25 (1979–1980).

BASEL 1974–1976
Basel, Kunstmuseum. *Lukas Cranach. Gemälde, Zeichnungen, Druckgraphik*. 2 vols. Exh. cat. by D. Koeplin and T. Falk. 1974–1976.

BASTELAER 1908
Bastelaer, R. V. *Les Estampes de Pieter Bruegel l'ancien*. Brussels, 1908.

BEAN 1982
Bean, J. *15th and 16th Century Italian Drawings in the Metropolitan Museum of Art*. New York, 1982.

BECK 1981
Beck, J. *Italian Renaissance Painting*. New York, 1981.

BEENKEN 1935
Beenken, H. "Beiträge zu Jörg Breu und Hans Dürer." *Berliner Jahrbuch* 56 (1935).

BÉGUIN 1973
Béguin, S. *Pour Speckaert. Album Amicorum J.G. van Gelder*. The Hague, 1973.

BENESCH 1928
Benesch, O. *Die Zeichnungen der niederlandischen Schulen des XV. und XVI. Jahrhunderts*. Vienna, 1928.

BENESCH 1954–1957
Benesch, O. *The Drawings of Rembrandt*. 6 vols. London and New York, 1954–1957.

BENESCH 1957
Benesch, O., and Auer, E. *Die Historia Friderici et Maximiliani*. Berlin, 1957.

BENESCH 1964
Benesch, O. *Meisterzeichnungen der Albertina*. Salzburg, 1964.

BENESCH-BUCHNER [n.d.]
Benesch, O., and Buchner, E. *Jörg Breu. Ein Süddeutscher Maler des 15. Jahrhunderts*. Augsburg [n.d.].

BERLIN 1975
Berlin, Kupferstichkabinett. *Pieter Bruegel d. Ae. als Zeichner. Herkunft und Nachfolge. Eine Ausstellung des Kupferstichkabinetts Berlin*. Exh. cat. 1975.

BERLINER 1955
Berliner, R. "Arma Christi." *Münchner Jahrbuch* 6 (1955).

Berliner Jahrbuch
Jahrbuch der Königlichen Preussischen Kunstsammlungen. Vols. 1–64 (1880–1943); *Jahrbuch der Berliner Museen* N.F. Vols. 1–23 (1959–1981).

BERNARD 1912
Bernard, E. *Souvenirs sur Paul Cézanne*. Paris, 1912.

BIALOSTOCKI 1959
Bialostocki, J. "Les Bêtes et les humaines de Roelant Savery." *Bulletin Musea voor Schone Kunsten, Brussel* 7 (1959).

BIANCHI 1968
Bianchi, L. "La Fortuna di Raffaello nell' incisione." In M. Salmi, ed., *Raffaello*. Vol. 2. Novara, 1968.

BIERENS DE HAAN 1948
Bierens de Haan, J.C.J. *L'Oeuvre gravé de graveur hollandais 1533–1578*. The Hague, 1948.

BLANKERT 1967
Blankert, A. "Heraclitus en Democritus in het bijzonder in de Nederlandse Kunst van de 17de e." *Nederlands Kunsthistorisch Jaarboek* 18 (1967).

BLUNT 1966
Blunt, A. *The Paintings of Nicolas Poussin. A Critical Catalogue*. London, 1966.

BOBER 1957
Bober, P. P. *Drawings after the Antique by Amico Aspertini*. London, 1957.

BOCK-ROSENBERG 1930
Bock, E., and Rosenberg, J. *Die Niederländischen Meister. Staatliche Museen zu Berlin*. Berlin, 1930.

BODMER 1939
Bodmer, H. *Lodovico Carracci*. Burg b.M., 1939.

BOLOGNA 1968
Bologna, Palazzo dell'Archisinnasio. *Il Guercino/Giovanni Francesco Barbieri, 1591–1666/Catalogo critico dei disegni*. Exh. cat. by D. Mahon. 1968.

BOSCHLOO 1974
Boschloo, A.W.A. *Annibale Carracci in Bologna. Visible Reality in Art after the Council of Trent*. 2 vols. The Hague, 1974.

BRECKENRIDGE 1957
Breckenridge, J.D. "'Et prima vidit': The Iconography of the Appearance of Christ To His Mother." *The Art Bulletin* 39 (1957).

BRIQUET
Briquet, C. M. *Le Filigranes. Dictionnaire historique des marques du papier*. 6 vols. Paris and Geneva, 1907.

BRIZIO-BRUGNOLI-CHASTEL 1981
Brizio, A.M., Brugnoli, M.V., and Chastel, A. *Leonardo the Artist*. London, 1981.

BRUGNOLI 1982
Brugnoli, M.V. "Il monumento Sforza e il cavallo colossale." In G.A. dell'Acqua, ed., *Leonardo e Milano*. Milan, 1982.

BUDAPEST 1963a
Budapest, Szépmüvészeti Múzeum. *A manierizmus korának müvészete*. Exh. cat. by M. Haraszti-Takács and T. Gerszi, 1963.

BUDAPEST 1963b
Budapest, Szépmüvészeti Múzeum. *Középitálial rajzok, Bologna, Firenze, Róma*. Exh. cat. by I. Fenyö. 1963.

BUDAPEST 1970
Budapest, Szépmüvészeti Múzeum. *Raffaello emlékkiállitás*. Exh. cat. 1970.

BUDDE 1930
Budde, I. *Beschreibender Katalog der Handzeichnungen in der Kunstakademie Düsseldorf*. Düsseldorf, 1930.

Bulletin
Bulletin du Musée Hongrois des Beaux-Arts

BURKE 1976
Burke, J.D. *Jan Both: Paintings, Drawings and Prints*. New York and London, 1976.

BUSHART 1961
Bushart, B. *Melchior Steidl's Entwürfe für dir Fresken in der Schönenberg - Kirche zu Ellwangen. E. Hanfstängl zum Geburtstag*. Munich, 1961.

BÜTTNER 1979
Büttner, F. "Die Sonne Frankens. Ikonographie des Freskos im Treppenhaus der Würzburger Residenz." *Münchner Jahrbuch* 30 (1979).

BYAM SHAW 1962
Byam Shaw, J. *The Drawings of Domenico Tiepolo*. London, 1962.

CHASTEL-MINERVINO 1972
Chastel, A., and Minervino, F. *L'opera completa de Seurat*. Milan, 1972.

CHURCHILL 1935
Churchill, W. A. *Watermarks in paper in Holland, England, France. . . .* Amsterdam, 1935.

CLAPP 1914
Clapp, F.M. *Les Dessins de Pontormo*. Paris, 1914.

CLARK 1969
Clark, K. "Leonardo and the Antique." In C.D. O'Malley, ed., *Leonardo's Legacy*. Berkeley and Los Angeles, 1969.

CLARK-PEDRETTI 1968
Clark, K., and Pedretti, C. *The Drawings of Leonardo da Vinci in the Collection of Her Majesty the Queen at Windsor Castle*. 3 vols. London, 1968.

COLOGNE 1978
Cologne, Schnütgen-Museum. *Die Parler und der Schöne Stil 1350–1400*. 5 vols. Exh. cat. 1978.

COUDERC [n.d.]
Couderc, C., ed. "Livre de la chasse par Gaston Phébus." Paris [n.d.].

COX-REARICK 1964
Cox-Rearick, J. *The Drawings of Pontormo*. 2 vols. Cambridge, Mass., 1964.

COX-REARICK 1970
Cox-Rearick, J. "The Drawings of Pontormo: Addenda." *Master Drawings* 8, no. 4 (1970).

CZÉRE 1976
Czére, A. "Un Dessin de Daniele Crespi au

Musée des Beaux-Arts. Daniele Crespi rajza a Szépmüvészeti Múzeumban." *Bulletin* 46–47 (1976).

CZÉRE 1981
Czére, A. "Neue Zeichnungen von Giovanni Antonio Burrini." *Pantheon* 39, no. 3 (1981).

DEGENHART 1949
Degenhart, B. *Italienische Zeichnungen des frühen 15. Jahrhunderts.* Basel, 1949.

DEGENHART 1968
Degenhart, B. *Corpus der italienischen Zeichnungen.* 4 vols. Berlin, 1968.

DELTEIL
Delteil, L. *Le Peintre-graveur illustré.* 31 vols. Paris, 1906–1926.

Dizionario Bolaffi
Dizionario enciclopedico Bolaffi dei pittori e degli incisori italiani. 6 vols. Turin, 1972–1976.

DODGSON 1909
Dodgson, D. *Holzschnitte zu zwei Nürnberger Andachtsbüchern aus dem Anfange des XVI Jahrhunderts.* Berlin, 1909.

DODGSON 1916
Dodgson, C. "The Calumny of Apelles by Breu." *The Burlington Magazine* 29 (1916).

DORDRECHT 1977–1978
Dordrechts Museum. *Aelbert Cuyp en zijnfamilie. Schilders to Dordrecht.* Exh. cat. 1977–1978.

DROBNA 1956
Drobna, Z. *Die gotische Zeichnung in Böhmen.* Prague, 1956.

DUSSIEUX 1852–1853
Dussieux, L. "Nouvelles recherches sur la vie et les ouvrages de Le Sueur." *Archives de l'art francais II* (1852–1853). (Lecture at Académie royale de peinture, 5 August 1690.)

ERTZ 1979
Ertz, K. *Jan Brueghel der Aeltere 1568–1625. Die Gemälde mit kritischem Oeuvrekatalog.* Cologne, 1979.

Evkönyv
Az Országos Magyar Szépmüvészeti Múzeum Evkönyvei (Yearbook of the Museum of Fine Arts, Budapest). 1918–1940.

FAGIOLO DELL' ARCO 1970
Fagiolo Dell'Arco, M. *Il Parmigianino. Un saggio sull'ermetismo nel Cinquecento.* Rome, 1970.

LA FAILLE 1970
Faille, J.B. de la. *The Works of Vincent van Gogh.* Amsterdam, 1970.

FENYÖ 1954
Fenyö, I. "Un dessin et quelques tableaux de Cranach au Musée des Beaux-Arts." *Bulletin* 5 (1954).

FENYÖ 1959
Fenyö, I. "Some Newly Discovered Drawings by Correggio." *The Burlington Magazine* 101 (1959).

FENYÖ 1961
Fenyö, I. "Sur Quelques Dessins italiens du XVIe siècle." *Bulletin* 19 (1961).

FENYÖ 1965
Fenyö, I. *North Italian Drawings from the Collection of the Budapest Museum of Fine Arts.* 2d ed. New York, 1966.

FISCHEL
Fischel, O. *Raffaels Zeichnungen.* 8 vols. Berlin, 1913-1941.

FISCHEL 1950
Fischel, L. "Werk und Name des 'Meisters von 1445.'" *Zeitschrift für Kunstgeschichte* 13 (1950).

FORSTER-HAHN 1978
Forster-Hahn, F. "Authenticity into Ambivalence: The Evolution of Menzel's Drawings." *Master Drawings* 16, no. 3 (1978).

FRIEDLÄNDER 1967
Friedländer, M. J. *Early Netherlandish Painting.* 14 vols. Leiden and Brussels, 1967–1976.

FRIEDLÄNDER-BLUNT 1939–1974
Friedländer, W., and Blunt, A. *The Drawings of Nicolas Poussin.* 5 vols. London, 1939–1974.

FRITZSCHE 1936
Fritzsche, H.A. *Bernardo Bellotto, Genannt Canaletto.* Burg b.m., 1936.

FRÖHLICH-BUM 1928
Fröhlich-Bum, L. "Studien zu Handzeichnungen der italienischen Renaissance." *Jahrbuch der Kunsthistorischen Sammlungen.* N.F. Vol. 2 (Vienna, 1928).

GAND 1954
Gand, Musée des Beaux-Arts. *Roelant Savery 1576 – 1639.* Exh. cat. by P. Eeckhout. 1954.

GARAS 1960
Garas, K. *Franz Anton Maulbertsch.* Budapest, Vienna, and Graz, 1960.

GARAS 1968
Garas, K. *A velencei Settecento festészete* (On the Seventeenth-Century Paintings). Budapest, 1968.

GARAS 1974
Garas, K. *Franz Anton Maulbertsch. Leben und Werk.* Salzburg, 1974.

GARAS 1980
Garas, K. *Deutsche und Osterreichische Zeichnungen des 18. Jahrhunderts.* Budapest, 1980.

GELDER-JOST 1969
Gelder, J.G. van, and Jost, I. *Vroegt contact van Aelbert Cuyp met Utrecht. Miscellanea J.Q. van Regteren Altena.* Amsterdam, 1969.

GERE 1960
Gere, J.A. "Two late fresco cycles by Perino del Vaga: the Massimi Chapel and the Sala Paolina." *The Burlington Magazine* 102 (1960).

GERE 1969
Gere, J.A. *Taddeo Zuccaro. His Development Studied in His Drawings.* London, 1969.

GERE 1971
Gere, J. *Il manierismo a Roma.* Milan, 1971.

GERSZI 1955
Gerszi, T. "Un dessin inconnu de Hans Leu le jeune au Musée des Beaux-Arts." *Bulletin* 7 (1955).

GERSZI 1956
Gerszi, T. "Eine unbekannte Zeichnung von Hans Burkmair dem Alteren." *Acta Historiae Artium* 4 (1956), fasc. 1–2.

GERSZI 1958
"Contribution à l'art des peintres allemands de la cour de Rodolphe II." *Bulletin* 13 (1958).

GERSZI 1964
Gerszi, T. "Dessins manieristes néerlandais." *Bulletin* 24 (1964).

GERSZI 1965
Gerszi, T. "Landschaftszeichnungen aus der Nachfolge Pieter Bruegels." *Berliner Jahrbuch* 7 (1965).

GERSZI 1968
Gerszi, T. "Unbekannte Zeichnungen von Jan Speckaert." *Oud Holland* 83, 3/4 (1968).

GERSZI 1971a
Gerszi, T. *Netherlandish Drawings in the Budapest Museum. Sixteenth-Century Drawings.* Amsterdam and New York, 1971.

GERSZI 1971b
Gerszi, T. "Etudes sur les dessins des élèves de Rembrandt." *Bulletin* 36 (1971).

GERSZI 1976
Gerszi, T. *Zwei Jahrhunderte niederländischer Zeichenkunst.* Budapest, 1976.

GERSZI 1981
Gerszi, T. "A 'Historia mester' Lovag és hölgy cimü rajzának témameghatározása." *Müvészettörténeti Ertesitö* 30/2 (1981).

GERSZI 1982
Gerszi, T. *Paulus van Vianen.* Hanau, 1982.

GIBSON 1977
Gibson, W.A. *The Paintings of Cornelis Engebrechtsz.* New York and London, 1977.

GILTAY 1980
Giltay, J. "De tekeningen van Jacob van Ruisdael." *Oud Holland* 94, 2/3 (1980).

GONCOURT 1875
Goncourt, E. de. *Catalogue raisonné. L'oeuvre peint, dessiné et gravé d'Antoine Watteau.* Paris, 1875.

GOULD 1954
Gould, C. "Leonardo's Great Battle-piece, a Conjectural Reconstruction." *The Art Bulletin* 36 (1954).

GOULD 1976
Gould, C. *The Paintings of Correggio.* London, 1976.

GOULD et al. 1982
See Los Angeles 1982.

GRANT 1954
Grant, M.H. *Jan van Huysum.* High-on-Sea, 1954.

GRISERI (BOLLATI AND FOSSATI) 1980
Griseri, A. In G. Bollati and P. Fossati, eds., *Storia dell'arte Italiana.* Vol. 9. Milan, 1980.

GROTE 1969
Grote, L. "Albrecht Dürer's Anna Selbdritt —Ein Auftrag von Leohard Tucher." *Anzeiger des Germanischen National Museums.* Nuremberg, 1969.

VON HADELN 1930
von Hadeln, D. *Die Zeichnungen der von Antonio Canale, genannt Canaletto.* Vienna, 1930.

THE HAGUE-CAMBRIDGE 1981
Mauritshaus, The Hague, and Cambridge, Fogg Museum of Art. *Jacob van Ruisdael.* Exh. cat. by S. Slive. 1981.

HALM 1930
Halm, P. "Die Landschaftszeichnungen des Wolfgang Huber." *Münchner Jahrbuch N.F.* 7 (1930).

HAUKE 1962
Hauke, C. de. *Seurat et son oeuvre.* Paris, 1962.

HEAWOOD
 Heawood, E. *Monumentae Chartae Papyra-ceae. I. Watermarks. Mainly of the XVII*th *and XVIII*th *Centuries.* Hilversum, 1950.

HEFFELS 1969
 Heffels, M. *Die Handzeichnungen des 18 Jahr-hunderts. Katalog des Germanischen National-museums.* Nuremberg, 1969.

HIND
 Hind, A.M. *Early Italian Engraving.* 7 vols. London, 1938–1948.

HIND 1926
 Hind, A.M. *Catalogue of Drawings by Dutch and Flemish Artists Preserved in the British Museum.* Vol. 3. Cat. by A.M. Hind. London, 1926.

HIRTH 1881–1890
 Hirth, G. *Kulturgeschichtliches Bilderbuch aus drei Jahrhunderten.* 6 vols. Munich, 1881–1890.

HIRTH 1908
 Hirth, G. *Der Formschatz. Herausgegeben von G. Hirth.* Munich, 1908.

HOETINK 1970
 Rotterdam, Museum Boymans-van Beun-ingen. *Drawings by Rembrandt and His School. Catalogue of the Collection in the Museum Boymans-van Beuningen.* Vol. 1. Cat. by H.R. Hoetink, 1970.

HOFFMANN 1926
 Hoffmann, E. "XVII. századi francia rajzok a Szépművészeti Múzeumban. Magyar Mü-vészet" (Seventeenth-century French Draw-ings in the Museum of Fine Arts). Budapest, 1926.

HOFFMANN 1927
 Hoffmann, E. "A Szépművészeti Múzeum néhány olasz rajzáról" (On Several Italian Drawings in the Museum of Fine Arts). *Evkönyv* 4 (1924–1926/1927).

HOFFMANN 1929
 Hoffmann, E. "A Szépművészeti Múzeum néhány németalföldi és német rajzáról" (On Several Netherlandish and German Draw-ings in the Museum of Fine Arts). *Evkönyv* 5 (1929).

HOFFMANN 1929–1930
 Hoffmann, E. "Ujabb meghatározások a rajzgyüjteményben" (New Attributions in the Drawing Collection). *Evkönyv* 6 (1929–1930).

HOFFMANN 1935
 Hoffmann, E. "Iparművészeti és egyéb raj-zok a Szépművészeti Múzeumban" (Draw-ings for the Applied Arts and Other Drawings in the Museum of Fine Arts). *Evkönyv* 7 (1935).

HOLLSTEIN A
 Hollstein, F.W.H. *Dutch and Flemish Etch-ings, Engravings and Woodcuts ca. 1450–1700.* 25 vols. Amsterdam, 1949–1981.

HOLLSTEIN B
 Hollstein, F.W.H. *German Engravings, Etch-ings and Woodcuts ca. 1400–1700.* 18 vols. Amsterdam, 1949–1980.

HUGELSHOFER 1928
 Hugelshofer, W. *Schweizer Handzeichnungen des XV und XVI Jahrhunderts.* Freiburg im Breisgau, 1928.

D'HULST 1974
 Hulst, R.A. d'. *Jacob Jordaens' Drawings.* Brussels, 1974.

HUMMELBERGER 1965
 Hummelberger, W. "Erzherzog Matthias in den Niederlanden." *Wiener Jahrbuch,* N.F. 25 (1965).

ISERMEYER 1963
 Isermeyer, C. A. "Die Arbeiten Leonardos und Michelangelos für den grossen Raatsaal in Florenz." In *Studien zur Toskanischen Kunst. Festschrift für Ludwig Heinrich Heyden-reich.* Munich, 1963.

JACOBS 1930
 Jacobs, R. *Paul Troger.* Vienna, 1930.

JANSON 1952
 Janson, H.W. *Apes and Ape Love in the Mid-dle Ages and the Renaissance.* London, 1952.

JENSEN et al. 1981
 See exh. cat. Schweinfurt 1981.

JOANNIDES 1983
 Joannides, P. *The Drawings of Raphael.* Ox-ford, 1983.

JOHNSON 1981
 Johnson, L. *The Paintings of Eugène Dela-croix. A Critical Catalogue (1818–1831).* 2 vols. Oxford, 1981.

JOHNSTON 1971
 Johnston, C. *Il Seicento e il Settecento a Bolo-gna. I disegni dei maestri.* Milan, 1971.

JUDSON 1973
 Judson, J.R. *The Drawings of Jacob de Gheyn II.* New York, 1973.

KAPOSY 1956
 Kaposy, V. "Les Dessins de Jacob de Wit au Musée des Beaux-Arts." *Bulletin* 9 (1956).

KAPOSY 1968
 Kaposy, V. "Remarques sur deux époques importantes de l'art Daumier Dessinateur." *Acta Historiae Artium* 14 (1968).

KAUFFMANN 1954
 Kauffmann, H. *Dürer in der Kunst und im Kunsturteil um 1600. Anzeiger des German-ischen National-Museums 1940–1953.* Berlin, 1954.

KIRSCHBAUM ED. 1973
 Kirschbaum, E. (ed.) *Lexicon der Christlichen Ikonographie.* 6 vols. Freiburg, Basel, and Rome, 1973.

KLEINSCHMIDT 1930
 Kleinschmidt, B. *Die heilige Anna. Ihre Verehrung in Geschichte und Volkstum.* Düssel-dorf, 1930.

KLESSMANN 1960
 Klessmann, R. "Die Anfänge des Bauernin-terieurs bei den Brüdern Ostade." *Berliner Jahrbuch* 2 (1960).

KNAB 1966
 Knab, E. "Zu Iván Fenyö, Norditalienische Handzeichnungen aus dem Museum der Bildenden Künste in Budapest." *Albertina Studien* 4 (1966).

KNAB-MITSCH-OBERHUBER 1983
 Knab, E.; Mitsch, E.; and Oberhuber, K. *Raphael. Die Zeichnungen.* Stuttgart, 1983.

KNOX 1980
 Knox, G. *Giambattista and Domenico Tiepolo: A Study and Catalogue Raisonné of the Chalk Drawings.* Oxford, 1980.

KOCH 1941
 Koch, C. *Die Zeichnungen Hans Baldung Griens.* Berlin, 1941.

KOZAKIEWICZ 1972
 Kozakiewicz, S. *Bernardo Bellotto genannt Canaletto.* 2 vols. Recklinghausen, 1972.

KREMS 1967
 Krems an der Donau, Kulturverwaltung. *Ausstellung Gotik in Österreich, veranstaltet von der Stadt Krems an der Donau.* Exh. cat. 1967.

KRIS 1926
 Kris, E. "Der Stil 'Rustique.'" *Wiener Jahr-buch* N.F. 1 (1926).

KRIS 1927
 Kris, E. *Georg Hoefnagel und der wessentschaft-liche Naturalismus. Festschrift Julius Schlosser.* Leipzig, 1927.

KÜNSTLE 1926
 Künstle, K. *Ikonographie der christlichen Kunst.* 2 vols. Freiburg im Breisgau, 1926.

LASCHITZER 1888
 Laschitzer, S. "Die Genealogie des Kaisers Maximilian I." *Wiener Jahrbuch* 7 (1888).

LAWRENCE 1981
 Lawrence, Kansas, The Spencer Museum of Art. *The Engravings of Marcantonio Raimondi.* Exh. cat. by I. H. Shoemaker. 1981.

LE BLANC
 Le Blanc, C. *Manuel de l'amateur d'estampes.* 4 vols. Paris, 1854–1890.

LEHRS 1908
 Lehrs, M. *Geschichte und kritischer Katalog des deutschen, niederländischen und französischen Kupferstichs im XV Jahrhundert.* Vol. 1. Vien-na, 1908.

LEWIS 1978
 Lewis, D. "The Washington Relief of Peace and Its Pendant: A Commission of Alfonso d'Este to Antonio Lombardo in 1512." In W. Stedman Sheard and J.T. Paoletti, eds., *Collaboration in Italian Renaissance Art.* New Haven and London, 1978.

LINZ 1965
 Stift St. Florian, Schlossmuseum Linz. *Die Kunst der Donauschule. 1490–1540.* Exh. cat. by F. Dvorschak et al. 1965.

LOS ANGELES 1982
 Los Angeles County Museum of Art, *The Armand Hammer Collection. Five Centu-ries of Masterpieces.* Exh. cat. by D.A. Gould et al. 1982.

LUGT 1921, 1956
 Lugt, F. *Les Marques de collections de Dessins et d'estampes. . . .* Amsterdam, 1921 (supple-ment, 1956).

LUGT 1927
 Lugt, F. *Les Dessins des écoles du nord de la collection Dutuit au Musée des Beaux-Arts de la ville de Paris.* Mus. cat. Paris, 1927.

MAISON 1968
 Maison, K.E. *H. Daumier. Catalogue Raison-né of the Paintings, Watercolors and Drawings.* 2 vols. New York, 1968.

VAN MANDER 1906
 Mander, C. van. *Das Leben der niederlän-dischen und deutschen Maler. Uebersetzung und Anmerkungen von Hanns Floerke.* Munich, 1906.

MAYER 1932
Mayer, H. "H.E. Weyer." *Oeffentliche Kunst-sammlung Basel*. Jahresberichte N.F. 28–29 (1931–1932).

MEINECKE BERG 1971
Meinecke Berg, V. *Die Fresken des Melchior Steidl*. Munich, 1971.

MELLER 1913
Meller, S. "Uj Watteau rajz a Szépművészeti Múzeumban." *Müvészet*, 1913.

MELLER 1918
Meller, S. "Leonardo da Vinci lovasábrázolásai s a Szépművészeti Múzeum bronzolovasa." *Evkönyv* 1 (1918).

MELLER 1963
Meller, P. "Physiognomical Theory in Renaissance Heroic Portraits." In *The Renaissance and Mannerism. Studies in Western Art*. Vol. 2. Princeton, 1963.

MEYERHEIM 1906
Meyerheim, P. *Adolf von Menzel, Erinnerrungen*. Berlin, 1906.

MIDDELDORF 1945
Middeldorf, U. *Raphael's Drawings*. New York, 1945.

MILAN 1958
Milan, Palazzo Reale. *Arte Lombarda dai Visconti agli Sforza*. Exh. cat. 1958.

MILAN [1974]
Milan, Pinacoteca Ambrosiana. *Il seicento lombardo. Catalogo dei disegni, libri, stampe*. Cat. by G. Bora et al. [1974].

MÖLLER 1954
Möller, L. In *Reallexicon zur Deutschen Kunstgeschichte*. Vol. 3, E. Gall and L.H. Heydenreich, eds. 1954.

MOLNAR 1959
Molnár, S. "Remarques sur quatre dessins de Camille Corot." *Bulletin* 15 (1959).

MONTAGNI 1968
Montagni, E.C. *L'opera completa di Watteau*. Milan, 1968.

MÜLLER-WALDE 1899
Müller-Walde, P. "Beitrage zur Kenntnis des Leonardo da Vinci." *Berliner Jahrbuch* 20 (1899).

MÜNSTER 1979–1980
Münster, Staatliche Kunsthalle Baden-Baden. Westfälisches Landesmuseum für Kunst- und Kulturgeschichte. *Stilleben in Europa*. Exh. cat. 1979–1980

MÜNZ 1961
Münz, L. *The Drawings of Bruegel*. London, 1961.

MUTHER 1884
Muther, R. *Die deutsche Bücherillustration der Gotik und Frührenaissance*. Munich and Leipzig, 1884.

NAGLER 1835–1852
Nagler, G.K. *Neues allgemeines Künstler Lexicon*. . . . 22 vols. Munich, 1835–1852.

NEUFELD 1949
Neufeld, G. "Leonardo da Vinci's 'Battle of Anghiari': A Genetic Reconstruction." *The Art Bulletin* 31 (1949).

NEWTON-SPENCER 1982
Newton, H.T., and Spencer, J.R. "On the Location of Leonardo's *Battle of Anghiari*." *The Art Bulletin* 64 (1982).

NUREMBERG 1971
Nuremberg, Germanisches Nationalmuseum. *Albrecht Dürer 1471–1971*. Exh. cat. by P. Strieder et al. 1971.

OETTINGER 1957
Oettinger, K. "Zu Wolf Hubers Frühzeit." *Wiener Jahrbuch* N.F. 17 (1957).

OETTINGER 1959
Oettinger, K. *Altdorfer-Studien*. Nuremberg, 1959.

OETTINGER-KNAPPE 1963
Oettinger, K., and Knappe, K.A. *Hans Baldung Grien und Albrecht Dürer in Nürnberg*. Nuremberg, 1963.

OLLENDORF 1926
Ollendorf, O. *Liebe in der Malerei*. Leipzig, 1926.

PALLUCHINI 1959
Palluchini, R. *Giovanni Bellini*. Milan 1959.

PANAZZA 1965
Panazza, G. *Affreschi di Girolamo Romanino*. Milan, 1965.

PANOFSKY 1948
Panofsky, E. *Albrecht Dürer*. 3d ed. 3 vols. Princeton, 1948.

PANOFSKY 1961
Panofsky, E. *The Iconography of Correggio's Camera di San Paolo*. London, 1961.

PARIS 1963
Paris, Louvre. *Mémorial de l'exposition Eugène Delacroix organisée au Musée du Louvre à l'occasion de la mort de l'artiste*. Exh. cat. by M. Sérullaz. 1963.

PARIS 1975A
Paris, Orangerie des Tuileries. *Hommage à Corot*. Exh. cat. by M. Sérullaz. 1975.

PARIS 1975B
Paris, Grand Palais. *Jean-François Millet*. Exh. cat. by R.L. Herbert et al. 1975.

PARIS 1983
Paris, Grand Palais. *Manet, 1832–1883*. Exh. cat. by F. Cachin et al. 1983.

PARKER 1948
Parker, K.T. *The Drawings of Antonio Canaletto in the Collection of His Majesty the King at Windsor Castle*. London, 1948.

PARKER 1956
Parker, K. T. *Catalogue of the Collection of Drawings in the Ashmolean Museum*. Vol. 2. Italian School. Oxford, 1956.

PARKER-MATHEY 1957
Parker, K.T., and Mathey, J. *Antoine Watteau, catalogue complet de son oeuvre dessiné*. 2 vols. Paris, 1957.

PASSERON 1979
Passeron, R. *Honoré Daumier und seine Zeit*. Freiburg and Würzburg, 1979.

PASTOR 1899
Pastor, L. *Geschichte der Päpste seit dem Ausgang des Mittelalters*. Vol. 3. Freiburg im Breisgau, 1899.

PATAKY 1967
Pataky, D. *Von Delacroix bis Picasso*. Budapest, 1967.

PETERS 1979
Peters, J.S. "Early Drawings by Augustin Hirschvogel." *Master Drawings* 17, no. 4 (1979).

PHILADELPHIA 1971
Philadelphia Museum of Art. *Giovanni Benedetto Castiglione. Master Draughtsman of the Italian Baroque*. Exh. cat. by A. Blunt and A. Percy. 1971.

PIGLER 1924
Pigler, A. "Guido Reni két rajza a Szépművészeti Múzeumban" (Two Drawings by Guido Reni in the Museum of Fine Arts). *Evkönyv* 3 (1924).

PIGLER 1927
Pigler, A. "A XVIII szazadbeli osztrák festök a Szépművészeti Múzeumban." *Evkönyv* 4 (1927).

PIGLER 1967
Pigler, A. *Katalog der Galerie alter Meister*. 2 vols. Budapest, 1967.

PIGLER 1974
Pigler, A. *Barockthemen. Eine Auswahl von Verzeichnissen zur Ikonographie des 17. und 18. Jahrhunderts*. 3 vols. Budapest, 1974.

PIGNATTI 1976
Pignatti, T. *Veronese*. 2 vols. Venice, 1976.

PIGNATTI [1980]
Pignatti, T. *I grandi disegni italiani nelle collezioni di Venezia*. Milan [1980].

PILZ 1962
Pilz, K. "Hans Hoffmann: Ein Dürer-Nachahmer aus der 2. Hälfte des 16. Jahrhunderts." *Mitteilungen des Vereins für Geschichte der Stadt Nürnberg* 51 (1962).

POPHAM 1945
Popham, A.E. *The Drawings of Leonardo da Vinci*. New York, 1945.

POPHAM 1957
Popham, A.E. *Correggio's Drawings*. London, 1957.

POPHAM 1971
Popham, A.E. *Catalogue of the Drawings by Parmigianino*. 3 vols. New York and London, 1971.

POSNER 1971
Posner, D. *Annibale Carracci. A Study in the Reform of Italian Painting around 1590*. 2 vols. London, 1971.

POUNCEY-GERE 1962
Pouncey, P.H., and Gere, J.A. *Italian Drawings in the Department of Prints and Drawings in the British Museum. Raphael and His Circle*. 2 vols. Mus. cat. London, 1962.

PULSZKY 1882
Pulszky, K. von. *Raphael Santi in der ungarischen Reichsgalerie*. Budapest, 1882.

PUPPI 1962
Puppi, L. *Bartolomeo Montagna*. Venice, 1962.

PUPPI 1966
Puppi, L. "Album Vicentino. 1. Aggiunta al catalogo di Bartolomeo Montagna." *Arte Veneta* 20 (1966).

Reallexicon 1954
Reallexicon zur deutschen Kunstgeschichte. Vol. 3. Stuttgart, 1954.

REGTEREN ALTENA 1936
Regteren Altena, J. Q. van. *The Drawings of Jacques de Gheyn*. Amsterdam, 1936.

REISS 1975
Reiss, S. *Aelbert Cuyp*. London, 1975.

REZNICEK 1961
Reznicek, E.K.J. *Die Zeichnungen von Hendrick Goltzius*. Utrecht, 1961.

RIDOLFI 1648
Ridolfi, Carlo. *Della Maraviglie dell'Arte*. . . .

Venice, 1648. 1924 ed.

RIPA 1630
Ripa, C. *Iconologia*. Padua, 1630.

RIZZI 1971
Rizzi, A. *The Etchings of the Tiepolos. Complete Edition*. London, 1971.

ROBAUT 1885
Robaut, A. *L'Oeuvre de Eugène Delacroix*. Paris, 1885.

ROBAUT 1905
Robaut, A. *L'Oeuvre de Corot*. 4 vols. Paris, 1905.

RODOCANACHI 1912
Rodocanachi, E. *Rome au temps de Jules II et de Léon X*. London, 1912.

ROME 1973
Rome, Palazzo Venezia. *Il Cavaliere d'Arpino*. Exh. cat. 1973.

ROME 1982
Rome, Museo Nazionale di Castel Sant'Angelo. *Gli affreschi di Paolo III a Castel Sant' Angelo. Progetto ed esecuzione, 1543-1548*. 2 vols. Exh. cat. 1982.

ROSENBERG 1960
Rosenberg, J. *Die Zeichnungen Lucas Cranach d. A.* Berlin, 1960.

ROSENBERG 1972
Rosenberg, P. "Dessins de Le Sueur à Budapest." *Bulletin* 39 (1972).

ROTTERDAM-AMSTERDAM 1956
Rotterdam, Museum Boymans-van Beuningen, and Amsterdam, Rijksprentenkabinet. *Rembrandt Tekeningen*. Exh. cat. 1956.

RÖTTINGER 1926
Röttinger, H. *Dürer's Doppelgänger*. Strasburg, 1926.

ROUART-WILDENSTEIN 1975
Rouart, D., and Wildenstein, D. *Edouard Manet. Catalogue raisonné*. 2 vols. Geneva, 1975.

ROUCHÈS 1923
Rouchès, G. *Eustache Le Sueur*. Paris, 1923.

RUGGERI 1967
Ruggeri, U. "Aggiunte a Ferraù Fenzone." *Critica d'arte* 14, fasc. 88 (1967).

RUSSEL 1968
Russel, J. *Seurat*. Berlin, 1968.

SALZBURG 1981
Salzburg, Salzburger Barockmuseum. *Oesterreichische Barockzeichnungen aus dem Museum der Schönen Künste in Budapest*. Exh. cat. by K. Garas, 1981.

SCAVIZZI 1960
Scavizzi, G. "Gli affreschi della Scala Santa ed alcune aggiunte per il tardo manierismo romano." *Bollettino d'arte* 45 (1960).

SCAVIZZI 1966
Scavizzi, G. "Ferraù Fenzoni as a Draughtsman." *Master Drawings* 4 (1966).

SCHADE 1974
Schade, W. *Die Malerfamilie Cranach*. Dresden, 1974.

SCHAW 1962
Schaw, B. *The Drawings of Domenico Tiepolo*. London, 1962.

SCHEIDIG 1962
Scheidig, W. *Rembrandt als Zeichner*. Leipzig, 1962.

SCHELLER 1963
Scheller, R.W. *A Survey of Medieval Model*

Books. Haarlem, 1963.

SCHIFF 1973
Schiff, G. *Johann Heinrich Füssli, 1741-1825*. Munich, 1973.

SCHILLING 1929
Schilling, E. *Nürnberger Handzeichnungen des XV und XVI Jahrhunderts*. Freiburg im Breisgau, 1929.

SCHMITT 1957
Schmitt, A. *Hanns Lautensack*. Nuremberg, 1957.

SCHNACKENBURG 1981
Schnackenburg, B. *Adriaen van Ostade, Isack van Ostade. Zeichnungen und Aquarelle*. Hamburg, 1981.

SCHNEEBALG-PERELMAN 1982
Schneebalg-Perelman, S. *Les Chasses de Maximilian*. Brussels, 1982.

SCHNEIDER 1973
Schneider, H. *Jan Lievens. Sein Leben und seine Werke*. Supplement by R.E.O. Ekkart. Amsterdam, 1973.

SCHNEIDER 1979-1980
Schneider, N. *Wirtschafts-und-sozial geschichtliche Aspekte des Früchtestillebens*. Münster, 1979-1980.

SCHOLTEN 1904
Scholten, H.J. *Catalogue raisonné des dessins des écoles françaises et hollandaises*. Haarlem, 1904.

SCHÖNBRUNNER-MEDER
Schönbrunner, J., and Meder, J. *Handzeichnungen alter Meister aus der Albertina und anderen Sammlungen*. 12 vols. Vienna, 1896-1908.

SCHUBRING 1923
Schubring, P. *Cassoni*. Leipzig, 1923.

SCHULZ 1978
Schulz, W. *Cornelis Saftleven 1607-1682. Leben und Werke. Mit einem kritischen Katalog der Gemälde und Zeichnungen*. Berlin and New York, 1978.

SCHWARZ 1917
Schwarz, K. *Augustin Hirschvogel, ein deutscher Meister der Renaissance*. Berlin, 1917.

SCHWEINFURT 1981
Schweinfurt, Kunsthalle zu Kiel. *Adolph Menzel. Gemälde-Gouachen-Aquarelle-Zeichnungen-Druckgraphik*. Exh. cat. by J.C. Jensen et al. 1981.

SÉRULLAZ 1963
See Paris 1963.

SÉRULLAZ 1975
See Paris 1975a.

SÉRULLAZ 1981
Sérullaz, M. *Delacroix*. Paris, 1981.

SHEARMAN 1972
Shearman, J. *The Vatican Stanze. Function and Decorations*. London, 1972.

SIGNAC 1964
Signac, P. *D'Eugène Delacroix au néo-impressionisme*. Paris, 1964.

SLIVE 1981
See The Hague-Cambridge 1981.

STANGE
Stange, A. *Deutsche Malerei der Gotik*. 9 vols. Berlin, 1934-1958.

STARING 1958
Staring, A. *Jacob de Wit*. Amsterdam, 1958.

STECHOW 1951
Stechow, W. "Lucretiae Statua." In *Beiträge für George Swarzenski*. Berlin and Chicago, 1951.

STECHOW 1963
Stechow, W. Review of Panofsky 1961 in *The Art Bulletin* 45 (1963).

STRAUSS 1974
Strauss, W.L. *The Complete Drawings of Albrecht Dürer*. 6 vols. New York, 1974.

STUTTGART 1970
Stuttgart, Staatsgalerie Stuttgart Graphische Sammlung. *Tiepolo. Zeichnungen von Giambattista, Domenico und Lorenzo Tiepolo aus der Graphischen Sammlung der Staatsgaleries Stuttgart, aus Würtembergischen Privatbesitz und dem Martin von Wagner Museum der Universität Würzburg*. Exh. cat. by G. Knox. 1970.

STUTTGART 1978
Stuttgart, Staatsgalerie Stuttgart Graphische Sammlung. *Sammlung Schloss Fachsenfeld. Zeichnungen, Bozzetti und Aquarelle aus fünf Jahrhunderten in Verwahrung der Staatsgalerie Stuttgart*. Exh. cat. by U. Gauss, H. Geissler, V. Schaus, and C. Thiem. 1978.

STUTTGART 1979
Stuttgart, Staatsgalerie Stuttgart Graphische Sammlung. *Zeichnungen in Deutschland: deutsche Zeichner 1540-1640*. 2 vols. Exh. cat. by H. Geissler. 1979-1980.

SUMOWSKI 1979
Sumowski, W. *Drawings of the Rembrandt School*. Vol. 1. New York, 1979.

SUMOWSKI 1980
Sumowski, W. "Observations on Jan Lievens' Landscape Drawings." *Master Drawings* 18 (1980).

TCHAF 1970
Tchaf. *Tekeningen uit het Prentenkabinet te Leiden*. Kerstnummer (Leiden, 1970).

THIEL 1968
Thiel, E. *Geschichte des Kostüms*. Berlin, 1968.

THUILLIER 1974
Thuillier, J. *L'opera completa di Poussin*. Milan, 1974.

TIETZE-CONRAT 1923
Tietze-Conrat, E. "Ikonographische Deutungen nach Columnas 'Historia Trojana.'" *Kunstchronik und Kunstmarkt*. N.F. 34, 21 (1923).

TIETZE 1944
Tietze, H., and Tietze-Conrat, E. *The Drawings of the Venetian Painters in the 15th and 16th Centuries*. 2 vols. New York, 1944.

TOESCA 1912
Toesca, P. *La pittura e la miniatura nella Lombardia*. Milan, 1912.

TOLNAY 1952
Tolnay, C. de. *The Drawings of Pieter Bruegel the Elder*. London, 1952.

VADLEY 1969
Vadley, N. *The Drawings of Van Gogh*. London, New York, and Toronto, 1969.

VAYER 1957
Vayer, L. *Meisterzeichnungen aus der Sammlung des Museums der Bildenden Künste in Budapest*. Budapest, 1957.

VAN DE VELDE 1975
 Velde, C. van de. *Frans Floris (1519/1520–1570) Leven en Werken.* Brussels, 1975.
VENICE 1965
 Venice, Fondazione Giorgio Cini. *Disegni veneti del Museo di Budapest.* Exh. cat. by I. Fenyö. 1965.
VENTURI
 Venturi, A. *Storia dell'arte italiana.* 11 vols. Milan, 1901–1939.
VENTURI 1936
 Venturi, L. *Cézanne. Son art, son oeuvre.* 2 vols. Paris, 1936.
VIENNA 1885–1886
 "Ehrenpforte des Kaisers Maximilian I." In *Beilage zum III und IV Bande des Wiener Jahrbuchs.* Vienna, 1885–1886.
VIENNA 1962
 Vienna, Kunsthistorisches Museum. *Europäische Kunst um 1400.* Exh. cat. 1962.
VIENNA 1967
 Vienna, Graphische Sammlung Albertina. *Meisterzeichnungen aus dem Museum der Schönen Kunste in Budapest.* Exh. cat. by I. Fenyö. 1967.
VIENNA 1981
 Vienna, Graphische Sammlung Albertina. *Guido Reni. Zeichnungen.* Cat. by V. Birke. 1981.
VOSS 1907
 Voss, H. *Der Ursprung des Donaustils.* Leipzig, 1907.
WARD-JACKSON 1979
 London, Victoria and Albert Museum. *Italian Drawings. Vol. 1. 14th–16th Century.* Mus. cat. by P. Ward-Jackson. 1979.

WEGNER 1973
 Wegner, E.W. *Niederländische Handzeichnungen des 15 – 18. Jahrhunderts.* Berlin, 1973.
WELCKER 1979
 Welcker, J.C. *Hendrick Avercamp 1585–1634, Barent Avercamp 1612–1679, "Schilders tot Campen."* Doornspijk, 1979.
WELLESLEY 1969
 Wellesley College Museum. *Dutch Drawings from the Abrams Collection.* Exh. cat. 1969.
WIED 1971
 Wied, A. "Lucas van Valckenborch." *Wiener Jahrbuch* N.F. 31 (1971).
Wiener Jahrbuch
 Jahrbuch der Kunsthistorischen Sammlungen des Allerhöchsten Kaiserhauses. Vols. 1–34, 1883–1918; *Jahrbuch der Kunsthistorischen Sammlungen in Wien.* Vols. 35–77, 1920–1981; N.F. 1–40, 1926–1981.
WILD 1980
 Wild, D. *Nicolas Poussin. Katalog der Werke.* 2 vols. Zurich, 1980.
WIND 1958
 Wind, E. *Pagan Mysteries in the Renaissance.* London, 1958.
WINKLER
 Winkler, F. *Die Zeichnungen Albrecht Dürers.* 4 vols. Berlin, 1936–1939.
WINTHER 1973
 Winther, A. "Die Zeichnungen des Jacob de Wit in der Kunst-Halle Bremen." *Niederdeutsche Beiträge zur Kunstgeschichte* 12 (1973).
WINZINGER 1949
 Winzinger, F. *Deutsche Meisterzeichnungen*

der Gotik. Munich, 1949.
WINZINGER 1952
 Winzinger, F. *Albrecht Altdorfer Zeichnungen.* Munich, 1952.
WINZINGER 1967
 Winzinger, F. "Unbekannte Zeichnungen Hans Burkmair's d.A." *Pantheon* 9 (1967).
WINZINGER 1971
 Winzinger, F. "Leonardo und Dürer." *Pantheon* 29 (1971).
WINZINGER 1975
 Winzinger, F. *Albrecht Altdorfer Die Gemälde.* Munich, 1975.
WINZINGER 1979
 Winzinger, F. *Wolf Huber. Das Gesamtwerk.* Munich and Zurich, 1979.
WÖLFFLIN 1904
 Wölfflin, H. *Die klassische Kunst.* 3d ed. Munich, 1904.
ZALENTINER 1932
 Zalentiner, E. "Hans Speckaert. Ein Beitrag zur Kenntnis der Niederländer in Rom um 1575." *Städel-Jahrbuch* 7/8 (1932).
ZENTAI 1978
 Zentai, L. "Considerations on Raphael's Compositions of the Coronation of the Virgin." *Acta Hungariae Artium* 24 (1978).
ZIMMER 1971
 Zimmer, J. *Joseph Heintz der Altere als Maler.* Weissenhorn, 1971.
ZINK 1968
 Zink, F. *Die deutschen Handzeichnungen. I. Die Handzeichnungen bis zur Mitte des 16. Jahrhunderts. Kataloge des Germanischen Nationalmuseums Nürenberg.* Mus. cat. Nuremberg, 1968.

Index of Artists